~ the ~

BURNING

HOUSE

~ the ~

# BURNING

## HOUSE

COMPILED BY

# FOSTER HUNTINGTON

itbooks
AN IMPRINT OF HARPERCOLLINS PUBLISHERS

# *it***books**

THE BURNING HOUSE. Copyright © 2012 by Foster Huntington. All rights reserved. Printed in the United States of America. No part of this book may be used or reproduced in any manner whatsoever without written permission except in the case of brief quotations embodied in critical articles and reviews. For information address HarperCollins Publishers, 10 East 53rd Street, New York, NY 10022.

HarperCollins books may be purchased for educational, business, or sales promotional use. For information please write: Special Markets Department, HarperCollins Publishers, 10 East 53rd Street, New York, NY 10022.

FIRST EDITION

*Designed by Shannon Plunkett*

Library of Congress Cataloging-in-Publication Data is available upon request.

ISBN 978–0–06–212348–0

12  13  14  15  16  [isd / RRD]  10  9  8  7  6  5  4  3  2  1

This book is dedicated to the people who submitted their photos and stories to The Burning House. Without them, this book could never have been made.

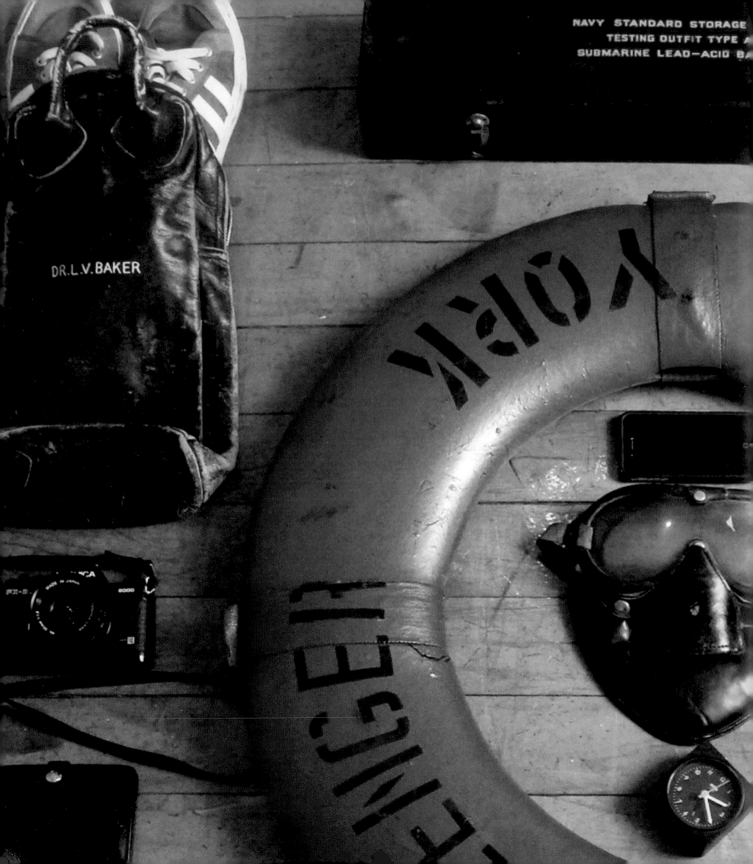

# CONTENTS

# INTRODUCTION

If your house were on fire, what would you take with you? It's a conflict between what's practical, valuable, and sentimental. What you choose reflects your interests, background, and priorities. A mother of three in her late thirties has very different priorities from a single, twenty-two-year-old man. Their selections reflect these differences. Think of the photos and lists collected in this book as the answers to a one-question interview.

*The Burning House* spawned from a conversation among friends at a dinner party. People were discussing their online dating profiles and the questions they ask others on dating sites. I thought about it for a second and asked the group what they would take if their house were burning, thinking that the question would be a subtle way to get people to discuss their values.

Everyone at the table immediately had a response. The photographer said she would take her Hasselblad and as many boxes of negatives as she could grab. The musician said he would grab his Gibson guitar, a Les Paul, and an old paper napkin with his first song lyrics scribbled on it. The consultant would take a first-edition copy of *The Grapes of Wrath* given to her by her grandfather a few months before he passed away. Walking home that night, I realized that these answers reflected people's interests but also exposed more intimate and human details about their lives, which they rarely shared with others. The conversation continued among our

group for the next few days, with a series of emails announcing new additions to their lists and analyses of others' lists. As our obsession with the topic and sharing each other's answers continued, I thought it would be interesting to take this discussion wide—and what better place than the web?

That weekend I thought about which objects of my own meant enough to me to pull from the flames, and I set about photographing what would be the first post for The Burning House blog. I also started asking other friends what they would take. Some needed further background and explanation, but most understood the question before I finished asking it. On May 10th, 2011 www.theburninghouse.com launched with ten posts. Within a few hours came my first submission from a complete stranger in Massachusetts, and then an hour later another submission came in from England.

As a child of the Internet generation, I was familiar with the idea of something going viral, but I never imagined it would happen to anything I initiated. The Burning House clearly raised a question that people wanted to both answer and discuss. Word spread quickly, and within just a few days the project was being written up in the media. This traction drove submissions to the site from all over the world. As curator, I was faced with an exciting but crucial decision in terms of which posts to include on the site. With the project only a few weeks old, I knew it was important to guide the posts in a way that made people from various backgrounds feel like they could be included. I also wanted to make sure the entries that made up the site were true to the discussion at hand—what's genuinely valuable to a person—and didn't allow the conversation to devolve into mere showboating of expensive possessions. I avoided posting photos that were only about the gear, focusing instead on the submissions that were dynamic and included irreplaceable items with clear personal meaning. And I sought for each post to complement and contrast the ones which preceded and followed. Although subtle, the selection of posts in the project's infancy established a precedent for both the visual quality of the submissions and their contents.

As The Burning House snowballed into something larger than I had ever hoped for, I decided to get more personally involved. I left my job in New York so that I could focus on expanding the blog's reach and in the process create a book. I bought a VW van and hit the road, looking for people to photograph.

For five months, I drove up and down the West Coast and around the Rockies, putting thousands of miles on my van in search of people other than typical blog readers. I wanted to expand the project generationally, geographically, and socioeconomically. I wanted to find people who had never heard of Tumblr, had never seen an iPad. With Richard Avedon's *In the American West* as my inspiration, I traveled the country's back roads looking for my subjects. Life on the road exposed me to a variety of people I never could have met if I'd stayed in Manhattan. I asked people at gas stations in Nevada and homeless people in Denver back alleys to participate. A few said no, but most were eager to share their answers. Although the people I met on the road came from wildly different backgrounds, they approached the question in a similar way, evaluating what they cared about materially.

Their answers were full of surprises, with my personal favorite being Bill Barr, a sixty-five-year-old resident of Gothic, Colorado, a small research outpost situated eleven thousand feet above sea level in the Gunnison National Forest. While Gothic's scant population swells from June to August each year with an influx of biology students, Bill lives there year round, cross-country skiing five miles to the nearest town just to pick up fresh produce. When asked what he would take, he walked over to a wall of Blu-ray discs and a hundred-inch HD projector—all powered by solar and hydroelectric energy from a nearby stream—and pulled out a copy of *The Princess Bride*. "Oh, and I would take my skis, so I could get out of here." I wouldn't have guessed that in a million years.

Hearing people's stories and seeing their submissions throughout the course of working on this project has taught me that I need a lot fewer material possessions. When I first considered what I would save, I selected eighteen items. Six months into the project and my selection dropped down to just two (my revised list is the last one in the book). This reduction came about after chatting with people about what they would take and hearing their different responses. These stories from all over the world—and some from people that have actually been forced to take things with them in a catastrophe—made me realize that I could live without my favorite belt or shoes. These conversations almost always centered on the conflict of what you want versus what you need. Sure it would be nice to save my favorite childhood book, *Two Little Savages* by Ernest Seaton Thompson, but do I *need* it? No. This continuous analysis prompted me to keep whittling down my list until it was comprised of just two items.

Today, developed countries are consuming more than ever before. This culture of consumption is often fueled by people's desire to define themselves by the possessions they amass. *The Burning House* takes a different approach to personal definition. By removing easily replaceable objects and instead focusing on things unique to them, people are able to capture their personalities in a photograph. More to the point, the objects in the photographs act as stand-ins for key moments in people's lives and thus, in a way, for the people themselves and all that has shaped them. Tidbits of where they live, what they do for a living, and what they care about manifest themselves in what they choose to include. The most unique items, and therefore the most identifiable to a specific person, often have little to no monetary value. Items like teddy bears, film negatives, and letters from friends are unique to a person's life and cannot be bought on Amazon. And while the four generations represented in this book expose many differences in people's selections, at heart there are fundamental and telling similarities. At first blush the younger generations represented here might seem more tech focused—repeatedly saving iPhones, laptops, and hard drives—but the reality is that these choices mirror older generations' valuing of film negatives, journals, and letters. These items address the same essential connection to others and to self-expression.

The core question of what you would take if your house were burning down I left open ended, purposely not restricting it with an item limit or time frame for selection. People answered the question as they saw fit. Some included dozens of items and took hours arranging their photos, while others took one or two items and took the photo in a few minutes. These differences reflect their relationships with materials but also their backgrounds. A soldier from Iran thinks about and addresses this question very differently than a fashion designer from Brooklyn.

For this book, I selected submissions that showcase the geographic, economic, and generational reach of the project. Eighty years separate the oldest and youngest participants, and every continent, except Antarctica, is represented. People from all walks of life are included in the book. There is no right or wrong answer to the core question. I hope the book will inspire conversations about materialism and perhaps help you evaluate what's important to you.

If these photos and lists intrigue or inspire, visit theburninghouse.com and join the conversation by submitting your own post.

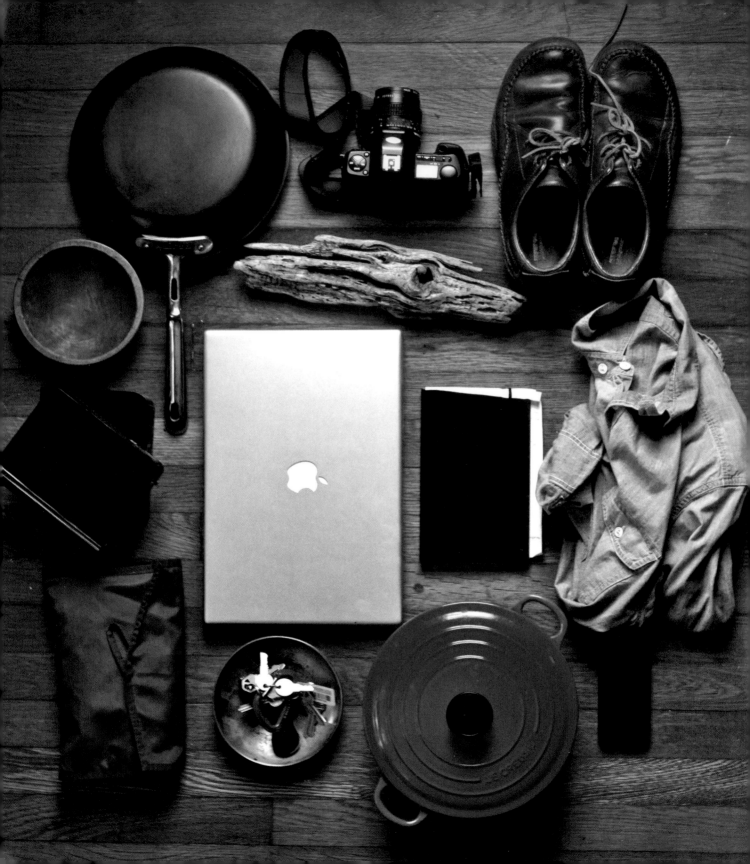

# TIM ROBISON

AGE: 26
LOCATION: North Carolina
OCCUPATION: Creative Digital Director, University of North Carolina at Greensboro
WEBSITE: www.thatsjustitphoto.com

- My grandfather's camera
- Favorite shoes (so comfortable)
- Some of my favorite bowls
- My Moleskine notebook, full of many sketches, ideas, and dates
- My favorite shirt
- Piece of driftwood I found and love
- Laptop. My iMac would be too hard to carry.
- Two full hard drives with years' worth of work and photos
- My most-used kitchen pans: an All-Clad LTD2 fry pan and
  Le Creuset Dutch oven
- Keys. They open and start a lot of things.
- Pencil bag full of my best pens and pencils
- iPhone

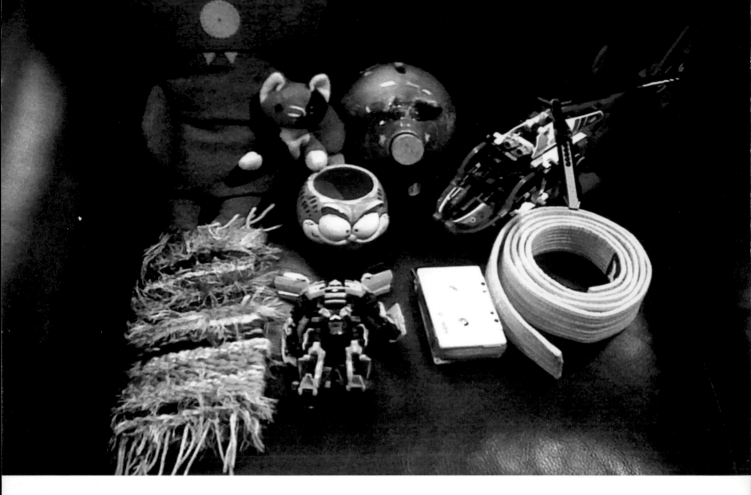

# BRODY TORS

**AGE:** 6
**LOCATION:** New Hampshire
**OCCUPATION:** A kid

- Wedgehead
- Garfield cup
- Lego helicopter
- Bumblebee Transformer
- Chip
- Yellow belt
- Piggybank
- Wallet
- Weaving
- Lego Camera used to take photo (not pictured)

# STEVEN RINELLA

**AGE:** 37
**LOCATION:** Brooklyn, New York
**OCCUPATION:** Writer

- Father's Bronze Star, awarded for combat duties on the Italian Peninsula during World War II
- Buffalo skull, circa 1750 AD, that provided the inspiration for my second book, *American Buffalo: In Search of a Lost Icon*
- A betting contract with my buddy in Alaska about whether or not I'd marry my wife, signed after our first date

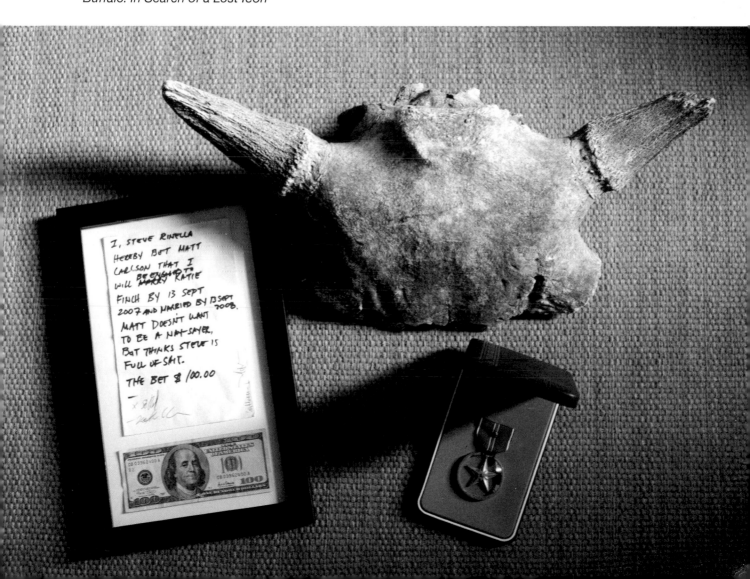

# BRENDA BELL

**AGE:** 60
**LOCATION:** Pinetop, Arizona, White Mountains (wildfire country in May/June)
**OCCUPATION:** Homemaker

- My dog, Baby Val, and treats for him
- My husband, Larry, and treats for him
- Peanut butter and crackers, peanuts, candy, and gum
- A spork (spoon/fork)
- Hand warmers
- Wool hat
- Lots of money (small denominations) and change
- Emergency first-aid kit and Ziploc bags
- Matches

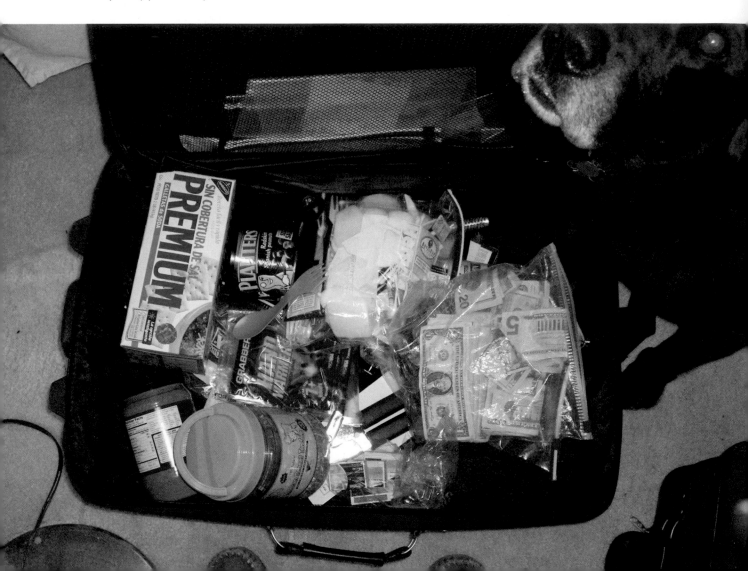

# ERIKA SPRING

**AGE:** 31
**LOCATION:** Greenpoint, Brooklyn, New York
**OCCUPATION:** Musician

- Suzuki Omnichord System Two
- Notebooks with song ideas, stories, dreams
- Passport
- Chanel lipstick
- 1960s Japanese picnic set for four
- Traveling Buddha
- Love talisman

- Crystal necklace I've worn since I was a baby
- Selection of my textiles collection
- MacBook
- Gardenia water
- Green fabric belt that looks good with everything
- Glasses

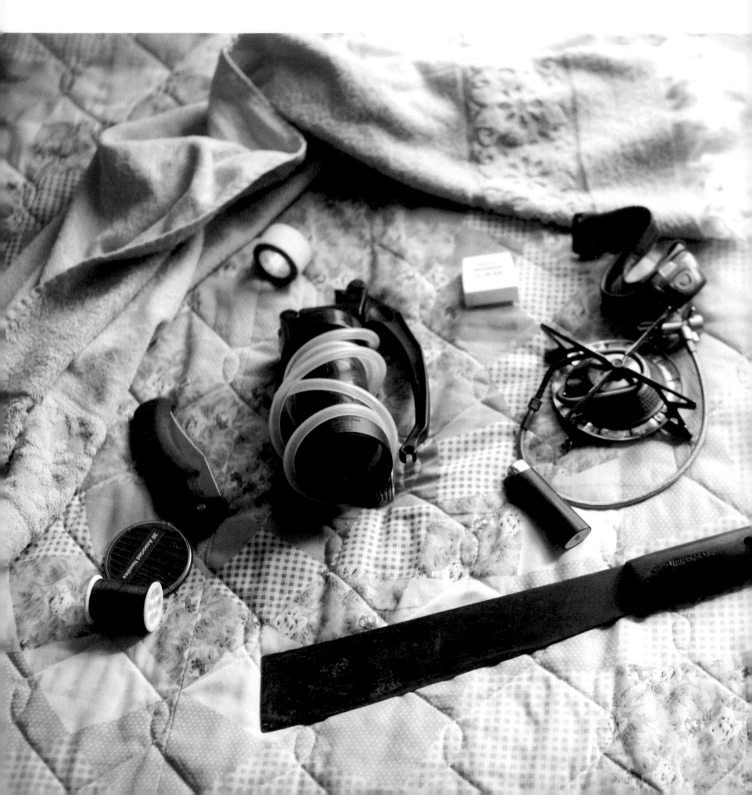

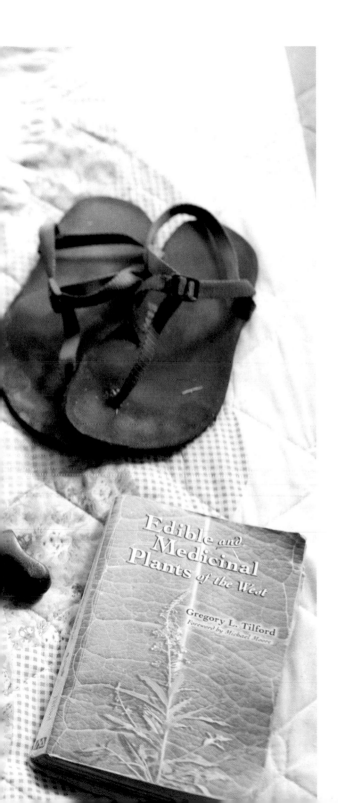

# TREVOR GRIFITHS

**AGE:** 26
**LOCATION:** The Lost Coast, Northern California
**OCCUPATION:** Native riparian and grassland
  restorationist

- Knife
- Water filter
- Camping stove
- Needle and thread
- Bedrock sandals
- Tape
- Lighter
- Floss
- Machete
- Towel
- Book on edible and medicinal
  plants of the West

# JENNIFER MAREE ROUSE

**AGE:** 23 (Aries/Taurus)
**LOCATION:** Melbourne, Australia
**OCCUPATION:** Undiscovered
**WEBSITE:** www.arousing.posterous.com
 and www.flickr.com/photos/jennifermareerouse

- My cat, Amber (not pictured)
- Nikon FE2, my first and favorite SLR camera
- My grandmother's Pentax ME Super camera
- iPhone (music, contacts, emergency computer)
- The negatives stash
- Universal Waite tarot deck
- Claddagh ring, the first piece of jewelry I bought myself
- Five-millimeter crochet hook
- Giant solid brass key my brother gave me for my twenty-first birthday
- TARDIS earrings my partner made for me
- The Chucks I lived in from 2005 to 2007, which is also the time period
  I spent with my best friend, Beth

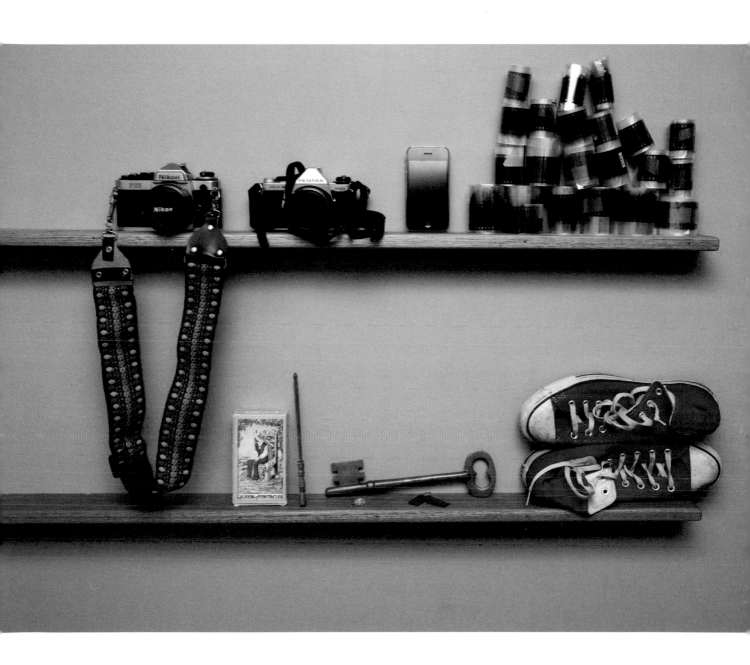

# REDI MENDOZA

**AGE:** 27
**LOCATION:** Manila, Philippines
**OCCUPATION:** Self-Employed

- Brown Onitsuka Tiger sneakers
- Fertility statue from Nigeria given by my mom
- A friend's copy of *Sputnik Sweetheart* by Haruki Murakami
- Copy of *The Dharma Bums* by Jack Kerouac
- Black journal and some fountain pens
- Vintage Russian rangefinder
- Fish bait from a solitary trip in a remote fishing village
- Some photos of beach trips and drunken nights
- WD portable hard drive
- Vintage Russian TLR camera
- Gingham shirt from Muji
- 1970s vintage Omega watch from my grandfather
- Roll of Ilford XP2 400 film
- Wooden boat statue from a memorable Palawan vacation
- Menko cards from Siazen

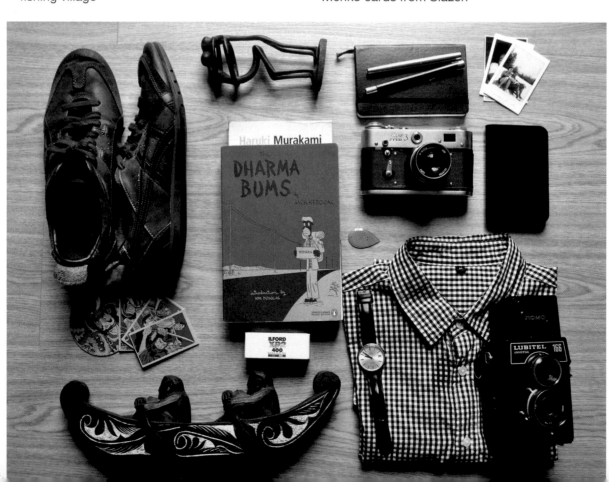

# MICHELLE ASHTON

**AGE:** 27
**LOCATION:** London, England, UK
**OCCUPATION:** Web designer
**WEBSITE:** mizhenka.blogspot.com

- MacBook Pro. It's uninsured and full of work and personal photographs.
- Twenty-seven-year-old teddy bear, "Teddy," who has already survived one burning house.

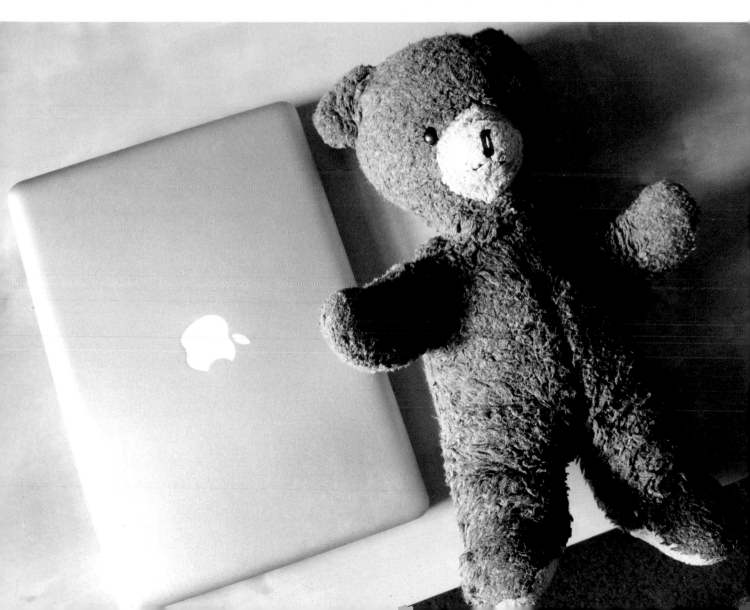

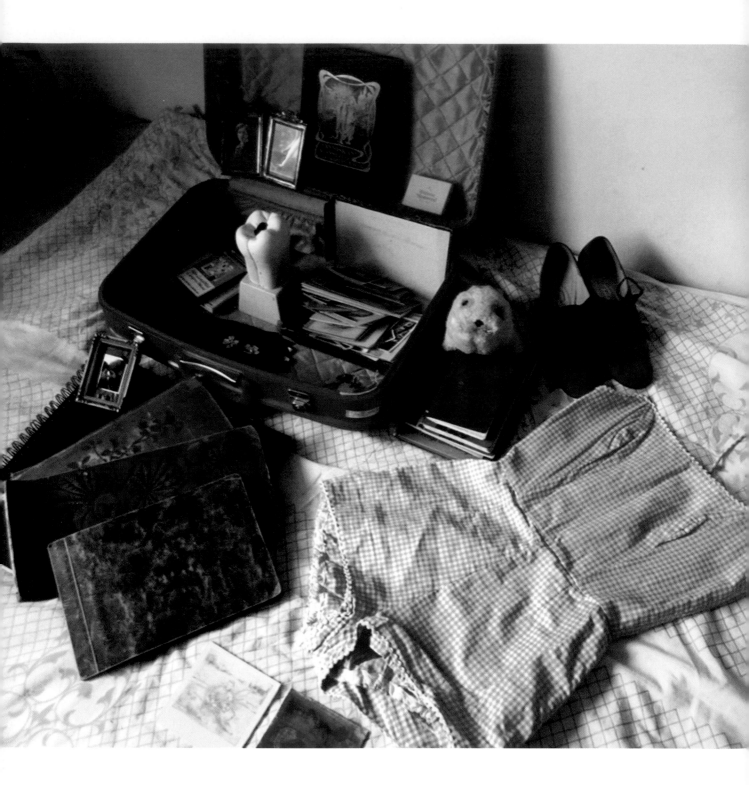

# KARIN ÖST

AGE: 24
LOCATION: Göteborg, Sweden
OCCUPATION: Vintage shop owner, environmental-science student
WEBSITE: blog.lilyofthevalley.se and www.lilyofthevalley.se

Okay, I guess this sounds a little bit paranoid, but I keep this suitcase packed at all times, just in case there actually is a fire! Not all of those things are always in the suitcase, but most are.

- Photo albums and diaries from my life
- Collection of antique photographs, and vintage photos of my family and ancestors
- Vintage tooth model my parents got me because I have a dentist/tooth fetish.
- A 1950s gingham jumpsuit
- Favorite shoes
- Sälas, the plush seal I got when I was a newborn
- Small paintings by my boyfriend, who is an artist (www.frejnicolaisensiden.se)
- Vivienne Westwood jewelry I got from Grandma when I graduated
- Blue 1940s/1950s leather gloves with silver bows
- Antique and highly amusing book on human sexuality, which has stories about how you die in a "nameless horror" from masturbation. It was a gift from my father, who refused to let go of it until a year or so ago.
- Audiobook of *Vem ska trösta knyttet?* (*Who Will Comfort Toffle?*, a picture book) by Tove Jansson
- The suitcase itself, which was given to me by my friend Natalie, who owned it and named it Daphne before she moved back to Canada

# LUDWIG

**AGE:** 27
**LOCATION:** In the middle of Germany
**OCCUPATION:** Student
**WEBSITE:** www.soundcloud.com/yellow-tangerine

- My favorite guitar
- Laptop
- Specs

- Cell phone
- Pen F camera
- OP–1 synthesizer

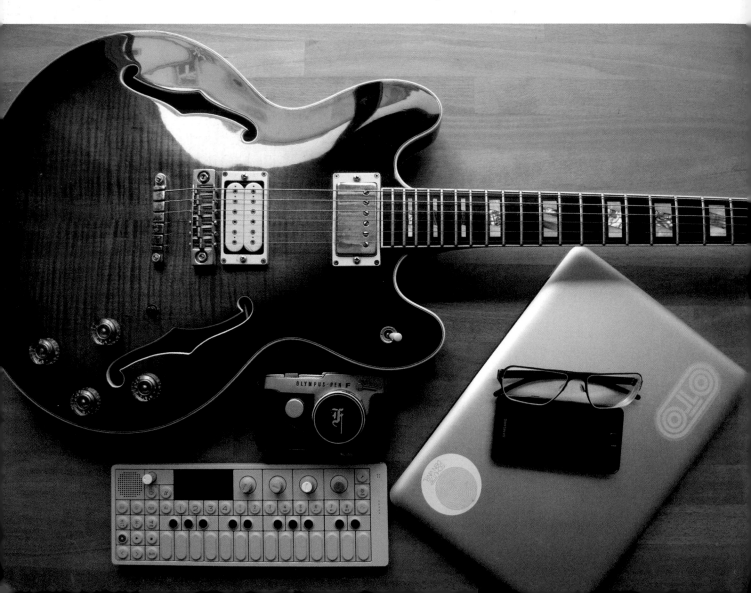

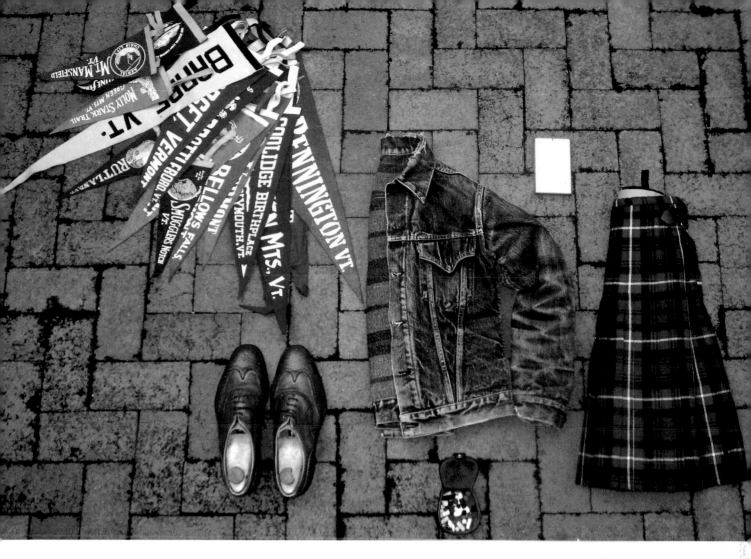

# JAMES OLIVER LAMONT FOX

**AGE:** 40
**LOCATION:** Somerville, Massachusetts
**OCCUPATION:** IT, and library-school student
**WEBSITE:** 10engines.blogspot.com

- Growing collection of old-timey Vermont pennants
- Ede & Ravenscroft brogues, bought for our wedding
- Box of cufflinks, including Grandpa's mother-of-pearl jobs and monogrammed silver ones, given to me by my godfather thirty-nine years ago
- Levi's Troy-lined jacket, thrifted for $2.50 a long time ago
- My kilt, Lamont, the only made-to-measure thing I own.
- External hard drive of photos

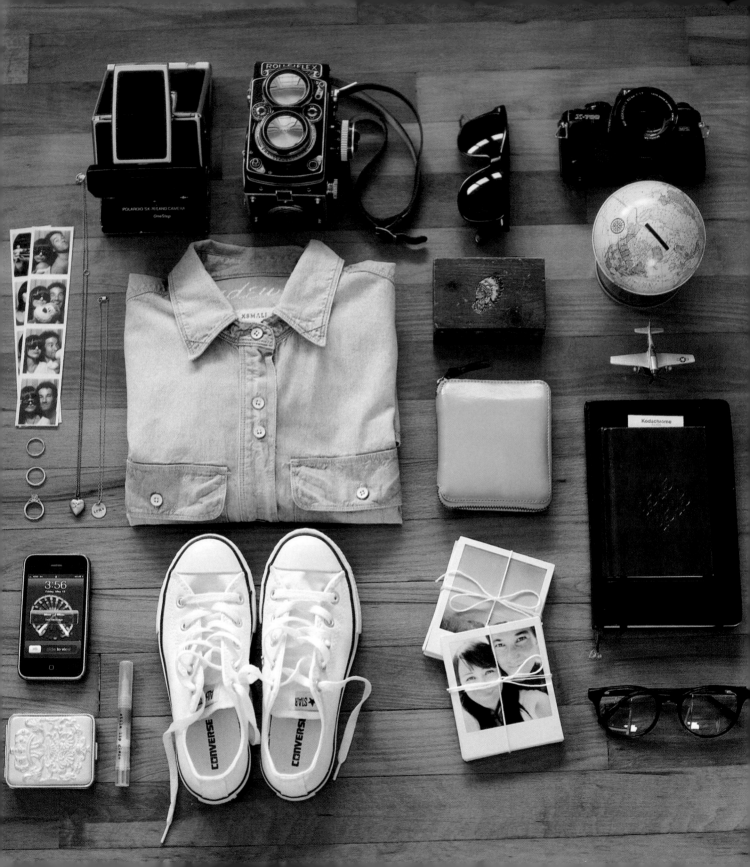

# LEILA PETERSON

**AGE:** 32
**LOCATION:** Los Angeles, California
**OCCUPATION:** Wedding photographer
**WEBSITE:** dearleila.wordpress.com

- Polaroid SX-70 camera passed down from my parents
- Rolleiflex camera and Minolta X-700 camera
  (first camera I owned)
- Dad's vintage Ray-Bans I somehow adopted
- Favorite mini globe
- Old box I found at a flea market, filled with rings and necklaces
  and a pin from grandmother
- Chambray shirt I wear with everything
- Wallet I bought at a museum in LA five years ago
- DIY model airplane that reminds me of a happy time
- Moleskine with daily writings and letters from my husband when
  we were dating
- Reading glasses from Prism in London
- Polaroids: some of my favorite shots taken around Southern
  California and Hawaii
- Favorite shoes
- Lip gloss and compact
- Heart locket and name-plate necklace
- Photo-booth photos: One was taken at a county fair in LA,
  and the other was taken on Magic Mountain in 2006

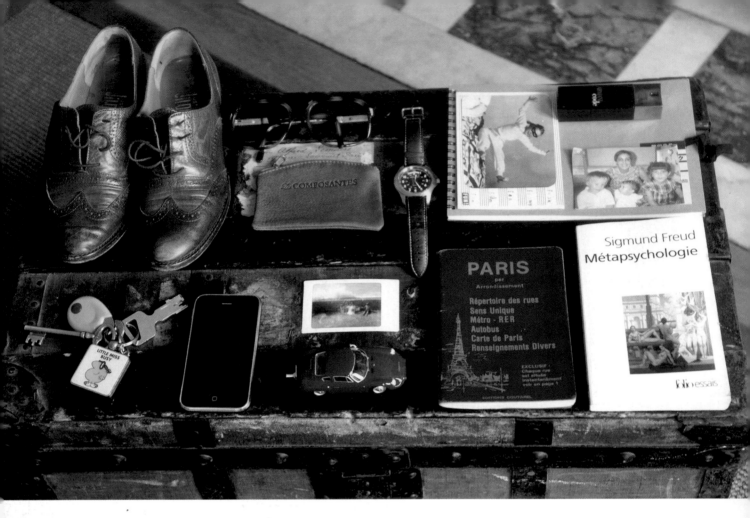

# MORGANE SEZALORY

**AGE:** 26
**LOCATION:** Paris, France
**OCCUPATION:** Founder and art director of French clothing and accessory line Les Composantes
**WEBSITE:** lescomposantes.com/

- Glasses, to be able to see
- Maps of Paris my dad gave me when I was twelve
- *The* picture of my family
- My favorite book
- The scent of the man I love
- Pen to write and a notebook
- My keys to feel like everything isn't lost

- My phone
- The most beautiful little red car, given to me by my brother. It's a little bit of him that I can easily keep with me.
- My wallet with my passport and some money
- My "always" shoes
- The watch the man I love gave me

# UNNI PALMGREN

**AGE:** 19
**LOCATION:** Tidaholm/Motala, Sweden
**OCCUPATION:** Art student
**WEBSITE:** luftfarden.blogspot.com

- Tote bag made by me
- Konica FC–1 camera
- Pencils and brushes
- My favorite necklace
- MacBook

- iPhone
- Glasses
- My cats (the photos are a stand-in)
- Teddy bear from my dear mom

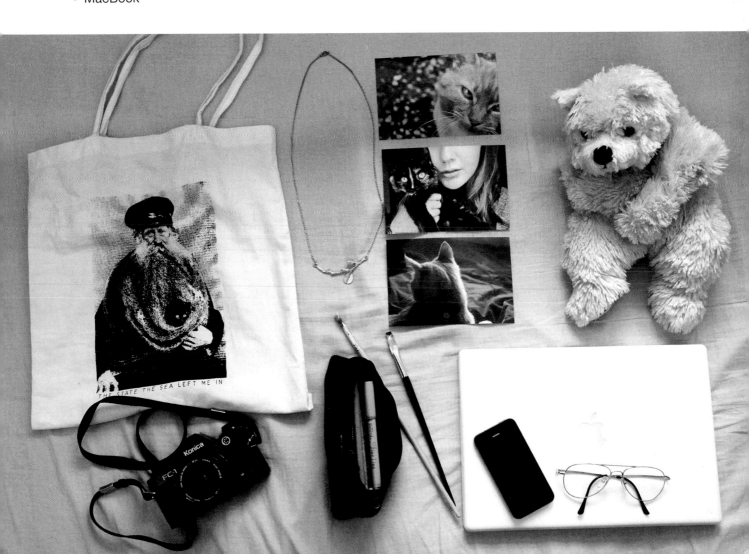

# SAM ALDEN

**AGE:** 22
**LOCATION:** Portland and New Orleans
**OCCUPATION:** Artist
**WEBSITE:** gingerlandcomics.blogspot.com

- Big beat-up portfolio containing the bulk of my two-year-long comics project
- Laptop
- Carrying case of art supplies, hand-sewn out of plastic bags by my mom
- Book of printed-out email correspondence from my girlfriend, in case Google ever bites it
- Planner/book of Japanese woodblock prints
- Red Alpine Polarguard jacket from the 1970s. It was my mom's and then my brother's, and now it's mine.
- Wrangler shirt from my uncle
- My only belt
- Finnish comic book by Tove Jansson
- My only sneakers
- Deodorant
- Cell phone
- Razor (electric, in case I need to take it on a plane)
- Wallet
- Windsor & Newton compact watercolor set from my dad
- Keys
- Oliver Peoples Larrabee glasses

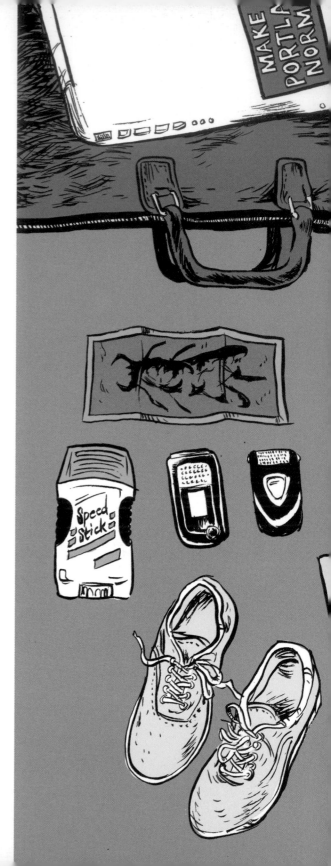

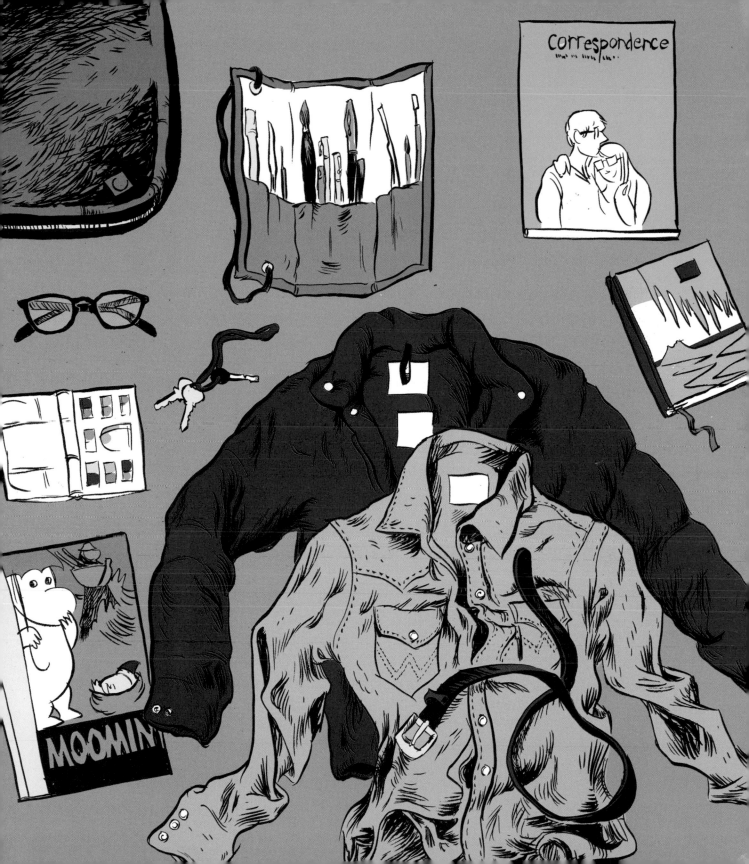

# MELISSA HOWARD

**AGE:** 37
**LOCATION:** New York
**OCCUPATION:** Stock, a vintage menswear store

- 1930s Spalding shawl collar sweater
- 1920s JCPenney leather jacket
- 1940s Chippewa engineer boots
- 1940s L.L. Bean duffle bag
- 1950s Rolex oyster army watch
- Credit card case
- Faded blue bandanas

- Early Carhartt bandanas
- Early leather jacket and overall-salesman samples
- Early Beaver State Pendleton blanket
- Early carved African-American mechanical toy
- 1906 hickory cane with carved handle
- Luna, my twelve-year-old Yorkshire Terrier
  (not pictured)

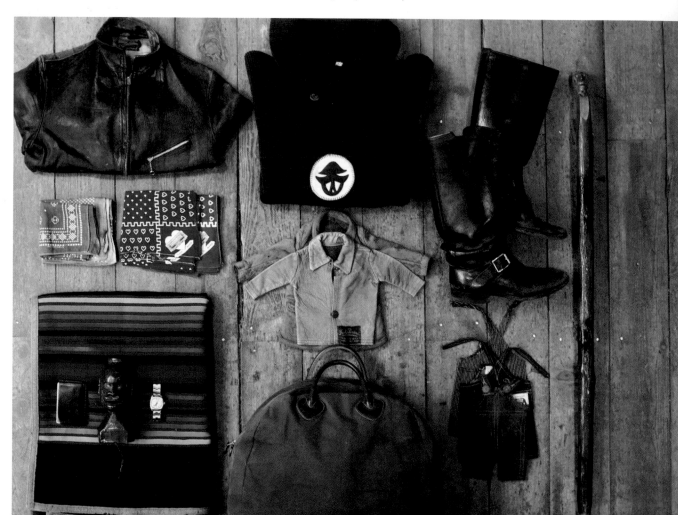

# LAURA POWE

**AGE:** 18
**LOCATION:** Brisbane, Australia
**OCCUPATION:** Musician, traveler, waitress, gap-year student

- My grandmother's earrings
- Favorite (and irreplaceable) skirt
- Owl of wisdom
- Family jewelry box
- Bundle of childhood photos
- iPod
- My mum's treasured wallet from Florence
- First Polaroid camera
- Beautiful old Bible
- Baby teddy
- Photo-booth photos
- Travel journals
- Favorite vintage satchel bag
- Beloved clarinet, I would never part with you!

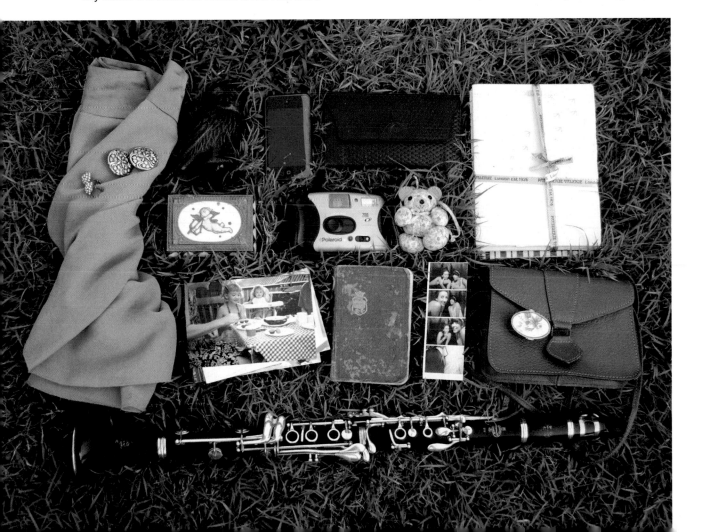

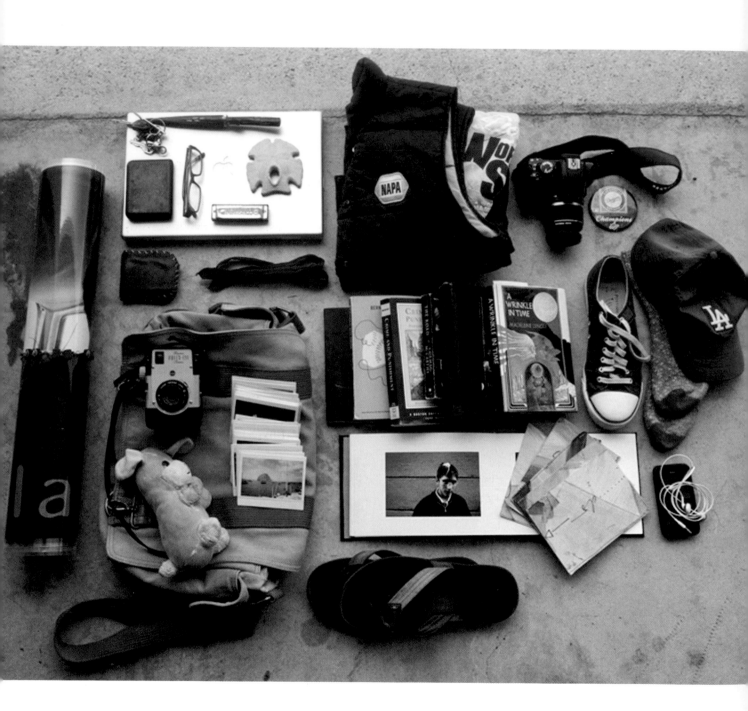

# COREY VAUGHAN

AGE: 22
LOCATION: Los Angeles, California
OCCUPATION: Photographer
WEBSITE: www.coreyvaughan.com

- MacBook Pro, with necessary programs and music
- Hard drive with thousands of photographs
- My trusty Ray-Ban glasses
- Keys
- Blues Band harmonica
- Weird shell I found in La Bahia de los Angeles, in Mexico
- Hand-carved knife from Thailand given to me by some friends
- Wallet, from Ensenada
- Red sash, for sentimental reasons
- Autographed poster of my favorite band
- My Brownie camera, purchased at a swap meet
- Several Polaroids of friends, family, and travel
- My stuffed dog from my childhood. As a baby, I picked off all his fur to help me fall asleep.
- Pair of well-worn rainbows
- Handmade book of my travel photos from Spain
- Some handmade postcards from my uncle
- *Velvet Elvis* by Rob Bell
- *The Natural* by Bernard Malamud
- *Crime and Punishment* by Fyodor Dostoyevsky
- *The Road* by Cormac McCarthy
- The Bible
- *Can You Drink the Cup? by* Henri Nouwen
- My autographed copy of *A Wrinkle in Time*
- My Napa vest, and a vintage World Series t-shirt from the 1988 Dodgers
- My Rebel XSi camera
- Vintage World Series button from the 1988 Dodgers
- My favorite shoes, PF Flyers (only one of the pair pictured)
- Dodgers hat
- Wool socks, because it gets cold
- iPhone and headphones

# KAT AND MAC McMILLAN

**AGE:** Both 36
**LOCATION:** Minneapolis, Minnesota
**OCCUPATION:** Menswear
**WEBSITE:** www.pierreponthicks-shop.com

- Orrlaskan wool blanket
- Antique 1970s Encyclopedia Britannica globe
- Baby-gator head
- Mac's fishing rods
- Kat's favorite bag by Schuler & Sons
- Photo of Tess, Kat's first dog/first love
- Kat's Adidas Sambas

- Mac's Sperry boat sneakers
- Pierrepont Hicks FW11 tie
- *Where the Wild Things Are* by Maurice Sendak
- *Scrapbooks from Africa and Beyond* by Peter Beard
- Baby: Mimi McMillan, ten weeks old
- Camille McMillan, age two (not pictured)

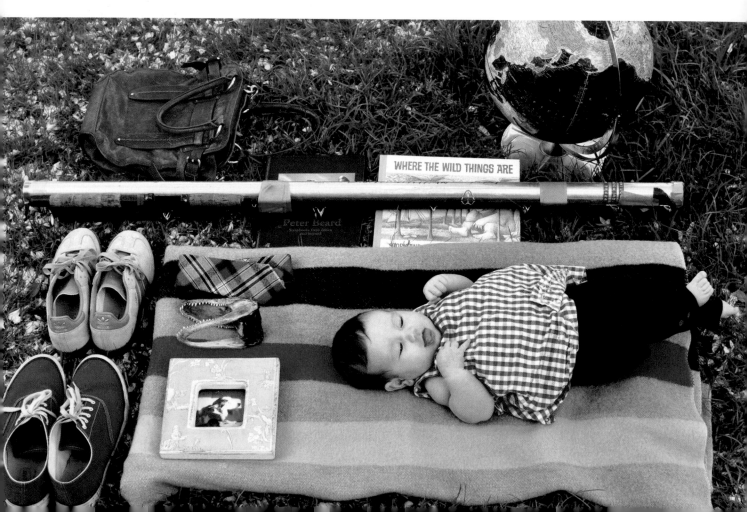

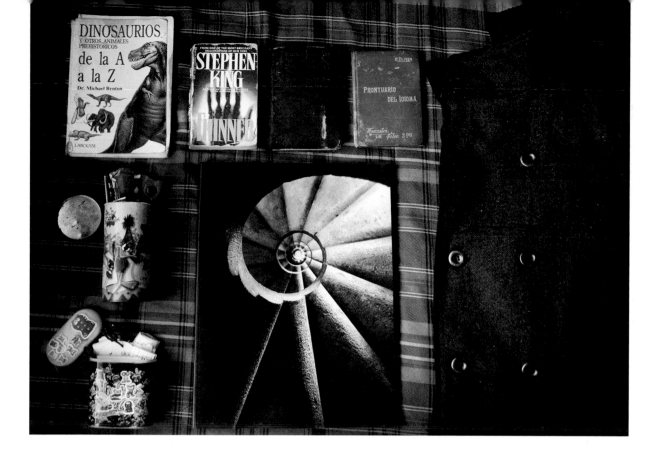

# BERNARDO RUIZ

AGE: 22
LOCATION: Monterrey, México
OCCUPATION: Web designer
WEBSITE: www.25-horas.com

- My favorite dinosaur book from my childhood, *Dinosaurios y Otros Animales Prehistóricos de la A a la Z* (*Dinosaurs and Other Prehistoric Animals from A to Z*) by Michael Benton
- *Thinner* by Stephen King, 1985 edition
- *Was ein Kleines Mädchen wissen muss* by Frau Dr. Mary Wood-Allen. This beautiful German book from 1910 was a gift from my girlfriend's mom.
- *Prontuario del Idioma* by Enrique Oliver Rodríguez, a Spanish book from 1905— the oldest book I have!

- My Pull & Bear grey coat. I simply love it.
- Looney Tunes can in which I keep various pieces of childhood memories like cards, souvenirs, fossils, key chains, etc.
- "Porta Hielocos." In the 1990s Coca-Cola once made several characters made of plastic called Hielocos, so this is a box where you could keep them. I used it to treasure some childhood letters I received from friends.

# BEN BATOR

**AGE:** 25
**LOCATION:** Detroit, Michigan
**OCCUPATION:** Cofounder of www.textsfromlastnight.com
**WEBSITE:** www.textsfromlastnight.com and www.benbator.com

Everything was within ten feet of my bed this morning, except for the coffee dripper, which was on the way out the door.

- A.P.C. jeans. Too stubborn to start over.
- Notebook (and picture) my dad left under my pillow after my parents dropped me off at college
- Hario coffee dripper
- Commonwealth Rwanda beans
- Wallet
- Glasses
- iPhone (mobile office)
- Detroit Pistons 89–90 Back to Back hat
- Reading material
- MacBook Pro (the office)
- Slippers (not pictured)
- Wings + Horns x Ace Hotel robe (not pictured)

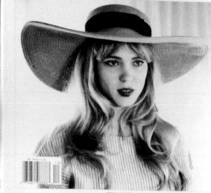

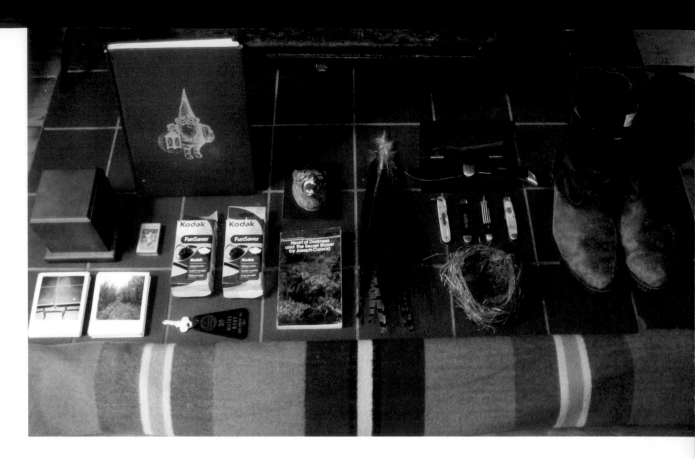

# MATT BLODGETT

**AGE:** 29
**LOCATION:** Housatonic, Massachusetts
**OCCUPATION:** Landscaping
**WEBSITE:** www.ridemedowneasy.com

- My cat Waylon's ashes. We had a good run.
- *Gnomes* by Will Huygen and Rien Poortvliet, signed by my father. I still believe.
- Some Polaroids of mine. The Northeast has been a faithful friend.
- Ohio Blue Tip matches (1955 dry)
- Kodak FunSaver cameras
- The key to Room 30 at the old Roxy Hotel in Cape Vincent, New York, which is where I'll go when I die
- Ceramic bear head (found folk art from the 1960s)
- *Heart of Darkness* and *The Secret Sharer* by Joseph Conrad
- Pheasant feathers (gifts for friends I've yet to meet)
- Pocketknife partial collection (when "handy" and hand meet)
- Bird's nest from the house I grew up in (never leave home completely)
- Red Wing Pecos boots. "You won't find the devil dancing . . ."
- Vintage Native-American blanket (room for two)

# MARIE-LAURE DAILLUT

**AGE:** 31
**LOCATION:** Soorts-Hossegor, France
**OCCUPATION:** Model and website editor
**WEBSITE:** www.le-monde-est-a-nous.net

- Portfolio
- Aviator Skull Candy headphones and iPod
- Amsterdam Moleskine
- Open toes
- RAEN sunglasses
- External disk
- Shell jewelry box
- Cup of tea
- Wallets, money, passport
- BlackBerry
- Laptop
- Scrapbook Indie diary
- My boyfriend and my kitty cat!

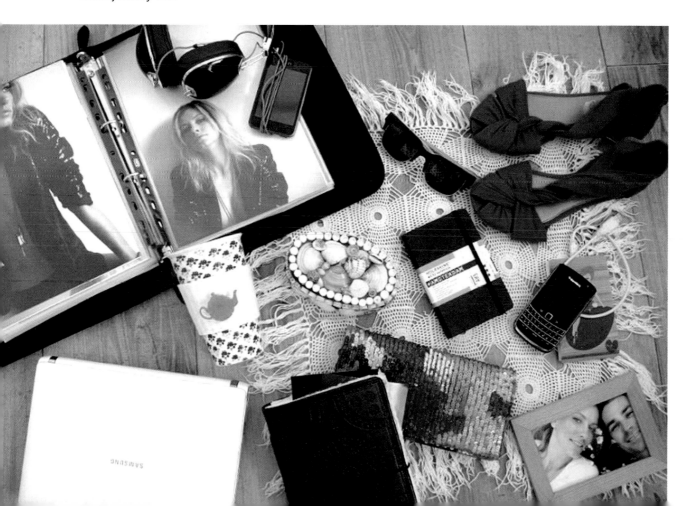

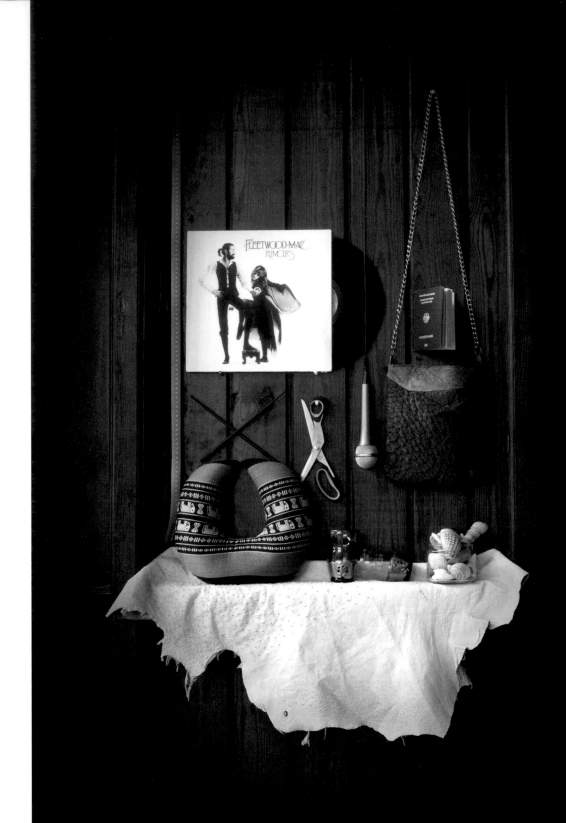

# CHRISTIANE ANELL

**AGE:** 28
**LOCATION:** Amsterdam, The Netherlands
**OCCUPATION:** Advertising strategist
**WEBSITE:** www.cargocollective.com/christianeanell

- LP collection
- Sewing supplies and sewing machine, which was too heavy to put up on that wall
- Homemade ostrich-leather bags
- Some pieces of ostrich leather I brought with me from South Africa
- Shells I collected from white beaches around the world
- Karaoke microphone
- German passport
- Neck pillow for long flights
- Chopsticks, 'cause I'm addicted to sushi
- Vintage glasses my grandma gave me

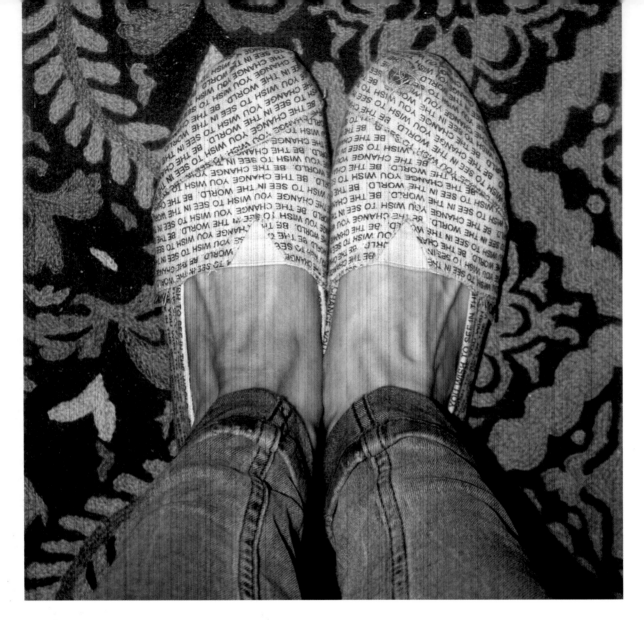

# FRANKIE ANDERSON

**AGE:** 29
**LOCATION:** Edinburgh, Scotland, UK
**OCCUPATION:** Administrator
**WEBSITE:** fleetingmomentproject.blogspot.com

- I wondered around my house, looking at the ornaments and memories that filled it. I collected a few things, even photographed them. But somehow they didn't seem to fit together. And then I looked down, at my feet, and realized that all I needed or wanted to "save" from the burning house was me.

# RICARDO PERINI

**AGE:** 28
**LOCATION:** Curitiba, Brazil
**OCCUPATION:** Forester
**WEBSITE:** www.flickr.com/photos/ricardoperini

- Panama hat. Although I'm Brazilian, I just can't stand the sun's heat over and over.
- Lomo Fisheye, a very light camera given to me by my adorable woman
- Sunglasses. These days are incredibly shiny.
- Harmonica (necessary for crying, as I wouldn't have tears)
- Dad's old watch to remember that time ticks away
- Moleskine. New ideas would come, I hope.

# BLAIR LUCIO

**AGE:** 33
**LOCATION:** Los Angeles, California
**OCCUPATION:** Owner, General Quarters

- Pendleton blanket given to my dad thirty years ago
- My first and favorite vintage belt
- Sterling silver St. Christopher medal that I made
- RRL wallet
- Hamilton Officer watch
- Keys (solid brass anchor that I also made)
- Wayfarers
- Ducati Monster key, 'cause if things go down, I'm heading east

- Bell motorcycle helmet (safety first . . . sort of)
- Kelty daypack
- Photos of my father
- Old Kershaw knife
- Gloves
- MacBook
- Phone
- Old gray sweatshirt

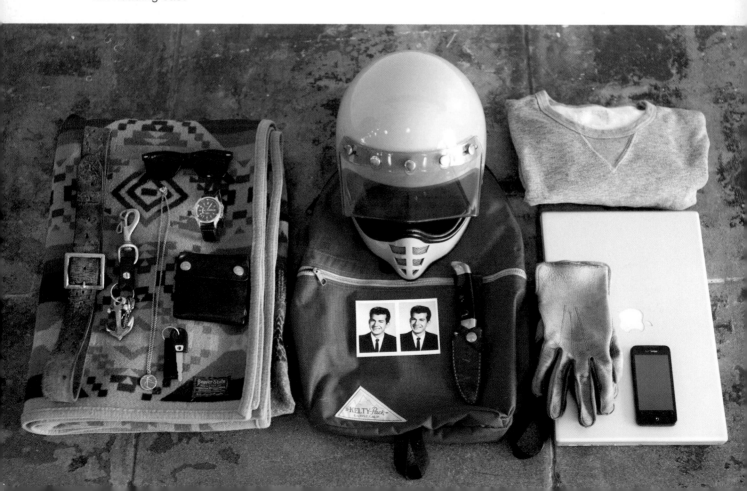

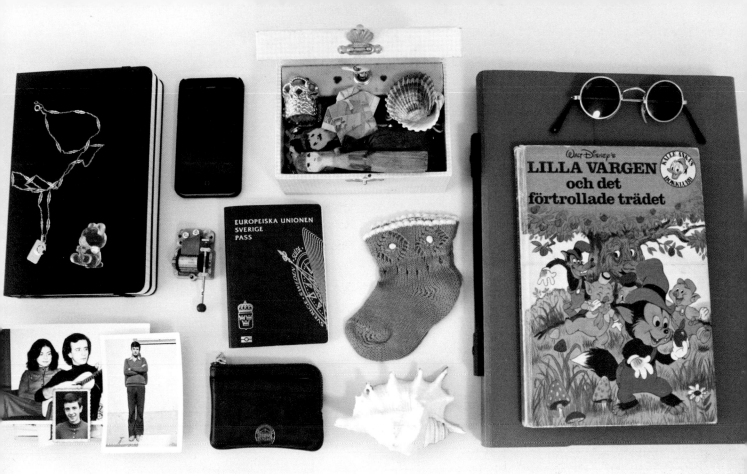

# DINA

**AGE:** 21
**LOCATION:** Stockholm, Sweden
**OCCUPATION:** Student, bank employee
**WEBSITE:** funnylittlefrogs.blogg.se

- Diaries
- Grandmother's necklace with my mother's pendant
- Plastic crystal teddy bear from my fifth birthday
- Old photographs of my parents
- Little music box that plays the melody from *Amélie*, a gift from my best friend
- Phone
- Passport

- Wallet
- Memory box with my childhood tokens
- My first baby socks
- Shell
- Sunglasses that I wore at the age of four
- Folder with all my drawings
- My favorite childhood book
- My family and my camera (not pictured)

# MAGGIE RUDY

**AGE:** 52
**LOCATION:** Portland, Oregon
**OCCUPATION:** Artist, children's book illustrator
**BLOG:** mouseshouses.blogspot.com

- Jackie, my childhood doll
- Wallet, made from a feed sack
- Postcard from Maurice Sendak, received in response to a fan letter I wrote in 1970
- My great-grandmother's prom dress
- Glasses
- Pictures of my sons
- Bird brooch, given to me by my husband
- Photograph of my dad, circa 1938, by Brett Weston
- Little felt mice characters that I made
- Laptop

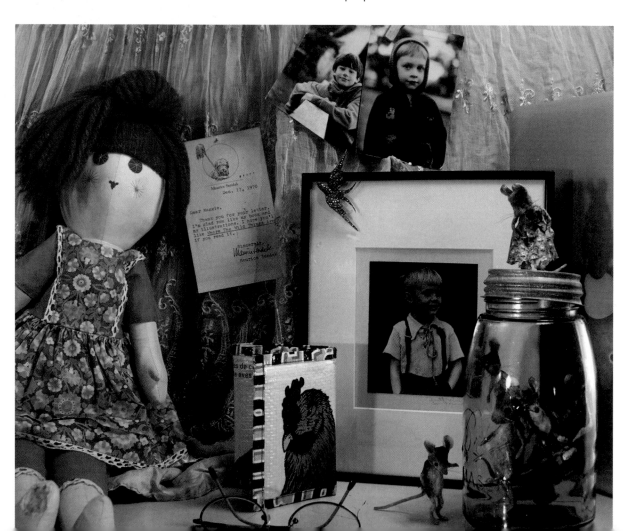

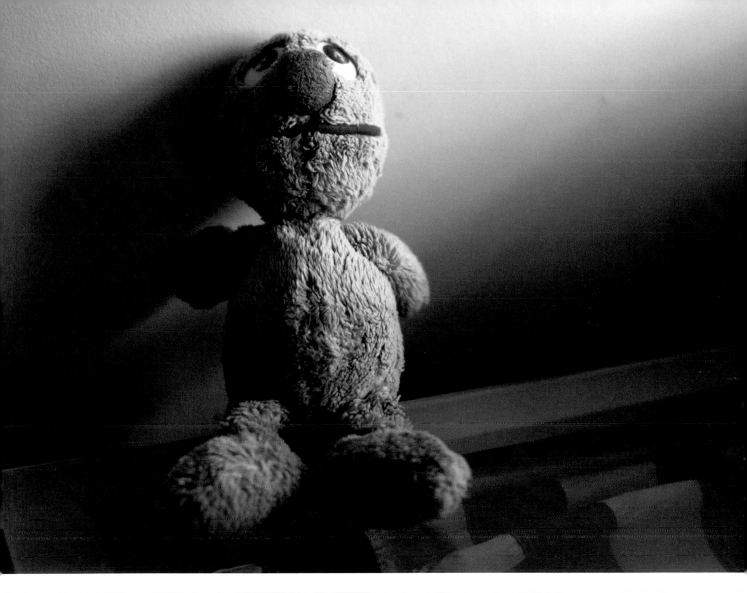

# NICHOLAS MAGGIO

**AGE:** 31
**LOCATION:** Los Angeles, California
**OCCUPATION:** Photographer
**WEBSITE:** www.nicholasmaggio.com

• Grover. When my house burned down on Thanksgiving weekend in 1987 it was the only thing I grabbed when I had to run out of the house at 4:30 a.m. It's been with me ever since. If he was important enough then, he's even more so now.

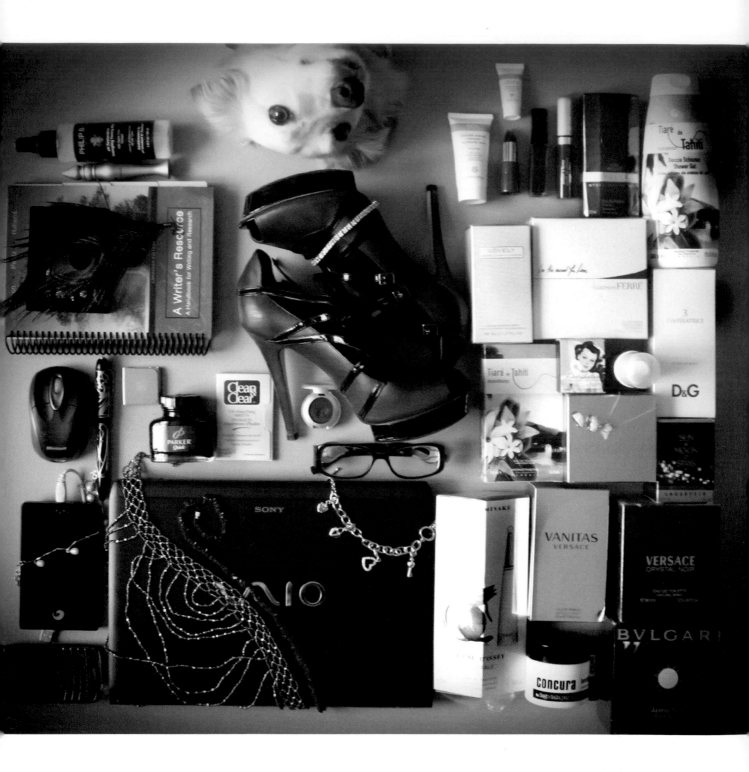

# DEVAYANI DAYAL

AGE: 28
LOCATION: Dubai, United Arab Emirates
OCCUPATION: Entrepreneur, freelance writer, and beauty addict
WEBSITE: www.devayanidayal.com (coming soon!)

- My dog, Ameera (three years old)
- Sony Vaio laptop
- BlackBerry
- Seagate external hard drive
- iPod
- Mont Blanc fountain pen, Dale Carnegie collector's edition
- Parker Quink blue-black ink
- Microsoft wireless mouse
- *The Writers Resource*, Canadian edition
- Peacock-feather earring
- Pearl anklet
- Teal and gold necklace
- Red garnet necklace
- Swarovskl love charm bracelet
- Giorgio Armani spectacles
- Diamond and sapphire bracelet
- Kurt Geiger high heels
- Neutrogena Clean and Clear oil-absorbing sheets
- Philip B. hair-detangling spray
- Urban Decay eye makeup base
- Black eye shadow
- The Balm bronze eye shadow
- Betty Boop red lipstick
- Betty Boop red nail polish
- Maroon over-top lip gloss
- REN Cleansing Milk X2
- Concura peeling face mask
- Fenix foaming face wash
- Monotheme Tahiti body wash and perfume
- Stella Rose Absolute perfume
- Ferre In the Mood for Love perfume
- Sarah Jessica Parker Lovely perfume
- D&G 3 L'imperatrice perfume
- D&G The One Rose perfume
- Karl Lagerfeld Sun Moon & Stars perfume
- Versace Vanitas perfume
- Versace Crystal Noir perfume
- Bulgari Jasmine Noir perfume
- Issey Miyake Florale perfume
- Diamond earrings and necklace

Living in Dubai, most people care only about appearances and glamour. So I wanted to do a photograph of what a self-declared beauty addict like me would want to save in the event of a burning house.

My photograph is both a parody and a metaphor for what people within this culture value.

# ANNIE PARK

**AGE:** 28
**LOCATION:** Cambridge, Massachusetts
**OCCUPATION:** Freelance human of all sorts. Hire me.
**WEBSITE:** www.robotuyebi.com, yumontheside.wordpress.com, and annierobot.tumblr.com

- Cherished 1940s mirrored shadow box
- Cameras: Canon, Polaroid, Kodak, and Lomography
- Spring Court neon orange sneakers (safety first)
- Japanese-made task binoculars and Mr. Well, the gnome
- Bunny head in a jar and ancient voodoo doll from best friends
- My very first Moleskine, and newborn photo
- *Paint Pens in Purses*, the first book I was featured in
- *Spook Country* signed by William Gibson
- A personal handmade poem collection from someone special
- Cash, eye glasses, set of keys, passport, and iPhone
- Favorite Filson camo wool field bag and Levi's denim shorts
- Dad's Korean sculpture boy, Mom's pearl necklace, and Gram's first pink vintage clutch

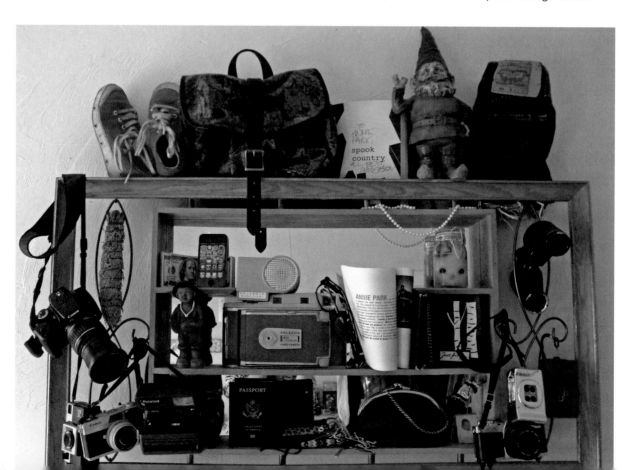

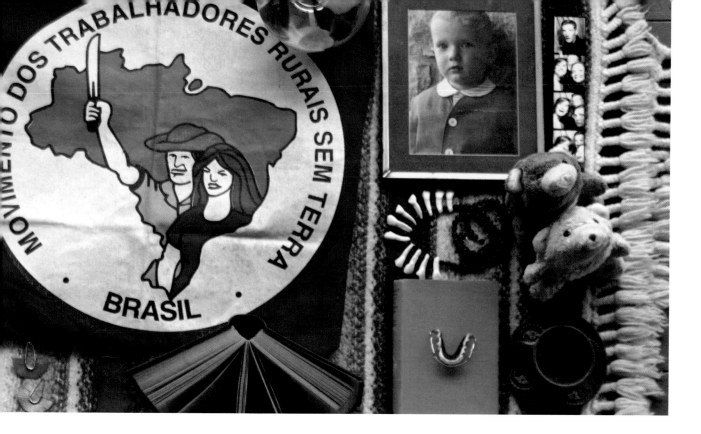

# ELIZABETH TUTTLE

**AGE:** 22
**LOCATION:** Usually Northampton
**OCCUPATION:** Between some things, student-ish
**WEBSITE:** As of yet inchoate

- Warm wool blanket knitted by my grandmother
- Constant companions: Brownie and Pinkie (bears)
- Favorite earrings
- Earliest photo taken of my dad, in which he looks just like my brother
- One of my first glass-blowing projects, lopsided and splotchy
- Photo booth pictures from a good day
- Gifted flag of Landless Workers' Movement in Brazil, where I have lived and researched and learned the most

- Gifted cow necklace from an elderly Brazilian woman I will never see again
- *Fowler's Modern English Usage* (first edition, a gift from my grandmother)
- Worn, turquoise copy of James Joyce's *Portrait of the Artist as a Young Man* containing an odd and juicy inscription, found and gifted by an old friend in an even older Scottish bookshop
- Clay teacup and saucer filled with sentiments
- Retainer to ensure future straight teethy-ness
- A nice pin I found on the ground one time (not pictured)

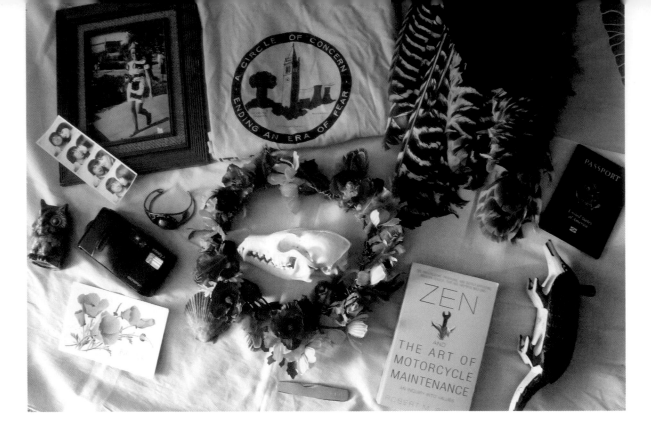

# WENDY GARRETT

**AGE:** 25
**LOCATION:** Los Angeles, California
**OCCUPATION:** Film student, blogger
**WEBSITE:** scoutandpine.blogspot.com

- Hawk wing that my boyfriend found. It smells a little funny, but I'd rather have this than my cell phone.
- Passport. Then I can move to Europe.
- Carved wooden armadillo that I bought while on vacation in Costa Rica
- *Zen and the Art of Motorcycle Maintenance*
- My grandpa's pocketknife
- Floral headdress that I made for my birthday last year
- Shell from the beach in Monterey to remind me of home

- Baby fox skull
- California poppies postcard from Big Sur to remind me of beauty
- Film camera to continue capturing memories
- Turquoise bracelet that my boyfriend's mother gave to me as a gift
- Owl saltshaker that I bought during an unforgettable weekend in San Francisco
- Photo-booth picture of my boyfriend and myself
- Framed photograph of my mom in Israel (very dear to my heart)
- Mom's vintage t-shirt from the 1970s

# CARLOS MOREVI

**AGE:** 36
**LOCATION:** Curitiba, Brazil
**OCCUPATION:** Designer
**WEBSITE:** morevi.tumblr.com

- My favorite book of all time, *The Illustrated Man* by Ray Bradbury
- An illustration by my best friend, dedicated to my son
- My portfolio backups
- Korg Kaoss pad
- Korg monotron
- Atari keychain with two built-in games
- Pen and ink
- *Twin Peaks* complete series on DVD
- Sketchbook
- Some important documents
- Wall clock that I made in the form of a time bomb

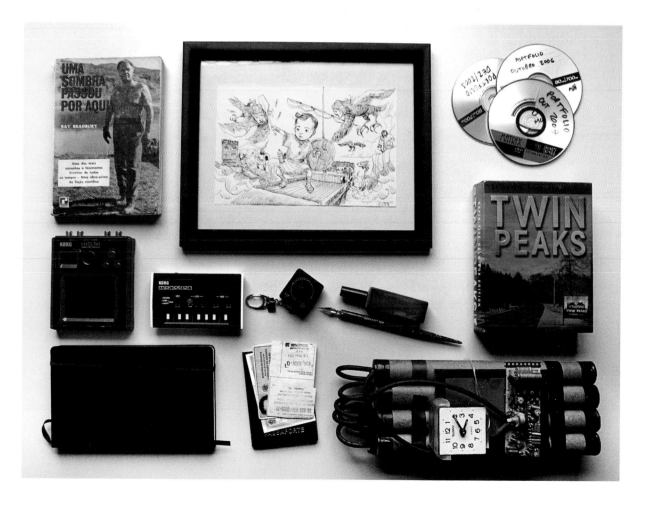

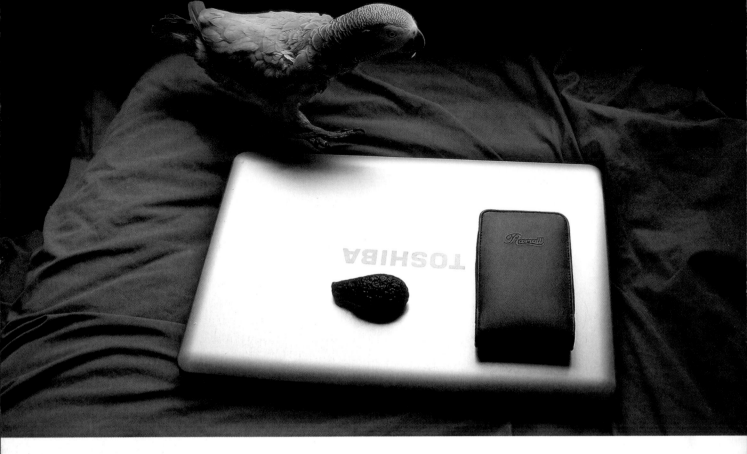

# SANDRA BELANGER

**AGE:** 52
**LOCATION:** Briones, California
**OCCUPATION:** Anthropologist, spirit medium
**WEBSITE:** www.heliumraven.com

- African gray parrot and best friend, Horus
- Hard drive with ten years of electronic-voice-phenomenon research
- Toshiba laptop
- Tektite, a rare rock believed to be created when a meteor hit the earth, from the Gobi desert

My house burned to the ground in 1977 and I lost everything. I learned that material possessions are unimportant. However, in a pinch I would take the hard drive and Horus and leave everything else. I'm about to get a safe-deposit box to keep an extra hard drive in so I can just worry about Horus and come back later to dig the tektite out of the ashes. Word to all the folks with big piles of stuff: you have way less time than you think.

# KARLA HENDY

**AGE:** 23
**LOCATION:** Brisbane, Australia
**OCCUPATION:** Fashion student
**WEBSITE:** thefeatheredcat.tumblr.com

- Kodak Retinette camera
- Instax photos
- A purse my mother gave me that she got in Egypt when she was my age
- Fujifilm Instax camera
- Engagement ring

- Passports
- Visual diary and Moleskine of ideas/memories
- Grandmother's opal ring
- Old family photos, in particular the one of my grandfather
- Carved marble cameo brooch

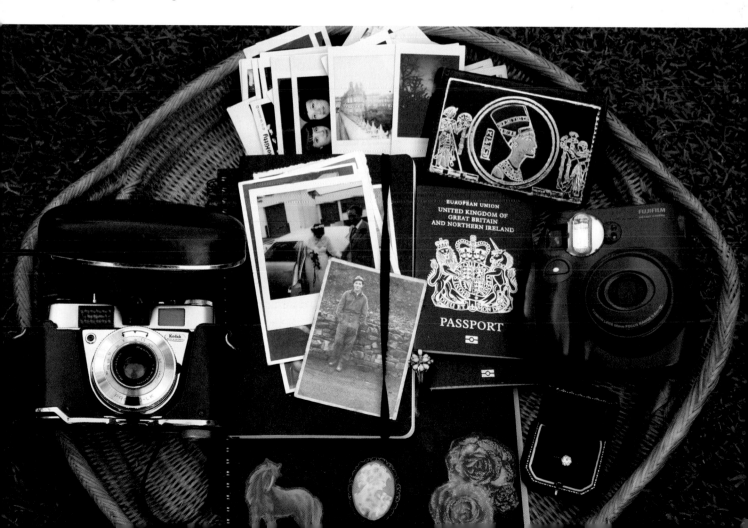

# JOHN TINSETH

**AGE:** 53
**LOCATION:** New York City, New York
**OCCUPATION:** Insurance consultant, writer
**WEBSITE:** thetrad.blogspot.com

*(top to bottom, left to right)*:

- Canadian army blanket (stolen last day of Canadian Airborne School, Griesbach Barracks, Edmonton, Alberta, 1978)
- World War II German infantry belt (war souvenir from grandfather, Sergeant Major [SGM] Tinseth)
- Trungpa quote from 1999 calendar: "To be a warrior is to learn to be genuine in every moment of your life"
- Canadian parachutist wings (not stolen)
- Vietnam-era army sewing-kit buttons from father, Lieutenant Colonel Tinseth
- World War II whistle from SGM Tinseth
- National Park Ranger badge and ID from the Statue of Liberty National Monument
- Randall Attack Survival Knife Model 18 from Lieutenant Colonel Tinseth
- Dunhill lighter. I've been smoke-free almost three years but can't give up the lighter

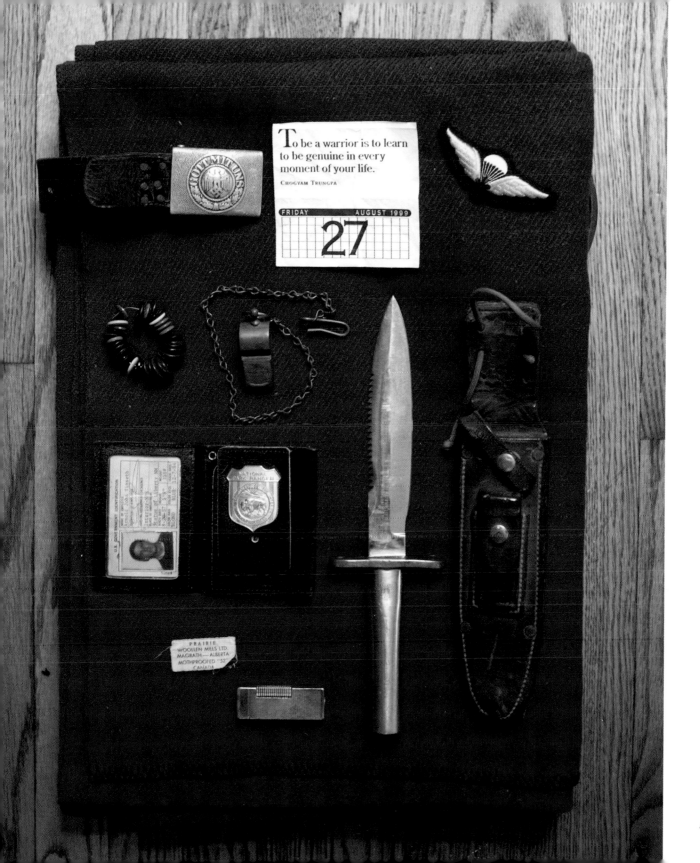

To be a warrior is to learn to be genuine in every moment of your life.

CHOGYAM TRUNGPA

FRIDAY    AUGUST 1999
27

# STEPHANIE NEUBAUER

**AGE:** 31
**LOCATION:** German-born, Floridian-based
**OCCUPATION:** Mom
**WEBSITE:** neubau.us

- One husband
- One son
- Three cats
- Three passports
- One Canon camera (not pictured)
- And up and away!

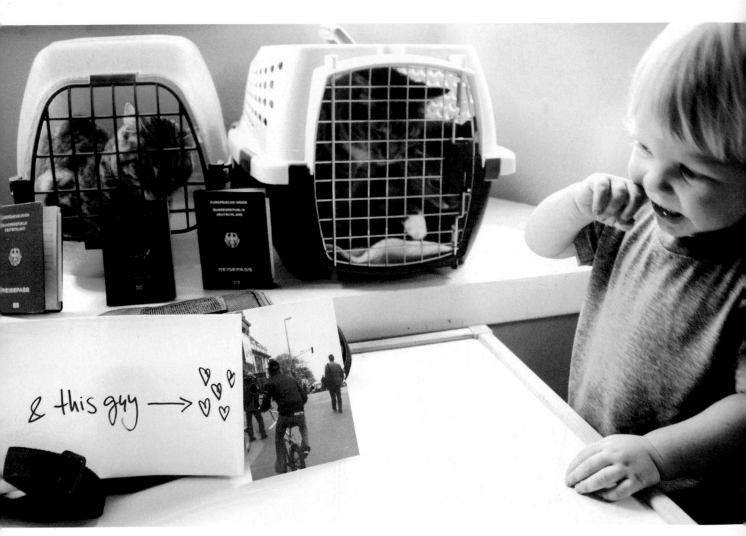

& this guy ⟶

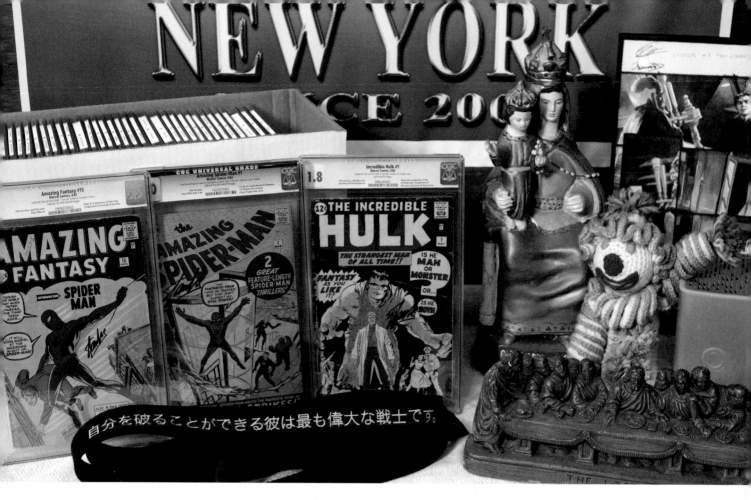

# PETE DELUCA

**AGE:** 30
**LOCATION:** Brooklyn, New York
**OCCUPATION:** Graphic artist, comic book–podcast host

- Box of CGC-graded Signature Series comic books. The prizes in my collection pictured here: *Amazing Fantasy* #15, *Amazing Spider-Man* #1, *The Incredible Hulk* #1, all signed by Stan Lee
- Statue of *The Last Supper* that belonged to my grandmother Barbara
- Statue of Our Lady of the Snow that belonged to my grandmother Rose
- Knit clown doll made by my great, grandma Lena in 1921

- Portable hard drive containing my portfolio and years and years of pictures
- An original page from *Fallen Angel* #4 drawn by J.K. Woodward, where myself and two friends are drawn into two panels
- Black belt inscribed, "He who can defeat himself is the greatest warrior"

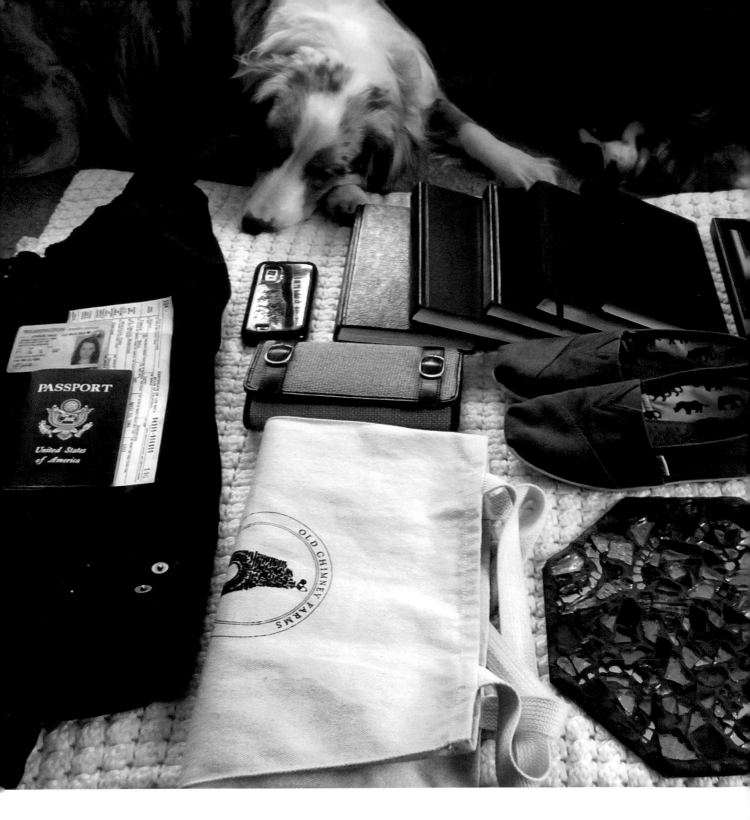

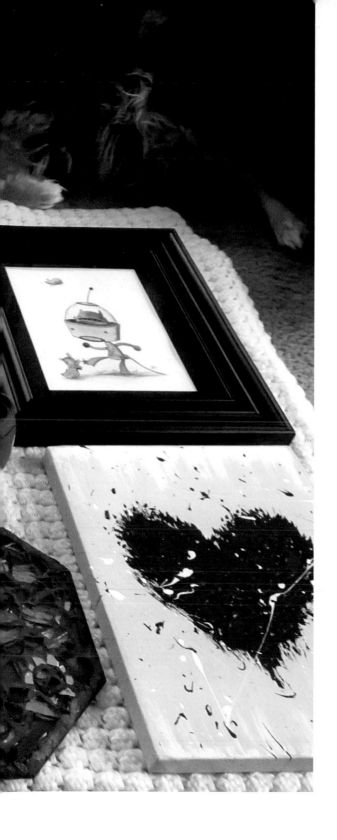

# STACY JOHNSTONE

**AGE:** 25
**LOCATION:** Seattle, Washington
**OCCUPATION:** Online school registrar, writer
**WEBSITE:** peoplejustfloat.blogspot.com

- Passport
- Original birth certificate
- ID
- Wallet
- Five handwritten journals
- Brown bomber jacket from Paris
- TOMS shoes (or whatever slip-ons were closest to the door)
- Yellow-and-black heart painting from my boyfriend
- "Kicking Puppies," an original Justin Hillgrove watercolor
- "Blue Elephant" mosaic, handmade by my best friend
- Cell phone
- Canvas bag to carry everything
- Crocheted quilt that my mom made for my grandmother
- My dogs, Peekay and Ennis

# BILLY BARR

**AGE:** 60
**LOCATION:** Gothic, Colorado
**OCCUPATION:** Accountant

- Fischer Backcountry skis with Solomon bindings
- *The Princess Bride* on Blu-ray

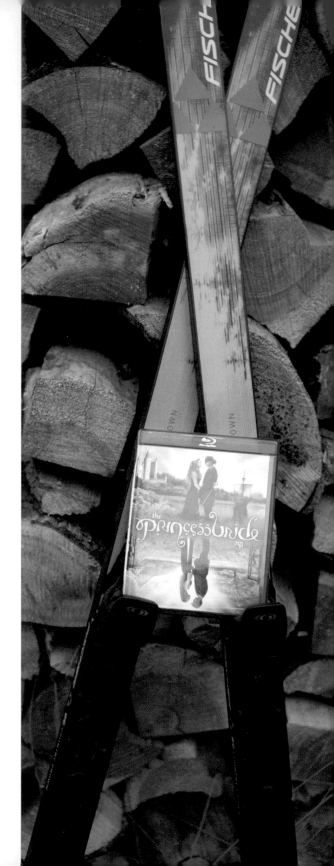

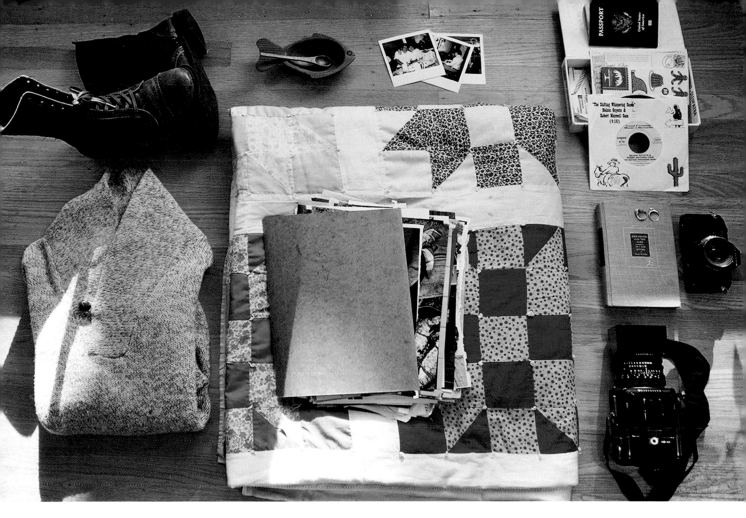

# JILLIAN GUYETTE

**AGE:** 21
**LOCATION:** Rochester, New York
**OCCUPATION:** Photographer
**WEBSITE:** www.jillianguyette.com

- Favorite pair of boots
- Vintage sweater
- Polaroids of my parents
- Wooden fish bowl
- Patchwork quilt that my mother made in her twenties
- Folder of pictures I've collected
- Passport

- Box of mementos from someone important
- Vinyl record of "The Shifting Whispering Sands," as done by my father, 1980
- My first copy of *As I Lay Dying* by William Faulkner
- Two rings, one from each grandmother
- Pentax P5 camera, originally used by my mother
- Hasselblad 501C camera

# PHILLIP T. ANNAND

**AGE:** 21
**LOCATION:** New Jersey
**OCCUPATION:** Funk purveyor, designer, tree climber
**WEBSITE:** www.madburyclub.com and www.theawardtour.com

- Knit poncho. I have never seen another human being with this piece, and if I'm going to be walking around in a post-apocalyptic world, with all my worldly possessions burned to the ground, I'd prefer to do it bare-chested with a poncho on.
- Visvim FBT shoes, for comfort. And they cost way too much to let burn.
- Burritos, for hunger
- Award Tour knit beanie or vintage Philadelphia Eagles cap, depending on the weather
- Family portrait. Family is really the only thing I'd worry about getting out. Everything else is secondary.
- Pendleton shirt, to channel the spirit of the Aztecs to survive after the fire
- Vintage Champion jersey tee, the only t-shirt I'd need for the rest of my life
- Belt, to keep the pants from sagging, keeping Grandmother proud
- Seals bumper sticker, for some necessary humor in times of tragedy
- Penfield wallet, hopefully with a fair amount of money in it
- Military waist pack, for carrying all of this junk
- Comic collection, select records, select books. *X-Men*, *America*, and *Swiss Family Robinson* are pictured.
- Hard drive. There's no need for computer if I've got this.
- iPhone. Granted, if someone else is bringing a charger, this is probably the only thing I need out of all of this.

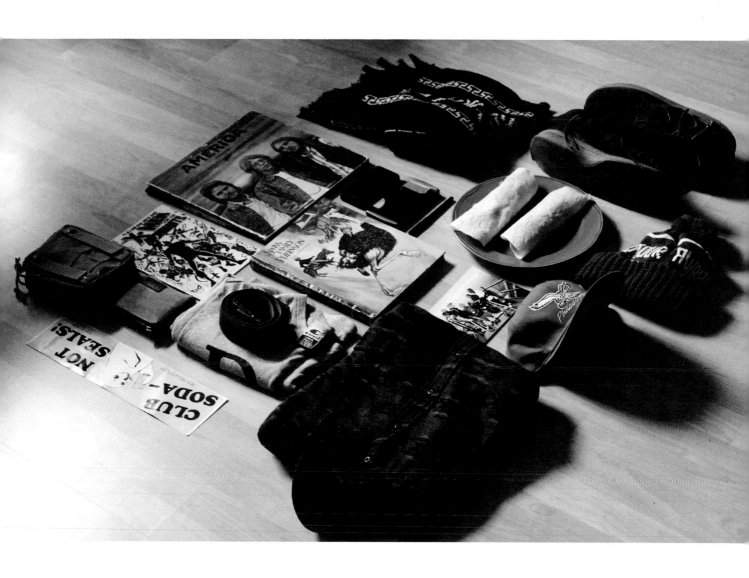

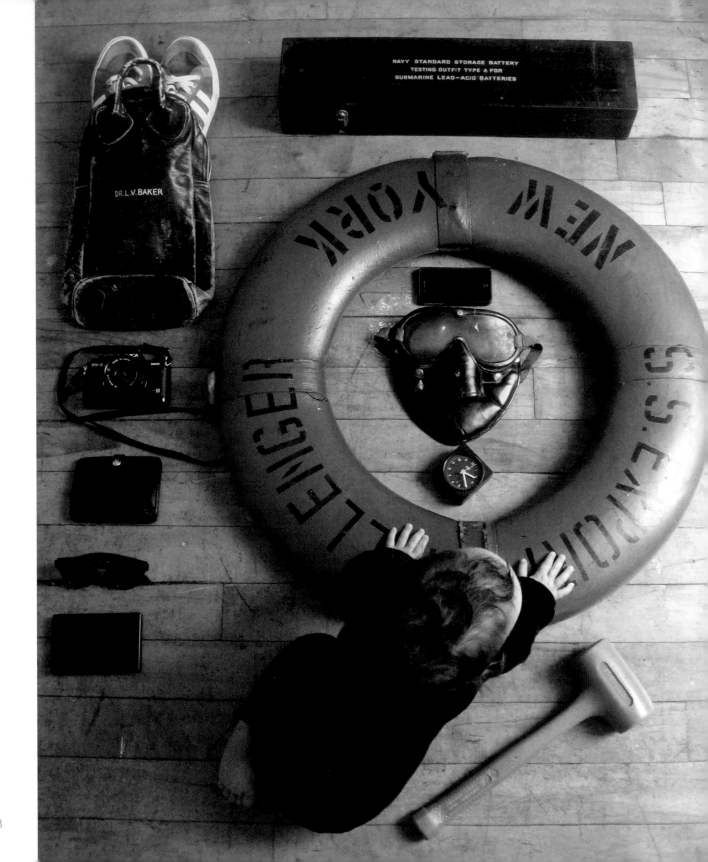

# LUCA CAVALLARO

**AGE:** 34
**LOCATION:** New York City, New York
**OCCUPATION:** Designer
**WEBSITE:** officineottiche.tumblr.com

- Alma Lou. She would be enough.

  If I have time:
- Hard drive, for memories that my brain failed to store
- Sunglasses. I feel naked without them.
- Wallet, a gift from my wife
- My father's old camera. I promised him I would take good care of it.
- Sneakers, emergency orange
- In the black box, my vintage eyewear collection (favorites only)
- Phone
- Vintage leather mask, in case I have to protect my face from the flames
- Dieter Rams alarm clock. I don't wake up on my own.
- Orange hammer, in case I have to break some windows during the escape
- Life buoy ring, in case of flooding. In Italy we say, "*Le sfighe non vengono mai da sole*" — Misfortunes never come alone.

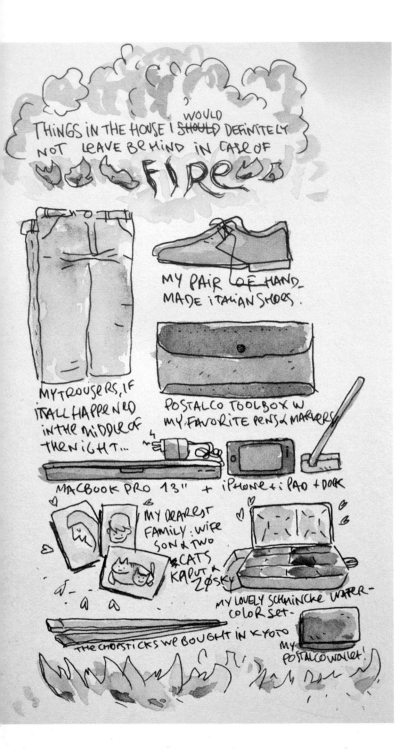

# LUIS MENDO

**AGE:** 41
**LOCATION:** Amsterdam, The Netherlands
**OCCUPATION:** Graphic designer, editorial design consultant, and illustrator
**WEBSITE:** www.luismendo.com and www.goodinc.nl

*(see illustration)*

# NIKKO MUELLER

**AGE:** 34
**LOCATION:** Los Angeles, California
**OCCUPATION:** Artist
**WEBSITE:** www.nikkomueller.com

- My wife, Hallie Silvas-Mueller (not pictured). I'm assuming she'll grab our dogs.
- My paintings
- Family photos
- Sketchbooks, one from Italy, one current
- My granddad's 35mm slides
- Turkish box from my oma
- My great-grandfather Enders's bear skull from the 1850s Colorado gold rush
- Italian Atomic espresso maker, inherited from my stepfather
- Albert Camus's *The Stranger*
- Owl ring from my granddad
- Framed silk postcard depicting "The Senjou-gahara of Nikko," sent from Japan to my great-grandfather Huntington
- World War II silk map of Germany
- Shield pin with the inscription HIDE BEHIND ME

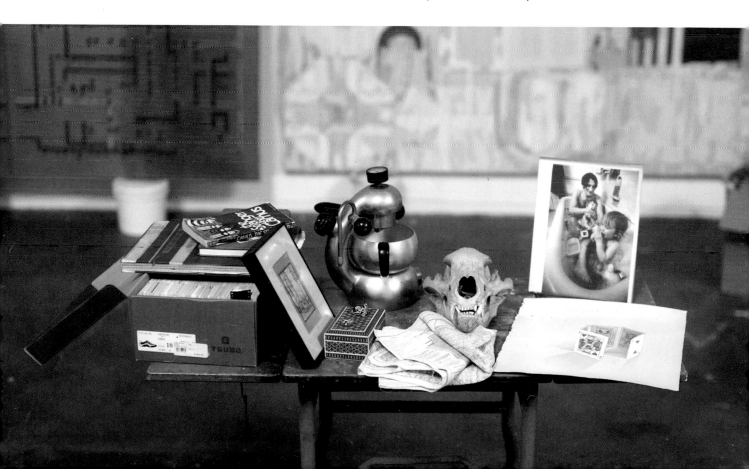

# BOB MYAING

**AGE:** 23
**LOCATION:** Philadelphia
**OCCUPATION:** Printer
**WEBSITE:** www.bobmyaing.com and www.corkgrips.wordpress.com

- North Face pack
- Barbour Bedale jacket
- Contax T2 camera
- Quoddy blucher moccasins
- Box of most recent negatives (past four years)
- My cat, William
- Indian blanket

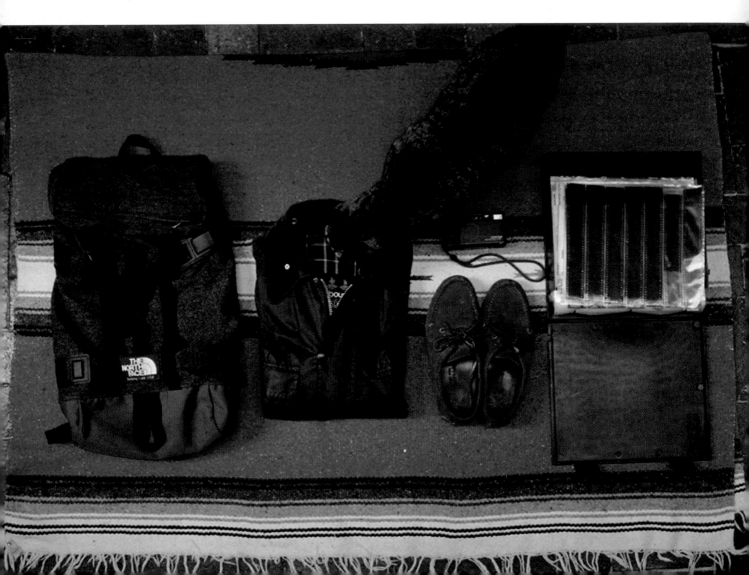

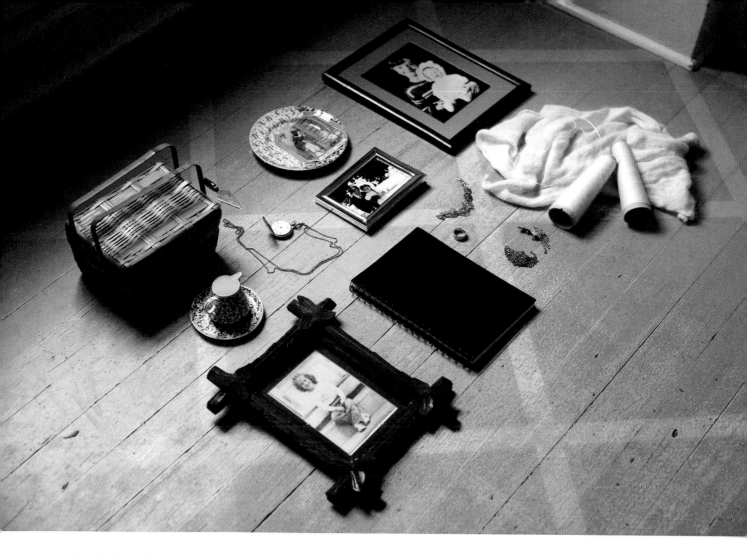

# ANN CARTER

**AGE:** 61
**LOCATION:** Salt Lake City, Utah
**OCCUPATION:** Creative dance teacher

- Sewing basket
- Spode creamer
- Photo of me when I was five years old
- Masonic trowel
- Grandfather's pocket watch
- Russ Nichols journal
- Grandmother's Mother Hubbard plate

- Photo of Will and Beth when they were young (1990-ish)
- Bracelet obtained in Bulgaria
- Wedding ring
- Favorite sparkly earrings
- Photo of my mother (Fern Arlene Tow)
- Unfinished *habu* sweater

# CLARA ZAPATILLA

**AGE :** 32
**LOCATION :** Montreal, Québec, Canada
**OCCUPATION :** Secretary

- My cat, my love (not pictured)
- My cat's mouse, Ratatouille
- Christmas heart from my grandma
- Turquoise scarf
- Pair of Converse sneakers
- Stieg Larsson's trilogy
- MP3 player
- Moleskine notebooks, address book, and a pen
- Sunglasses
- Jewelry given by friends and family
- Panda USB drive with digital pictures, music, and personal documents
- Survival kit: tweezers, nail clipper, mascara, concealer, perfume, lip balm, mirror, and gum
- Pictures of grandparents and me as a child with my mum
- Passport
- Camera
- Red Swatch

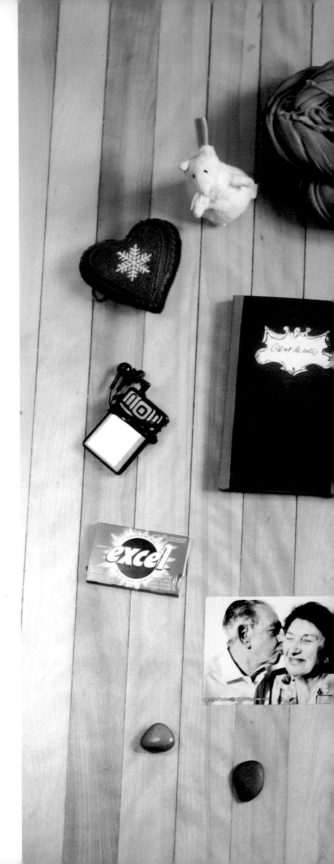

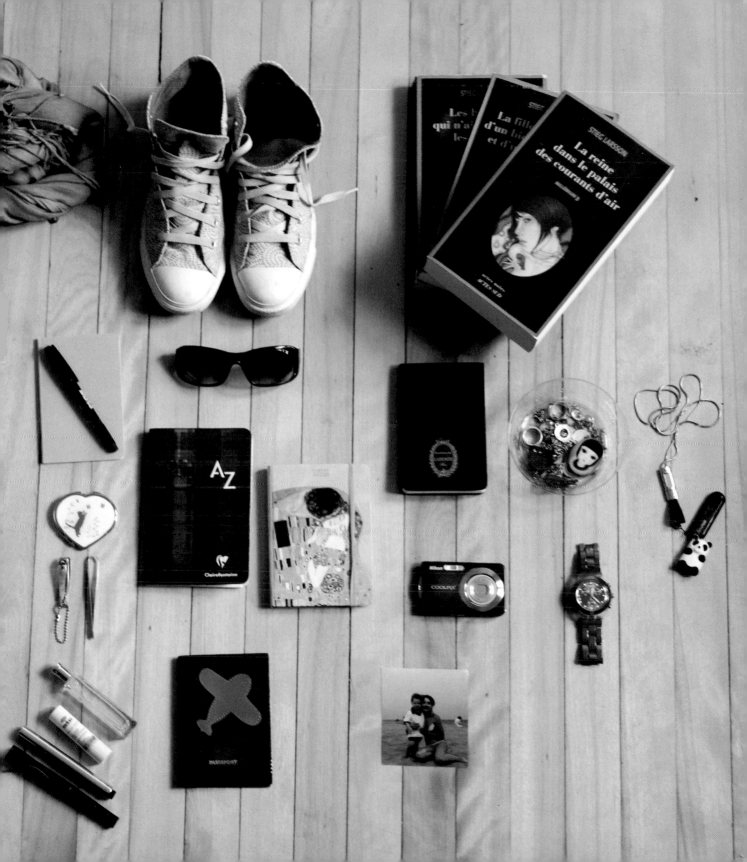

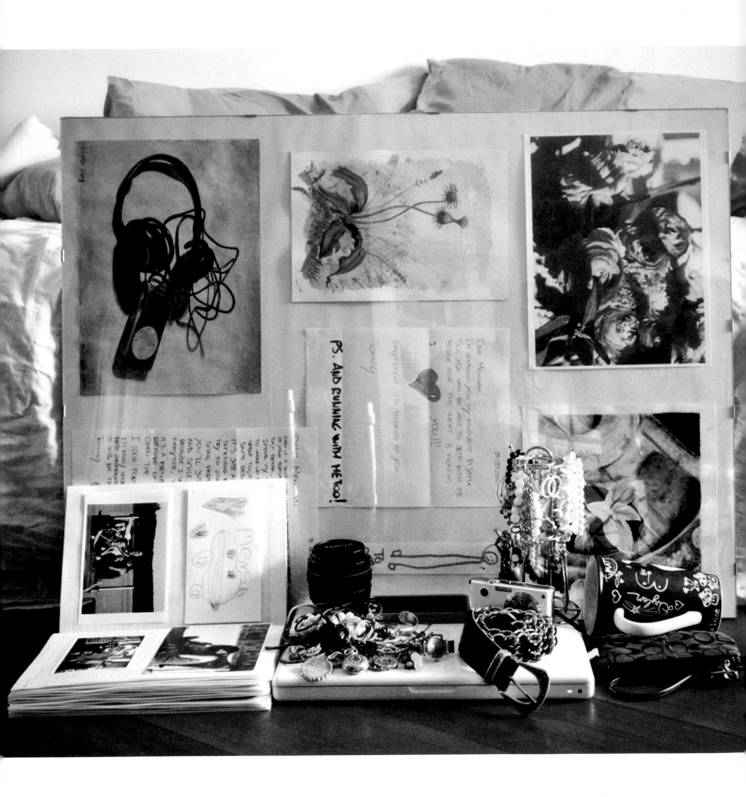

# MENSA WANG

AGE: 22
LOCATION: Milan, Italy (for now)
OCCUPATION: Student
WEBSITE: yellowjeans.tumblr.com

- Paintings from high school and letters from my boyfriend when we were dating while on opposite ends of the world
- Photos of family and friends, and drawings and doodles from my little brother and sister. These all used to be on the wall of my room at university. I put them in a notebook when I moved to Italy.
- Starbucks mug signed by friends. It was my goodbye gift when leaving Canada.
- Accessories collected over the years from living and traveling to different parts of the world. Some are presents from people who mean a lot to me.
- MacBook + phone = my life
- Canon 50mm lens and my very first digital red-dot sight. It's not the best digital camera but a reminder for myself to stop being such a tech brand whore.
- Clutch with credit cards

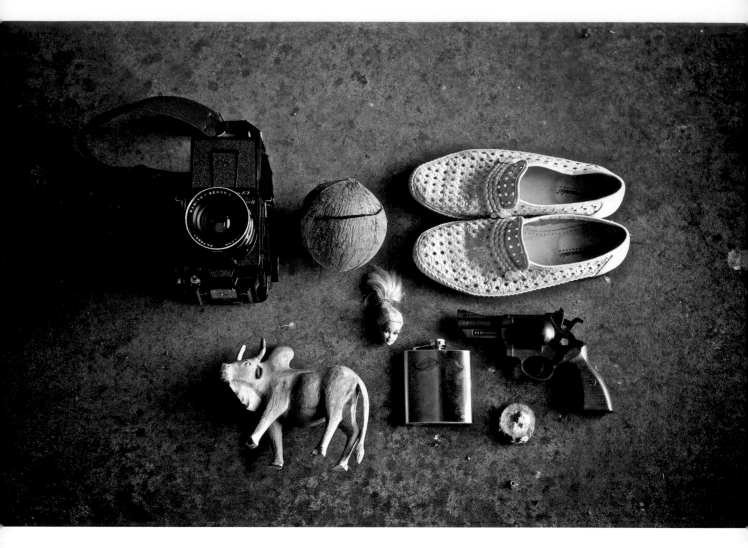

# LUCA MARIANI

**AGE:** 33
**LOCATION:** Barcelona, Spain
**OCCUPATION:** Director
**WEBSITE:** www.lucamariani.me

- Mamiya RB67 camera
- Coconut broken with my head
- Macassino Blanco by Gonzalo Malaga
- Wood cow used to make my short film *MATU*
- Barbie Glitter head
- Jack Daniels flask with moustache
- Toy gun
- Snow globe of Milan

# NICOLE MASSARO

**AGE:** 29
**LOCATION:** South Carolina
**OCCUPATION:** Graphic designer
**WEBSITE:** www.myundefinedview.com

- My great-grandmother's four-leaf clover pin
- A special letter from my beau
- A special letter from my great-grandmother
- My grandfather's gospel music recordings
- Piece of wallpaper torn from my childhood home

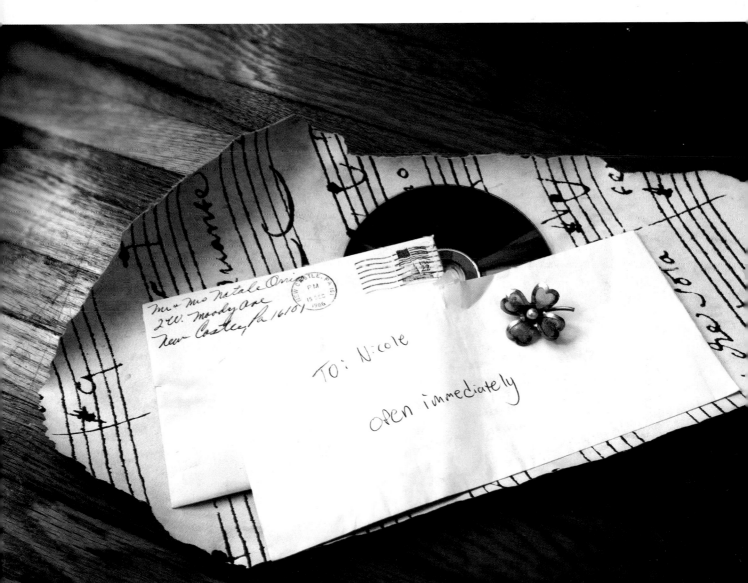

# KIM HØLTERMAND

**AGE:** 34
**LOCATION:** Denmark
**OCCUPATION:** Freelance architectural and landscape photographer,
  fingerprint expert in the Crime Scene Unit of the Danish National Police
**WEBSITE:** www.holtermand.dk

- Sigur Rós *Takk* CD
- Holga 120 CFN Color Flash camera
- Glasses from IE Glasses
- Antlers
- Sigur Rós *Heima* DVD
- Jet Set San Remo watch
- Action Journal from Behance
- *The Stanley Kubrick Archives* book
- Dot Grid Book from Behance
- Artline Drawing System pens
- "Architects I met and I liked" notebook
- Dot Grid Cahier from Behance
- Canon EOS 7D
- Cretacolor 430 12 lead holder
- Grafo 5340 lead holder
- *Olafur Eliasson: Space is Process* DVD
- Action Runner from Behance
- *Blade Runner Trilogy: 25th Anniversary* 3-CD set
- iPhone in Exovault metal phone case
- Light green Volkswagen Caravette from Lesney

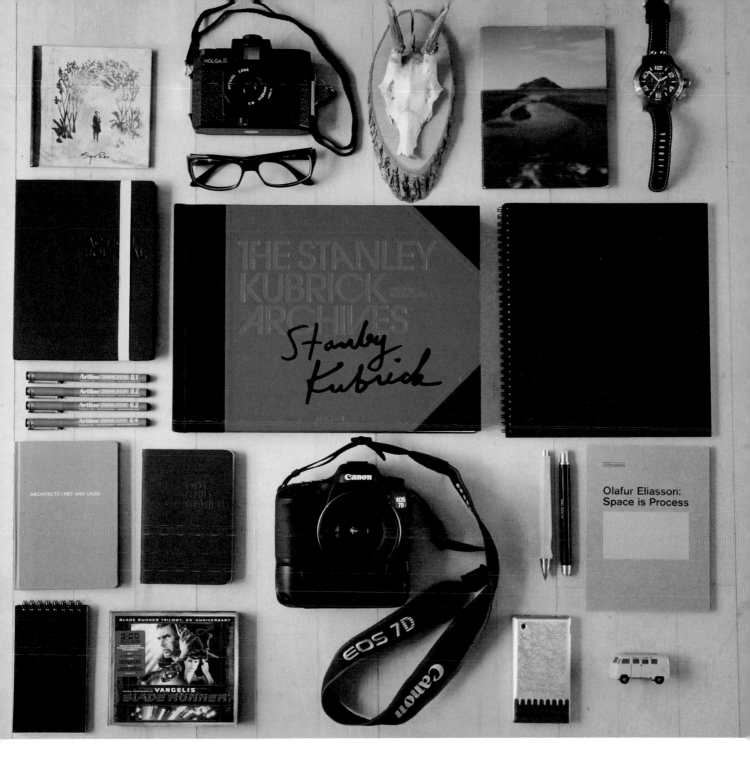

# ALLISON TAYLOR

**AGE:** 18
**LOCATION:** Seattle, Washington, and Rexburg, Idaho
**OCCUPATION:** Full-time student studying geology
**WEBSITE:** allisoncelestia.blogspot.com

- Vintage Charlotte typewriter
- Worn-out boots
- Journal from the summer
- Jewelry inherited from my mother and grandmother
- Birkenstocks that I wear practically every day
- Messenger bag with patches of the places I've been to
- Travel journal
- Glasses and sunglasses
- My first pair of climbing shoes
- Pendleton blanket

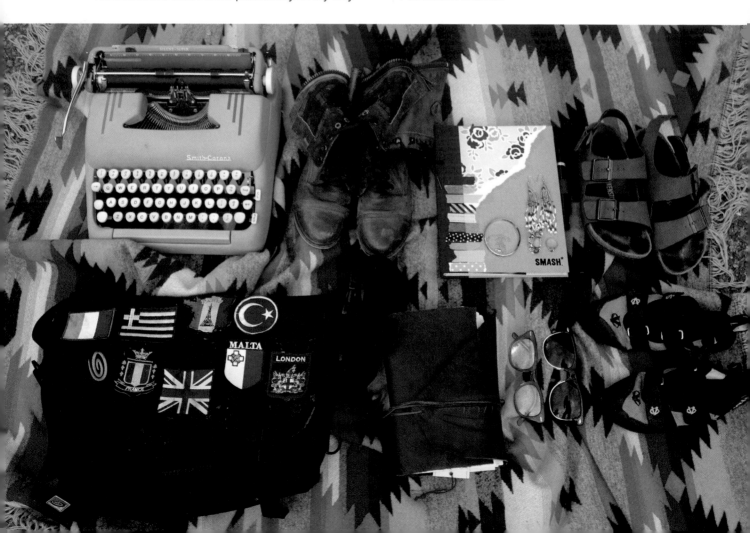

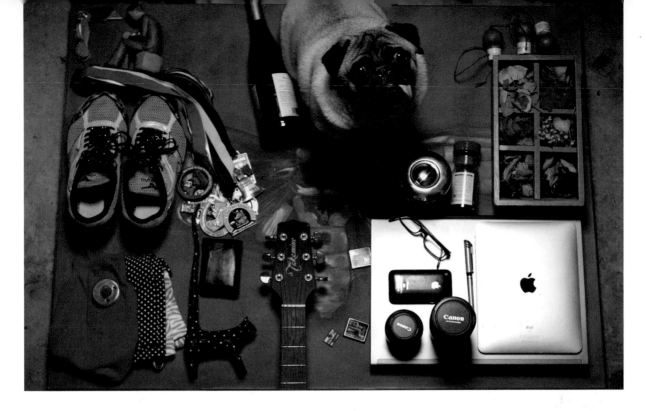

# BRETT ROGOWSKI

AGE: 38
LOCATION: Pennsylvania, United States
OCCUPATION: Programmer, photographer, runner

- Trusty knife
- Willow Tree dad with baby figurine. We had such a hard time conceiving our first child—this gift moved me.
- Medals from many, many, many marathons
- Wallet
- My favorite Mizuno racing shoes
- Change of clothes for my two girls, and a pacifier from the hospital (the only one that works)
- Papier-mâché cat that my wife and I both had when we met
- My guitar, the only item that has survived more than fifteen years with me
- Wine from the day in 2008 my first daughter was born (Big Sur Marathon)

- Gimli, my trusty pug
- Gimli's treats
- Illegal fireworks
- Box of miscellaneous flowers given to me by my wife over eleven years ago
- Red pepper
- Glasses
- My favorite pen
- Memory cards
- iPhone and iPad
- 50mm and 125mm lenses
- Canon 40D camera (not pictured)
- Dell 2600. My life is almost completely digital now.
- Monochromatic painting from 2005 of a moth

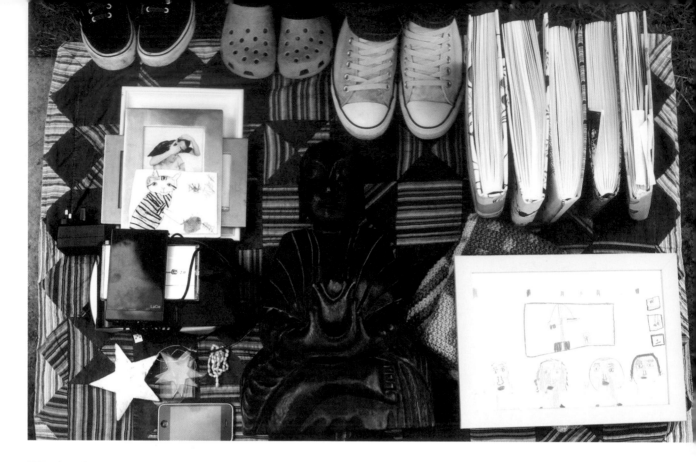

# XANTHE BERKELEY

**AGE:** 37
**LOCATION:** London, England, UK
**OCCUPATION:** Photographer, artist, mother
**WEBSITE:** www.xantheberkeley.com

- My family and cat
- Photo scrapbooks. What's shown here is just a selection of the more than twenty I have.
- A favorite family portrait, drawn by my youngest
- My son's baby blankets. In the picture, one's folded and one's laid out.
- Wooden Buddha from our time living in Thailand
- iPhone
- The first piece of jewelry Luke gave me
- My collection of stars. What's shown here is just a selection.
- Four hard drives full of photos from the past twelve years
- Photo frames of special, once-in-a-lifetime moments
- Canon 5D Mark II camera (not pictured)
- A large box of film negatives (not pictured)

I hope I never experience a burning house—I would be devastated by the loss of memories and moments captured.

# WILLEM WILHELM

**AGE:** 23
**LOCATION:** Germany
**OCCUPATION:** Biology and Arts
**WEBSITE:** willemwillem.tumblr.com/

- My father's Contax RTS camera
- Bag
- Twisting balloon
- Watch
- Organic candy bars
- Copic markers
- My mother's accordion sheet music
- Moleskine notebook
- Scalpel and scissors
- My lucky shirt, brought from Hong Kong by a friend
- Laptop
- Key for my (old and awesome) bicycle
- Key ring from a flea market in Paris showing astronaut Andriyan Nikolayev
- Canon 500D camera
- Glasses

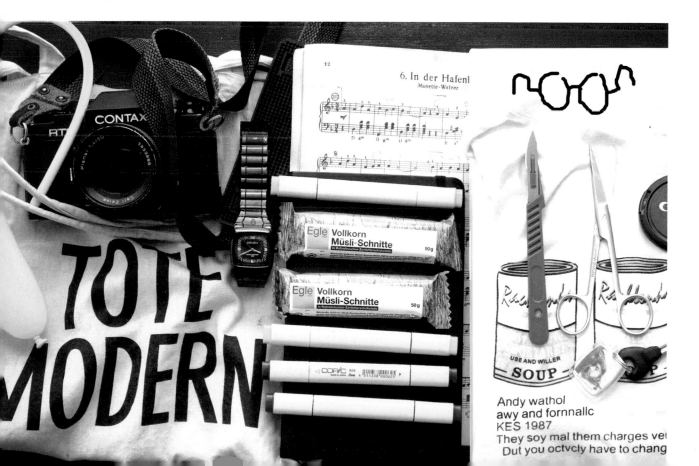

# ANONYMOUS

**AGE:** Unknown
**LOCATION:** Unknown
**OCCUPATION:** Unknown

A few years back, I got a call that our house was in flames. I wasn't there, so I don't know what really happened, but I actually felt OK knowing that, in a way, I could start again. In the end, it was only the bathroom that got destroyed, so I've still got far too much junk.

But, if I would have had the possibility to take some things with me, I would have grabbed:

- My tartan baby blanket
- All the letters and postcards I got from my parents when I was little
- Backup hard drive
- My mom's first sewing machine
- The Communistic one-hundred-crown banknote I took from my grandma's cupboard shortly after she died because I couldn't stand anyone else taking it away. And to be honest, I've no idea why I really bothered about something like that—it seems only to be the memory of my grandma and what she had managed during those hard times. Wonderful woman. R.I.P.
- *If Only They Could Talk* book. I got it from my grandma's boyfriend a few months before he died.

# AARON JAMES DRAPLIN

AGE: 38
LOCATION: Mean Streets, Portland, Oregon
OCCUPATION: Graphic designer

- My journals, going all the way back to eighth grade (history)
- My field notes, going back to 2004 (always writing it down)
- MacBook Pro laptop, so I can work (mortgage battles)
- iPhone 4S (shameless connectivity)
- iPad (checkers, chess, and Scrabble)
- Handmade fingerboard, 1987 (every surface is a skate park)
- Wallet with $847 in it (always have cash on hand)
- Hard drive with all my work on it (back it up, man, back it up)
- Car keys (not afraid to live out of my rig)
- Bullet pencil stash (great for the front pocket of my 501s)
- Pocketknife (pencil sharpening)
- Passport (international intrigue)
- Lumix GF1 camera (good for shooting burning houses)
- Gary card (I miss the little man real bad)
- Gary's last footprint (still surreal to think about)
- Gary's old leash (we used to walk down by the train tracks)
- Martin D–35 acoustic guitar (learning songs, then forgetting them)

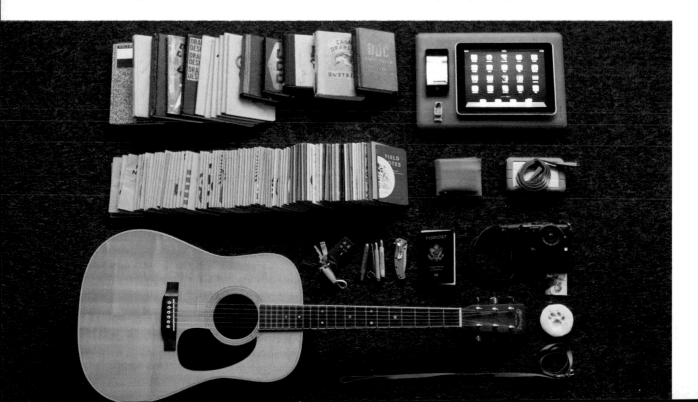

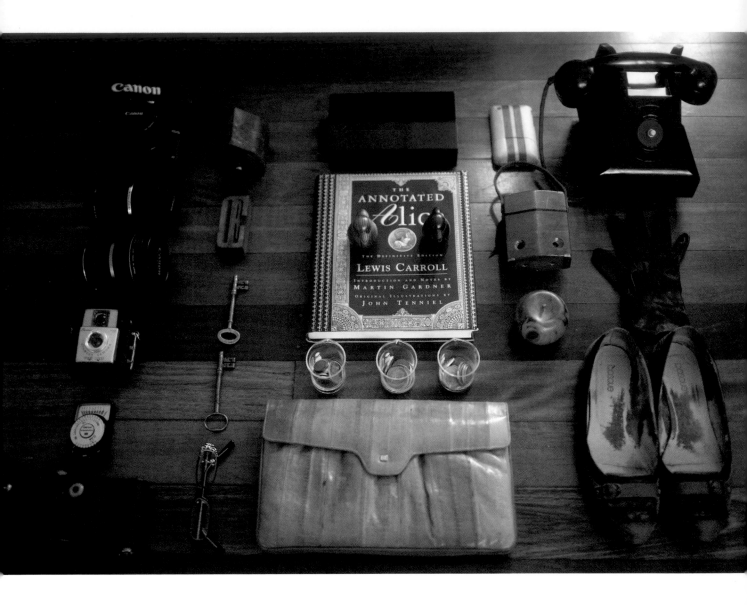

# ELOISE CLAIRE TREDENICK

**AGE:** 26
**LOCATION:** Brisbane, Australia
**OCCUPATION:** Radiographer
**WEBSITE:** www.curiouser-n-curiouser.org

- Canon 500D camera and 50mm f/1.8 lens
- Tamron macro 90mm f/2.8 lens
- Canon EF-S 10–22mm f/3.5 lens
- Vintage Brownie camera
- Vintage Hanimex light meter
- Vintage 1940s Box Brownie inherited from a great aunt
- Jean Lafont glasses
- Vintage skeleton keys
- Vintage wooden "E" (for Eloise) letterpress block, apple, ducks, and jewelry box
- LaCie backup
- *The Annotated Alice* by Lewis Carroll
- Old coins
- Eel-skin clutch purse
- Vintage intercom Bakelite telephone
- iPhone 3GS in CaseCrown wooden case
- Vintage electrician's timing box
- Red leather gloves
- Basque shoes from twenty-first birthday
- iMac, of course

# HALLIE ROSE SILVAS-MUELLER

**AGE:** 32
**LOCATION:** Los Angeles, California
**OCCUPATION:** Dodging my student loans, writer, child therapist

- My husband, Nikko David Mueller (not pictured)
- My dogs (Rocco, pictured; Gigi, not pictured)
- My books (impractical, weighty, irreplaceable): Gabriel Orozco's MOCA catalogue; Nabokov, Hemingway, Salinger, Borges, Paz, Fuentes, Neruda, Miller, Hesse, and my original copy of Oscar Wilde's *The Picture of Dorian Gray*
- Three photos
- Two journals
- One painting from Nikko
- My first pair of Adidas Copa cleats
- Every card, note, and handwritten letter of consequence
- Paper airplane with the words "Hallie Pants, I love you" written on it
- My thesis in hard copy and my research notebook
- Wooden hand, butterfly necklace, two rings, "HAL" belt buckle
- *Reality Bites.* "Life is always funnier when it happens to someone else."

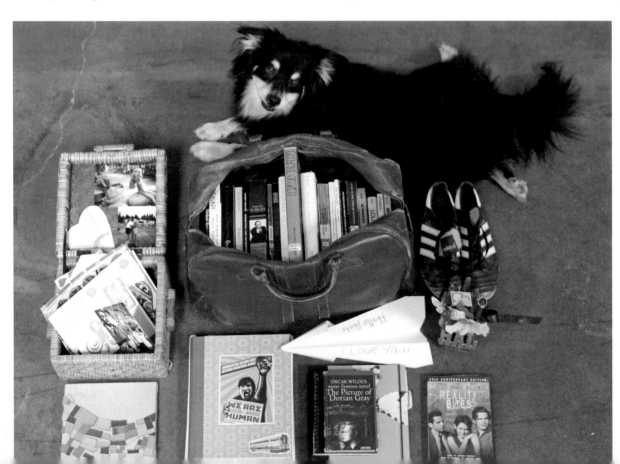

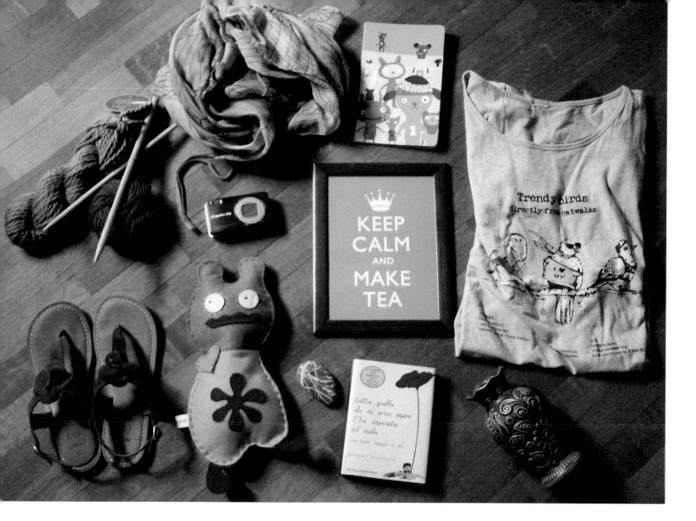

# CRISTINA CAVALLARI

**AGE:** 43
**LOCATION:** Italy
**OCCUPATION:** Crafter, graphic designer
**WEBSITE:** cristina-c.blogspot.com

- My family cat (not pictured)
- Wool and wood knitting needles
- Gray and yellow scarf
- Travel journal
- Canon 1000D instead of the pictured Caplio
- My best t-shirt
- Blue comfortable sandals
- "Keep Calm and Make Tea" picture
- Felt monster I made
- Sea rock from my father
- Robert Fulgham's *All I Ever Really Needed to Know I Learned in Kindergarten*
- Old German vase

# SHANE MARCEL MILLER

**AGE:** 23
**LOCATION:** Mauritius (an island in the middle of the Indian Ocean)
**OCCUPATION:** Graphic designer
**WEBSITE:** shanemarcelmiller.tumblr.com, and www.shanemarcelmiller.com

- The Holy Bible, the source of life
- U.S. passport, my ticket around the world
- Birth certificate, my proof of existence
- Collection of Starbucks Via coffee, a special gift from Mom and Pop in the States. The nearest Starbucks is hundreds of miles away.
- Ray-Bans, to help me see when I make it out alive
- Favorite dress shoes, purchased at a thrift store in Florida a couple of years ago
- Nixon watch, a gift from friend back home
- Genuine ostrich leather wallet, given to me by a close friend in college
- My mobile office: 17" MacBook Pro, two 1TB hard drives with all my work, Magic Mouse, Manfrotto Tripod, Canon 7D, and other photo equipment (not pictured)
- Green Quechua rain jacket. I can't go anywhere without it during the rainy season.
- All the rupees I own, to get me a place to stay the next night

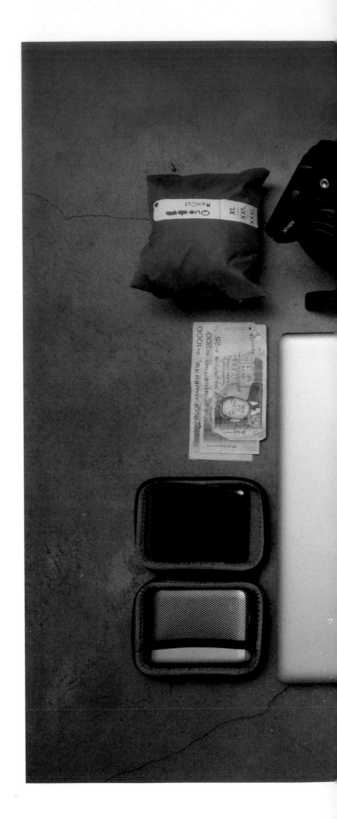

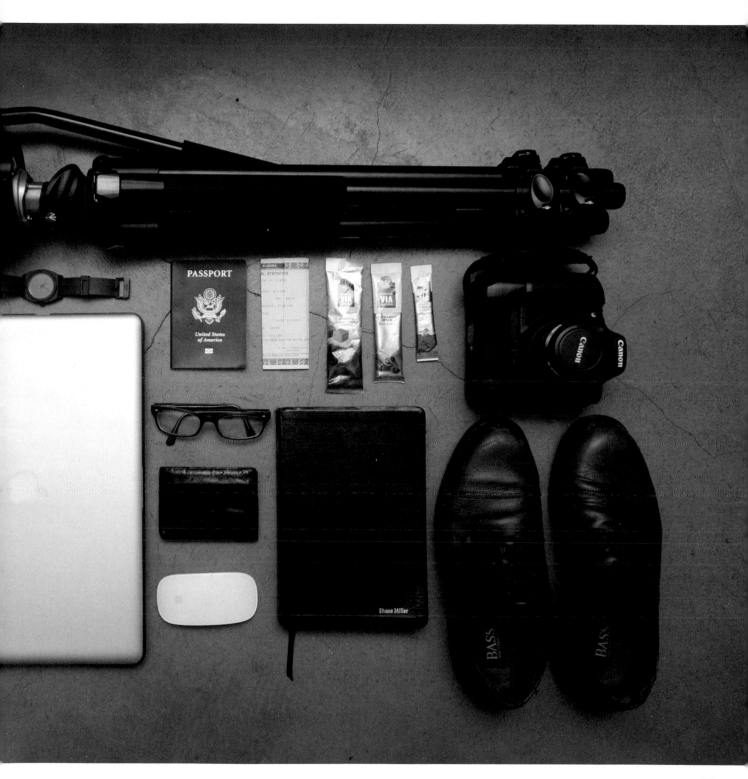

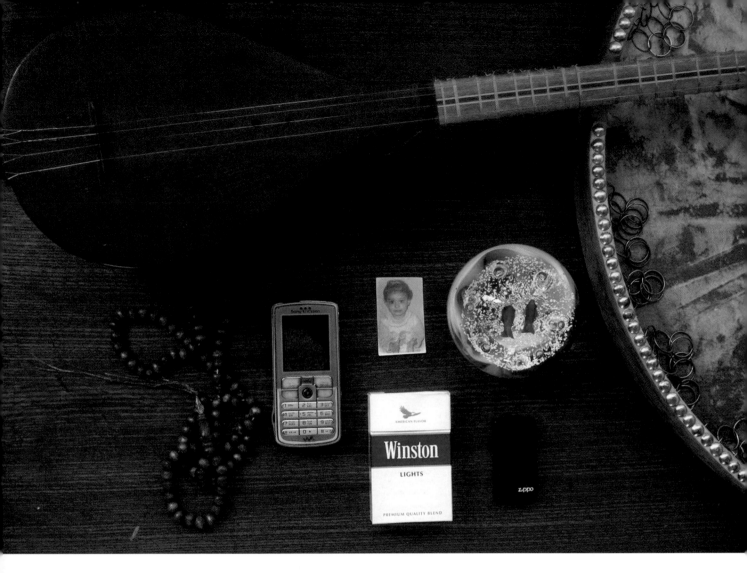

# MOOSEN ALISHIRI

**AGE:** 23
**LOCATION:** Karaj, Iran
**OCCUPATION:** Soldier
**WEBSITE:** ihardlyknowher.com/moosened/big

- Sitar
- Daf (Iranian drum)
- Prayer beads that Mom brought back as a souvenir from Mecca
- Sony Ericsson W800 mobile phone
- Winston Lights
- Zippo lighter
- Memento glass ball
- Photo of my first love from childhood

# WILL CHEYNEY

AGE: 27
LOCATION: London, England, UK
OCCUPATION: Design director
WEBSITE: www.flickr.com/willcheyney

- 11" MacBook Air
- Eddy the Teddy
- Nintendo Game Boy
- Ray-Ban folding Wayfarers

- iPhone 4
- White chino shorts
- Lomo LC-A camera

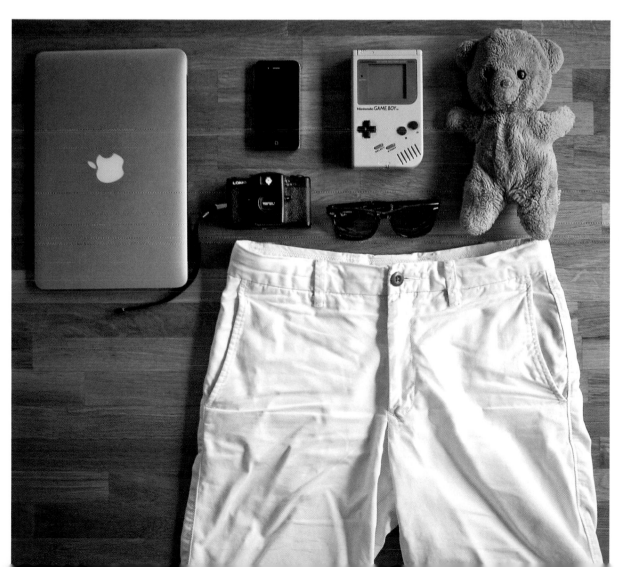

# TUVA MINNA LINN ODDSON

AGE: 28
LOCATION: Malmöe, Sweden
OCCUPATION: Vintage collector and blogger
WEBSITE: www.oddlovin.com

- My dog, Oddy
- Vintage Emilio Pucci robe
- My wedding dress, a 1970s Gunne Sax
- My favorite poetry books
- Blue crystal earrings and silver brooch, gifts from my husband
- Antique cameo that used to belong to my great-grandmother
- 1960s Dior necklace
- My favorite 1970s leather purse with a butterfly painted on it
- My Bulova watch. The engraving on the back says, "From Carl to Adele 1934."
- My favorite pearl bracelet from the 1940s
- The golden sandals my grandma gave me when I was seven. They'd never fit me, but I kept them anyway.
- A photograph of my father and my oldest brother

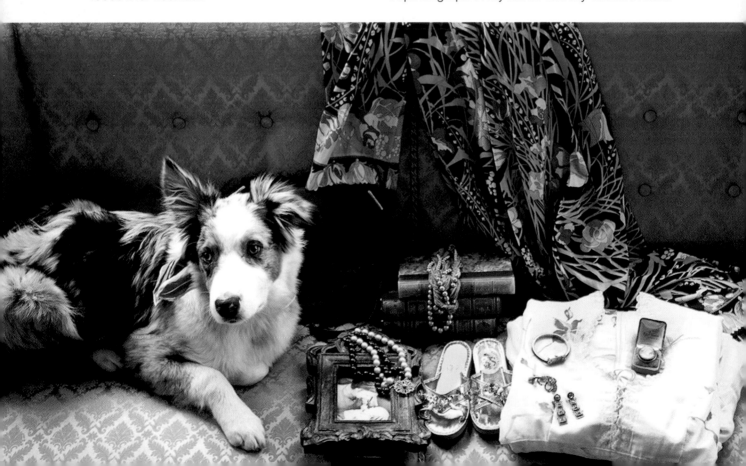

# LH

**LOCATION:** Bay Area, California
**OCCUPATION:** Designer
**WEBSITE:** www.adailykit.com

- Keys to my car
- Notebooks and address book
- A few rare records
- Box from Egypt

- A few items from the road
- Grandfather's camera
- Fly-fishing pole

# JEFF SHELDON

**AGE:** 25
**LOCATION:** Pennsylvania
**OCCUPATION:** Designer
**WEBSITE:** www.ugmonk.com

If my house was burning, I'd sacrifice everything to make sure my wife and puppy (Pixel, pictured) made it out safely, but these are a few things I'd grab if there was time:

- Sketchbooks with all of my concepts and ideas
- Keys
- Wallet
- Leather journal
- iPhone
- MacBook Air
- Hard drive with a backup of everything I've ever designed
- Panasonic Lumix GF1 camera
- Favorite leather shoes
- Vintage letterpress type
- Brass Ugmonk brand

# LIBBY HEGTVEDT

AGE: 28
LOCATION: Minneapolis, Minnesota
OCCUPATION: Maker, finder, florist and decorator, freelancer, salesclerk
WEBSITE: www.pinkshirtsandcarwrecks.com

- My father's ashes in a box handmade by my pseudo-grandpa
- Photographs of my family, my boyfriend as a baby, and my parents as children, and a photo I took in college of my father's hands
- Three heart-shaped rocks, two of which were found at my family's farm
- Watch
- Dad's pipe, smoking toolkit, pocketknife
- Favorite vintage Japanese mug
- Small clay container from the studio in Italy where I studied ceramics for a month in college
- Skeleton key from the farmhouse
- A few rings that belonged to my father's maternal grandmother, and great-grandmother (not pictured)
- Books: *Harriet's Recital* by Nancy Carlson, given to me when I was born; an out-of-print first edition of *Maiden Voyage* by Tania Aebi that I used to read over and over (my boyfriend tracked down a copy for my birthday); a vintage edition of *Swiss Family Robinson*
- My boyfriend, Steve, and my two cats, Marvin and Margie (not pictured)

# LUCILA BREA

AGE: 28
LOCATION: Buenos Aires, Argentina
OCCUPATION: Actress

- My best friend, Ramona
- Bike
- My bunnies jacket
- A teddy bunny I've had since I was born
- Glasses
- iPod
- My Blythe doll
- Passport and ID
- A kitsch picture frame handmade by my mom, with a picture of my sister and me
- Shirt that my ex-boyfriend gave me
- Picture of my mom when she was a teen
- White American Apparel shoes
- Wallet with credit cards and money
- Two books handmade by me
- A cute little bag that my friend Clarisa gave me. It was hers when she was a kid.
- Skates
- Shoes from Chinatown
- Favorite panties

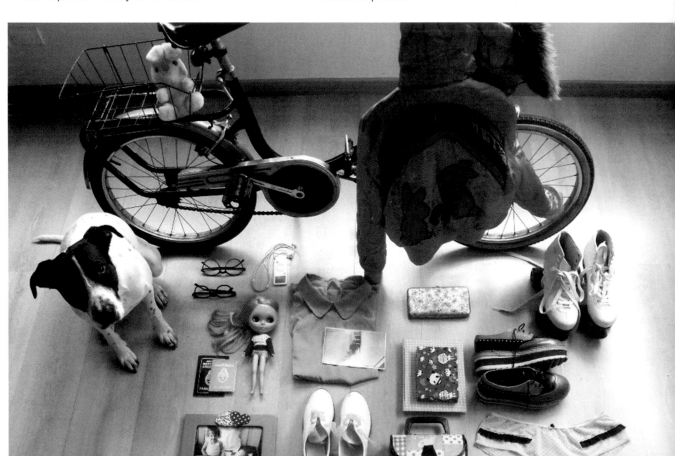

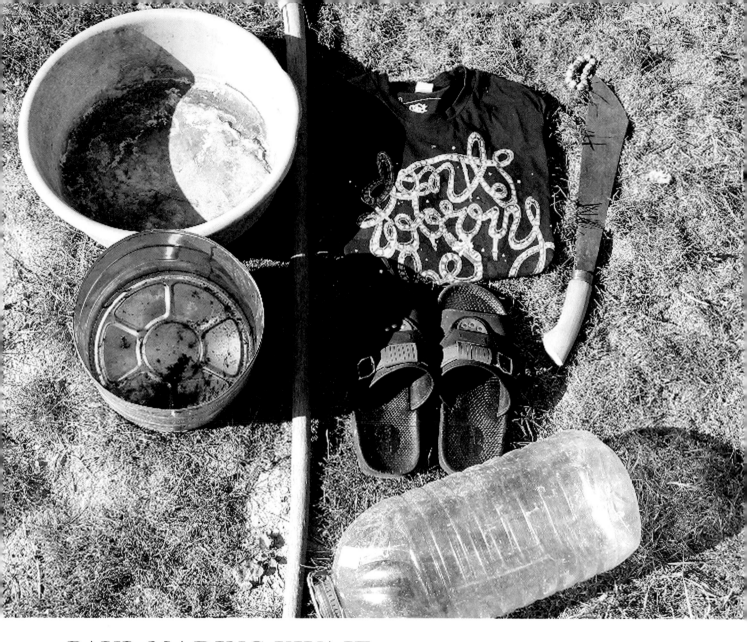

# PAUL MADING KWAJE

**AGE:** 22
**LOCATION:** Kauda, Sudan
**OCCUPATION:** Farmer

- Bush knife
- Favorite shirt
- Wood bracelet (not pictured)

- My largest bowls
- Hoe
- Water bottle

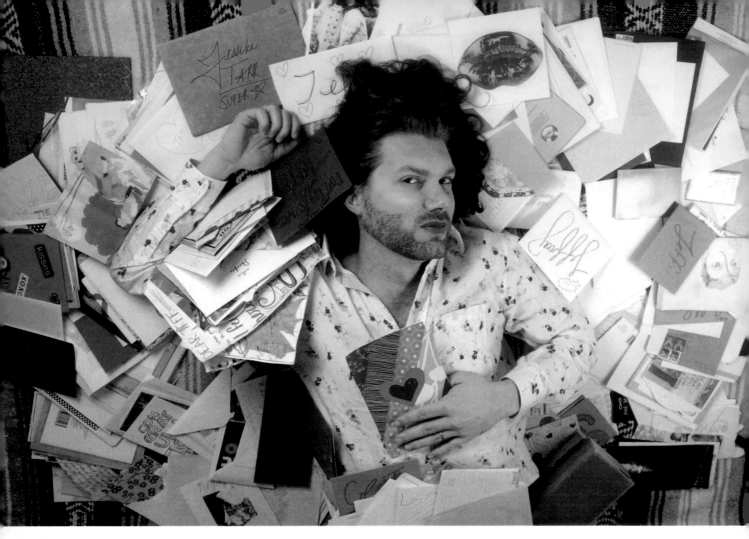

# JESSIKA DENÉ TARR

**AGE:** 23
**LOCATION:** Washington, DC
**OCCUPATION:** Visual artist
**WEBSITE:** www.jessikatarr.com

- My husband
- Our love letters to one another
- The 1939 copy of *The Complete Works of Lewis Carroll* that my grandfather received as an award from his high school in Manchester and later gave to me for my sixteenth birthday

- A few of the books my parents read to me when I was young: *Tales from Beatrix Potter, Enid Blyton Collection, If You Ever Wonder,* and *Love You Forever*

# T.I.

**AGE:** 31
**LOCATION:** São Paulo, Brazil
**OCCUPATION:** Unknown

- Magtech shotgun
- Ammunition
- Foreign money
- My father's watch

- Bank account security-token device
- Car key
- Birth certificate
- Hard drive

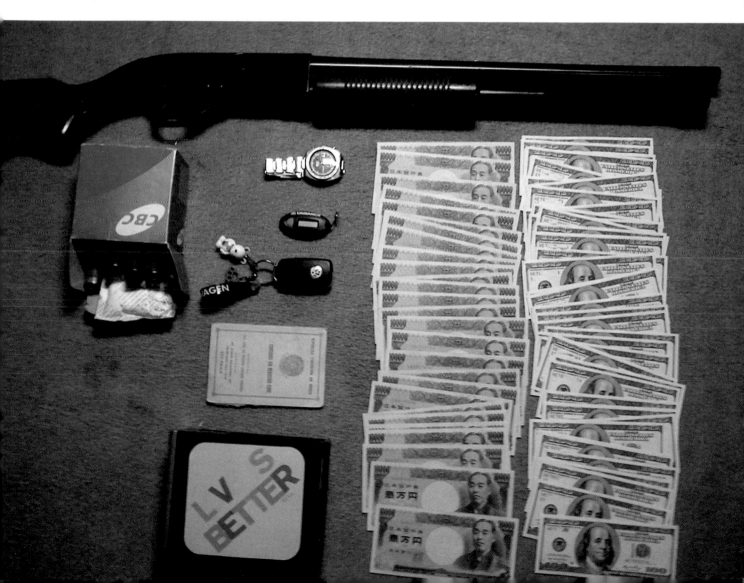

# DAVID COGGINS

**AGE:** 36
**LOCATION:** New York
**OCCUPATION:** Writer
**WEBSITE:** www.groverscleveland.com

- *The Great Gatsby* (first edition)
- Two good pens
- Bottle opener
- Watch
- Cigar holder
- Flask
- Favorite English suit
- Cleverley brogues
- Olch tie
- Antique casino chip
- Plastic cowboy
- Smythson calendar
- Calling card
- (Rugs not included)

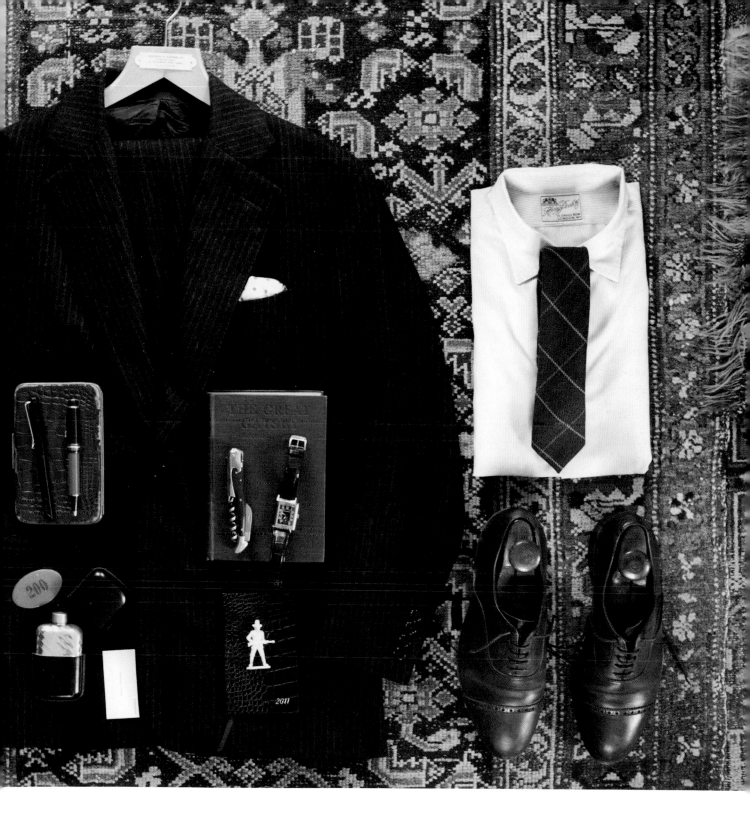

# ÅSA

**AGE:** 21 or something
**LOCATION:** Halmstad, Sweden
**OCCUPATION:** Web editor, student
**WEBSITE:** brutalweapons.blogg.se

- Cash
- Wallet
- My cat, Harry
- Lucky Strikes
- Contraceptive pills
- Red lipstick
- Cell phone
- Pictures from adventures
- External hard drive
- *Dyngkåt och hur helig som helst* by Mia Skäringer
- Picture of me and a secret person
- The perfect Levi's jeans
- The one and only elephant

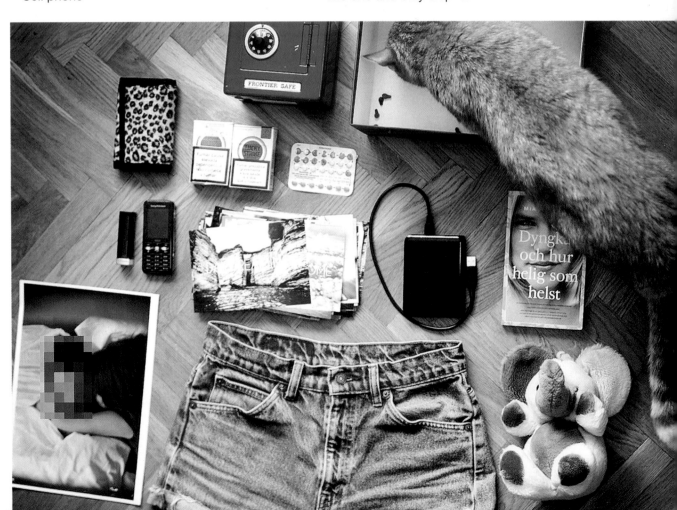

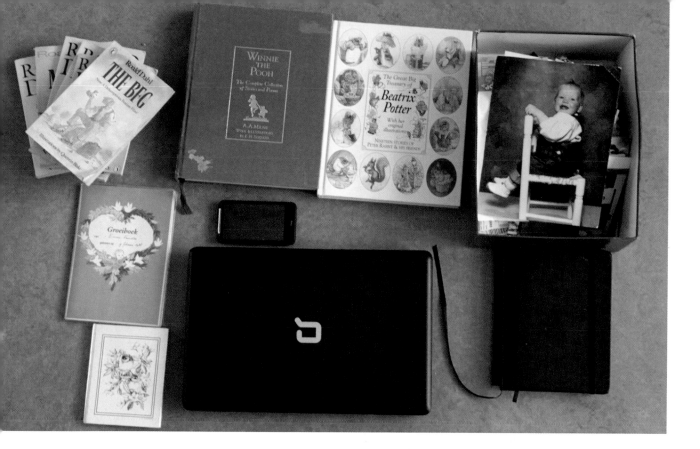

# EMMA

**AGE:** 23
**LOCATION:** The Netherlands
**OCCUPATION:** Blogger
**WEBSITE:** iheartblogging.nl

I thought about this question for months, which is kind of silly because if there is a fire you have to decide within seconds. I had a fire in my last apartment about a year and a half ago, and I didn't bring anything except for pets. And I would probably do the same thing if another fire occurred. But if I could bring something—if I had enough time—this is what I would bring.

- The journal my mom kept from my birth up to when I was a toddler. It's my most precious belonging.
- Box filled with photos that I only have prints of, and not digital files
- My laptop and my notebooks

- My green book, filled with stuff about me when I was a baby, like length, date of first tooth, etc.
- My Roald Dahl books, a Winnie the Pooh book, and a Beatrix Potter book. Those are my favorite children's books and are quite important to me.

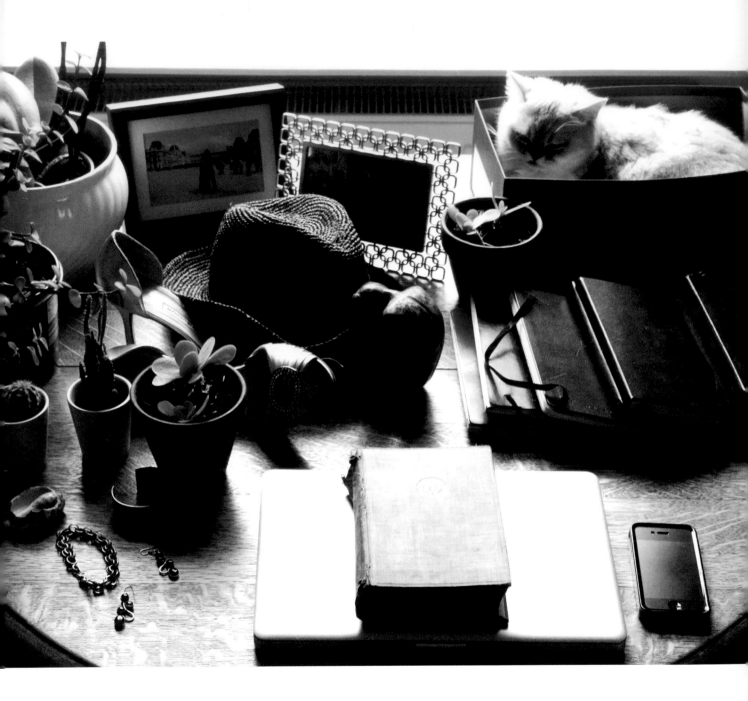

# KATE McAULEY

AGE: 36
LOCATION: Australian-born, London-based (for the moment)
OCCUPATION: Writer
WEBSITE: www.i-am-not-a-celebrity.com

- Goose, the cat
- A broken shell, the first thing my beloved ever gave me not long after we met in Port Moresby, Papua New Guinea
- Jade and silver earrings bought by my beloved at the *souq* in Muscat, Oman
- Silver cuff bought by my beloved at a market in Douala, Cameroon
- My grandmother's copy of *The Complete Works of Oscar Wilde*. Most of my books are in storage at the moment.
- Link bracelet bought by my beloved at a market in Cyprus
- Flapjack succulents struck from my mum's plant in Sydney
- Money plant struck from favorite plant in my yard in Dubai
- Orchid given to me for my birthday. If you could see the flowers bloom, you'd understand.
- Handful of notebooks, where I make plans and write prose for my novels and the other bits and pieces I'm commissioned to produce
- MacBook Pro with an almost-finished novel, photographs, and music hiding somewhere safe inside
- iPhone (for reasons obvious)
- Bronze statue bought in the markets in Douala, Cameroon
- Silver, glittery Manolo Blahniks
- Green woven hat from Sydney
- Framed photographs of us at the Grand Canyon and outside the Louvre
- The baby cactuses I got in Ikea, just because I love them and I'm so happy I've been able to keep them alive for more than a year

# DUSTIN DEAL

**AGE:** 26
**LOCATION:** North Carolina
**OCCUPATION:** Photographer
**WEBSITE:** www.dustin-whitney.com and www.ohdarlingphotography.com

- My wife, Whitney
- Our dog, Dexter
- Wallet
- Keys
- Necklace from a trip to Tuba City, Arizona, with wife
- My favorite Case pocketknife (a yellow slimline trapper)
- My great-grandfather's hand tools
- Hard drive of backed-up photographs and music
- Lemon Ball baseball from my wedding day
- Bible
- Contax 645 camera
- Martin 000–18S guitar
- Oh, and a rucksack to throw everything into since my house is burning

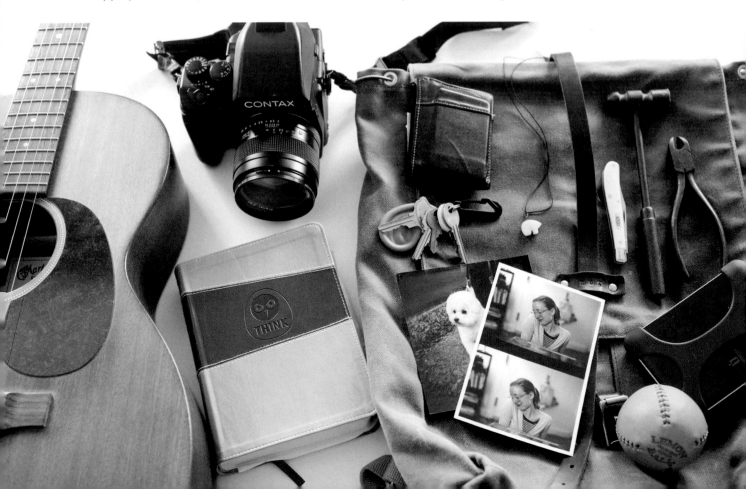

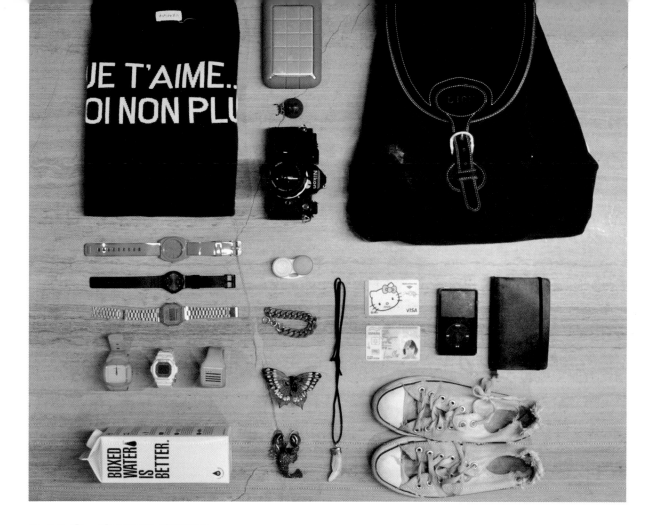

# LEO OTEGUI

**AGE:** 26
**LOCATION:** Brooklyn, New York (originally from Spain)
**OCCUPATION:** Senior Art Director
**WEBSITE:** www.merryvalenzuela.com

- "Je t'aime . . . moi non plus" sweater
- Hard drive
- My dad's camera
- Boxed Water
- Debit card
- Spanish ID. I can't seem to find my passport.
- Music
- Moleskine sketchbook
- My ten-year-old Converse shoes
- My Lion backpack
- A ladybug flashlight
- Collection of watches
- Bracelet
- Contacts
- Butterfly hair accessory
- My dad's lucky charm: an African wild boar tooth

# MANIFES

**AGE:** 27
**LOCATION:** Tehran, Iran
**OCCUPATION:** Jerk

- Cigarettes
- Lighter
- Wedding ring

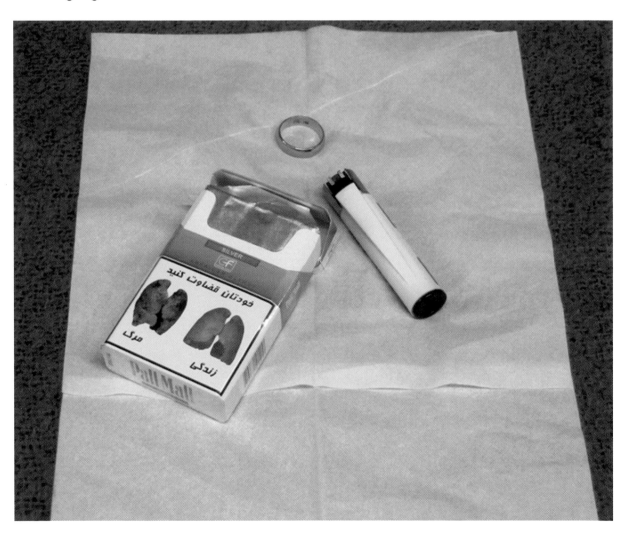

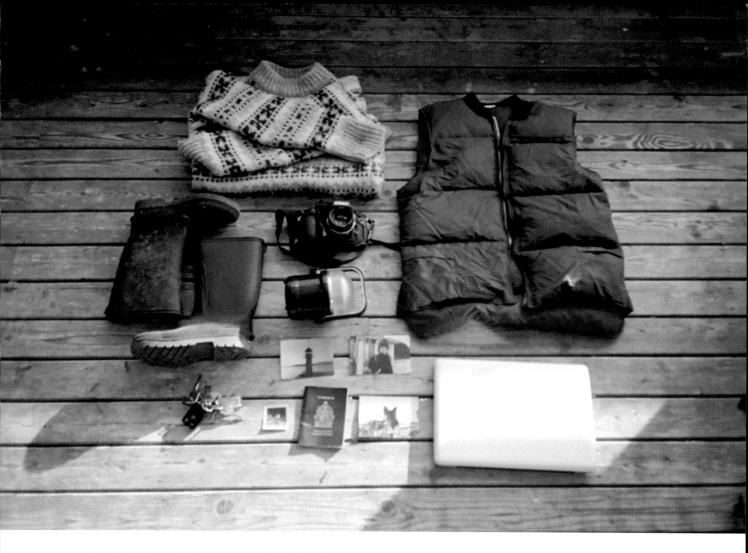

# ALANA PATERSON

AGE: 27
LOCATION: Gabriola Island, British Columbia, Canada
OCCUPATION: Photographer, farmhand

- Boot
- Sweater
- Vest
- Camera
- Flashlight
- Laptop

- Keys to my truck
- Picture of where I grew up
- Picture of my sister as child
- Picture of my favorite dog
- Picture of my dad
- Passport

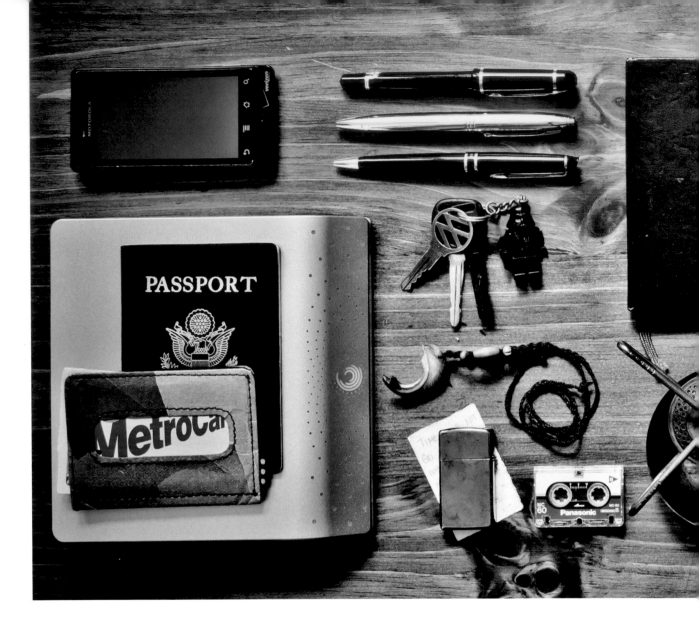

# JOSEPH H. AUGSTEIN

**AGE:** 27
**LOCATION:** New York City, New York
**OCCUPATION:** Creative
**WEBSITE:** www.augsteindesign.com

- Semi-functioning phone
- The three important pens

- Chief Moleskine
- 2TB hard drive with photos

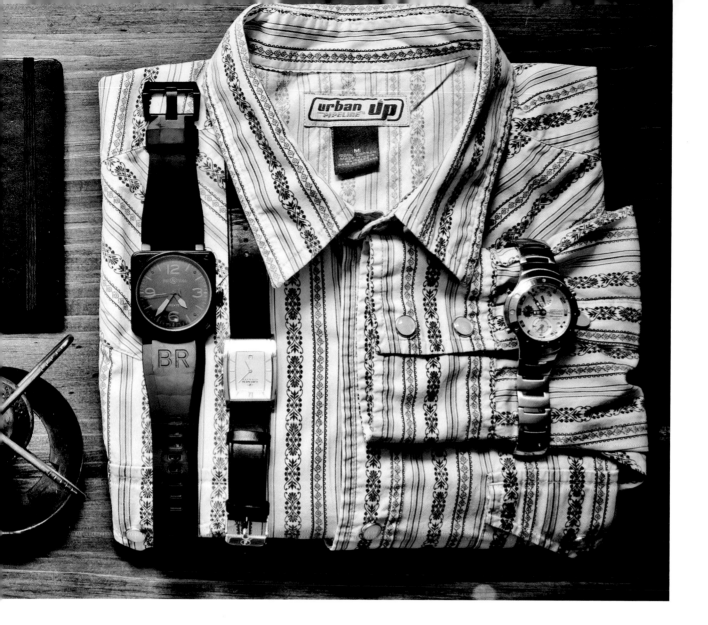

- U.S. passport
- Mostly empty wallet
- Keys to my current and former cars
- Seed necklace, the "his" of a his/her set
- Zippo lighter, one of three-part roommate set
- My favorite love letter
- Recording of an interview with my grandmother
- My most trusted camping stove
- *The* spring break shirt
- Watch I've had for five years
- Wedding-party watch
- "Inherited" watch

# LORRAINE

**AGE:** 29
**LOCATION:** Paris, France
**OCCUPATION:** Communication assistant
**WEBSITE:** www.polaroid-passion.com/galerie/lkarl/
  index.php

- My engagement ring with its *écrin* (case)
- My box of Polaroids
- Picture of my cute nephew and godson, taken
  when he was seven months
- My father's Asahi Pentax camera
- Old Chinese camera found by my father in Shanghai
- A 1972 Clartés edition of a volume on Beaux Arts
  from my grandfather
- Two photo books, one by Raymond Depardon
  and the other by Duane Michals
- My cell phone
- My most luxurious perfume
- Roses scarf
- My mother's green beret
- Most recent Moleskine notebook
- Car keys

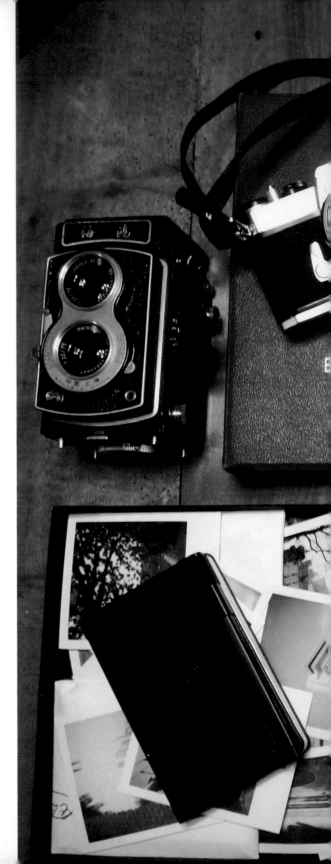

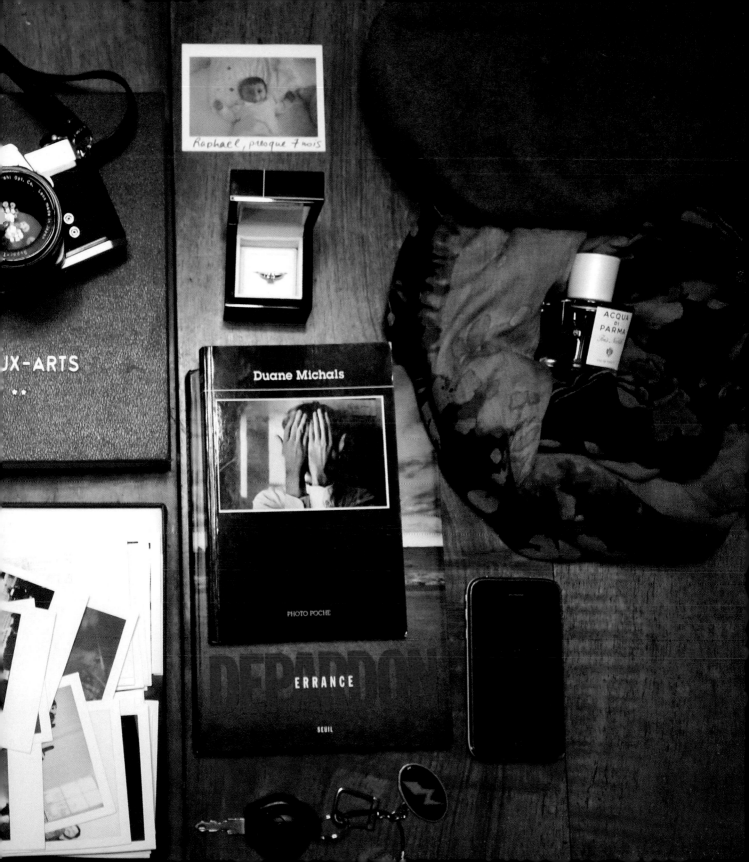

# DANIEL SMELANSKY

**AGE:** 14
**LOCATION:** Boston, Massachusetts
**OCCUPATION:** High school student
**WEBSITE:** www.flickr.com/photos/mrspacemanspiff/sets

- Some of my favorite books: *MAUS I* and *II*, *The Little Prince*, and *Animal Farm*
- Nikon N75 camera
- Two rolls of film
- External hard drive
- iPod
- Phone
- Glasses
- Journal
- Little sketchbook
- Markers
- Altered Book project
- My cat named 3
- Nikon D50 camera (not pictured)

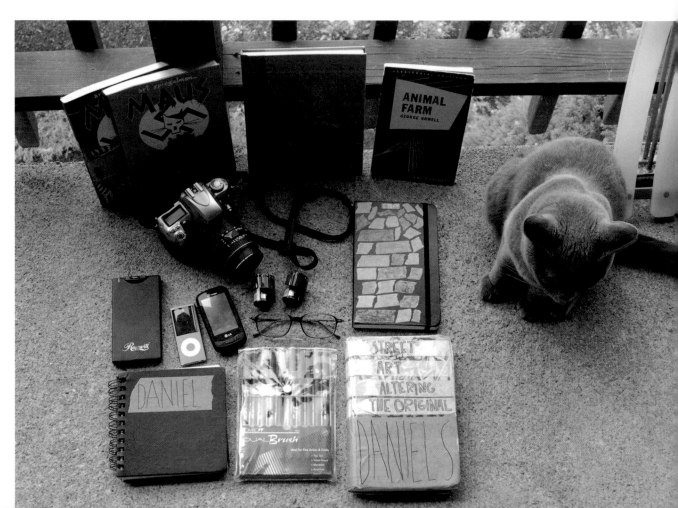

# BOBBY BONAPARTE

**AGE:** 24
**LOCATION:** Portland, Oregon
**OCCUPATION:** Owner/Creative Director of SKATE LiFT
**WEBSITE:** www.skatelift.com

- "Spirit" SKATE LiFT shirt I designed and silk-screened
- Native-American medicine pouch, where I secure all my art supplies on the go
- Super limited Adidas Dennis Busenitz shoes (this color way never made it to production)
- Brent Atchley cruiser board with rainbow Portland Player wheels
- François Pralus 100% chocolate bar
- Fjällräven fur hat
- Naked and Famous jeans that fit like a glove

# KJ VOGELIUS

AGE: 28
LOCATION: Stockholm, Sweden
OCCUPATION: Digital designer
WEBSITE: www.vogelius.se

- In my left hand: an oil painting. I was very close with my paternal grandparents but don't really have many things to remember them by, except for this. I remember being a kid and sitting in Granddad's lap while he was working on this. I remember his voice and how he smelled, the room, the paintbrush in his steady hands. The painting hung in their house up until they both passed away and the house was sold. My youngest cousin was also very fond of this painting, so in the name of fairness we flipped a coin for it. I'm very glad I won.
- Wearing: whatever was handy, and this jacket from Wood Wood, which I quite like, to keep warm while waiting out on the street for the firefighters to arrive.
- In my pocket: wallet, containing everything needed to get by in the aftermath (debit cards, ID, etc.)
- Over my shoulder: Panasonic GF1 camera, for documentation, but only if it were somewhere where I could just grab it on the way out, along with whatever lens was currently attached (most probably the 20/1.7). I wouldn't even consider my Canon 5D Mark II—too large.
- In my pocket: two external backup drives, the digital equivalent of photo albums/journals/ documents. Between these two drives I have pretty much every photo I've ever taken, most of the design I've ever created, and a lot of whatever I've written.
- In my pocket: iPhone, my command central. With this I would be able to do pretty much whatever communication I needed: get in touch with people I know, arrange somewhere to sleep, transfer money, sort out insurance, etc.
- On my wrist: the pewter bracelet made and given to me by my girlfriend. Love it. I wear this often, so it would also be easy to find and bring.
- Obviously, my girlfriend and dog (not pictured)

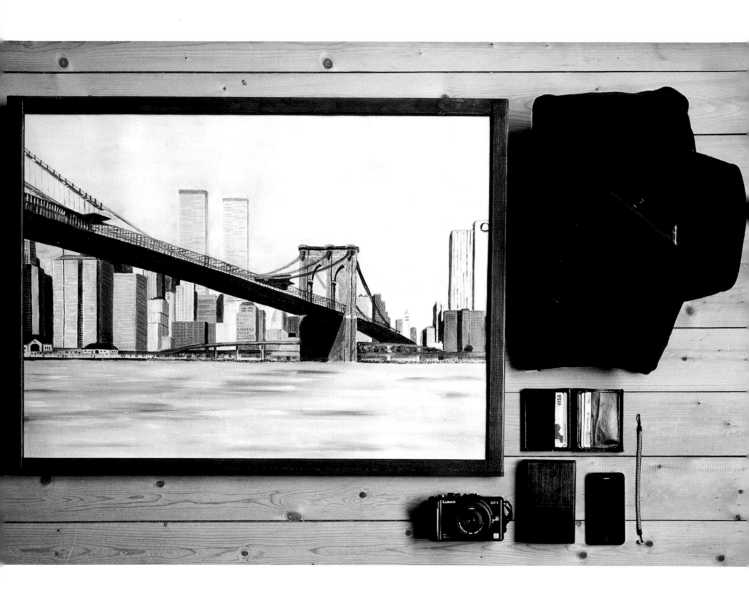

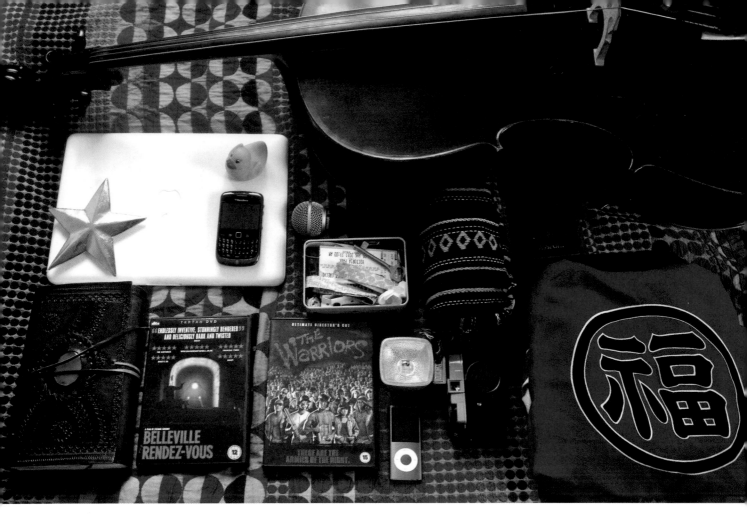

# STELLA LE PAGE

**AGE:** 24
**LOCATION:** London, England, UK
**OCCUPATION:** Musician, singer
**WEBSITE:** www.stellamusic.co.uk

- Cello, even though I hate lugging the thing around
- Laptop with precious recordings
- iPod with music to get me through
- Rubber duck from a Berlin hotel
- Gold star from New Year's Eve, 2008
- SM58 mic, a gift from my ex
- Irreplaceable box of memories
- My top-secret diary full of gossip and drama
- Makeup bag *of course*!
- Japanese kimono belonging to my mother
- Passport for travel to those places I dream of
- *The Warriors* and *Belleville Rendez-Vous* DVDs
- BlackBerry, much needed in order to find somewhere else to stay

# HANNA LEE REEHL

**AGE:** 14
**LOCATION:** New Jersey
**OCCUPATION:** Student, writer, photographer
**WEBSITE:** www.flickr.com/photos/hanna_lee

- The bunny my aunt gave my mother as a baby-shower gift
- My *Every Day and Every Night* Bright Eyes CD
- My *Execution of All Things* Rilo Kiley CD
- Locket my mom gave me as an 8th grade graduation gift
- The two diaries I've filled over the past year
- Camera
- Owl mug for coffee- and tea-ingestion purposes
- Polka-dotted Hanna Andersson shirt from when I was nine
- My bottle of Exclamation! perfume

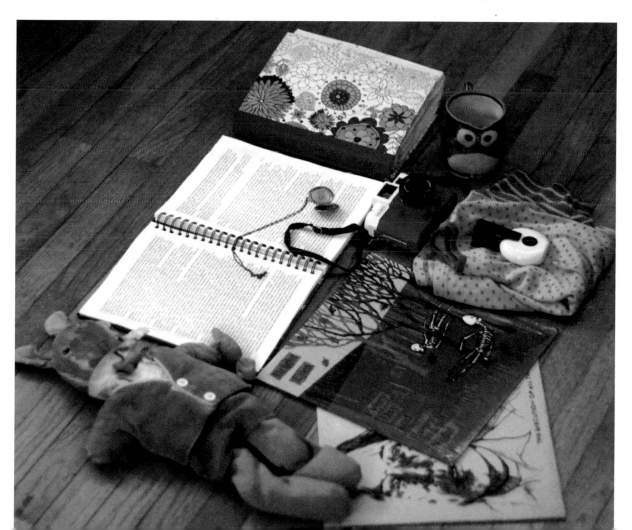

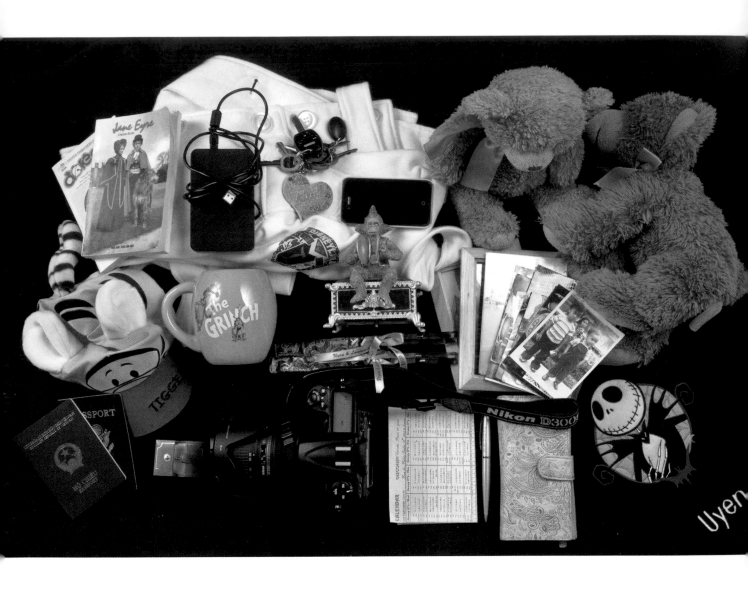

# UYEN TRAN

AGE: 29
LOCATION: San Francisco, California
OCCUPATION: Accounting, student photographer
WEBSITE: www.wix.com/uyentranphotography/uyentran

- Wallet
- Phone
- Car keys, house keys
- Camera
- Passports
- Engagement ring
- Hard-drive storage of my pictures
- A pen my husband gave me
- Photographs of my mom, dad, brother, and sister; a wedding photo with both of our families; graduation picture with my dad; and a picture of myself when I was four
- Books: *Jane Eyre*, my favorite movie and book of all time; *Doraemon,* my favorite Japanese comic book since I was in elementary school
- A mug my husband gave me on Christmas because he knows I like collecting mugs
- Music box from *Phantom of the Opera* that my husband bought for me after seeing the show in Las Vegas
- Tigger hat I bought at Disneyland for my niece when she was four months old. It didn't fit her and she doesn't live with me anymore, so I keep the hat. I'll give it to her when I see her again.
- My stuffed animals
- White jacket I bought at Disneyland
- The only copy I have of the perpetual calendar my grandfather studied and developed, with his writing on the back
- Tim Burton's *The Nightmare Before Christmas* fleece blanket my husband gave me with my name embroidered on it
- Pairs of chopsticks that were our wedding favors

# CHRIS ADAMIAK

AGE: 30
LOCATION: Milton, Ontario, Canada
OCCUPATION: Maintenance worker
WEBSITE: www.damnyak.ca

- My cats: Indy (left) and Scout
- My late 1950s Red Wing work boots (size 13 is hard to come by!)
- Paddle that's been on almost a decade of canoe trips
- Engraved Zippo from my wife
- Custom James McGowan knife. I designed it, he made into life.
- Cyma Navystar watch from my pop
- My wallet and contents
- World War II U.S. bayonet from my late uncle
- 1940s shell bag
- First edition *Song of the Paddle* signed by the late Bill Mason
- 1TB hard drive with thirteen years of music and pictures on it

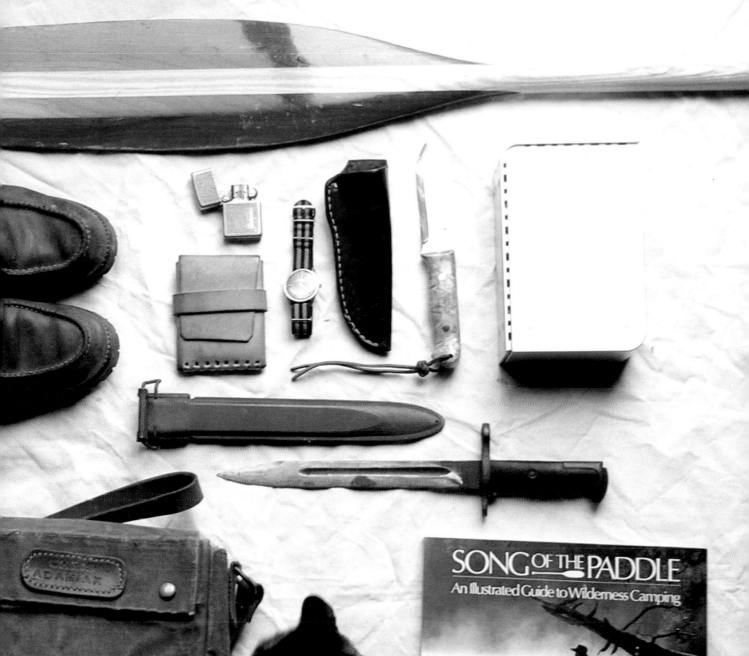

# CLAIRE COTTRELL

**AGE:** 30
**LOCATION:** Los Angeles, California
**OCCUPATION:** Filmmaker, etc.
**WEBSITE:** www.clairecottrell.com

- My first painting
- Pink parachute-silk rabbit
- My uncle's Rolleiflex camera
- Yashica T4 camera
- The journal I keep now
- The journal I kept as a child
- Slides of my parents' wedding
- My grandmother's jewelry: two rings, a pair of diamond earrings, and a peach cameo necklace that my grandfather had made for her
- Box my mom's wedding ring came in. It says "orange blossom" on the top.
- Signed copy of Henry Roy's book *Spirit*
- Rare pink book of Sophia Coppola's photos from 2003
- Geode from a magical gem shop in Paris
- One-of-a-kind handmade pink lace lingerie from Odile de Changy in Paris
- Flower garland from my most recent film

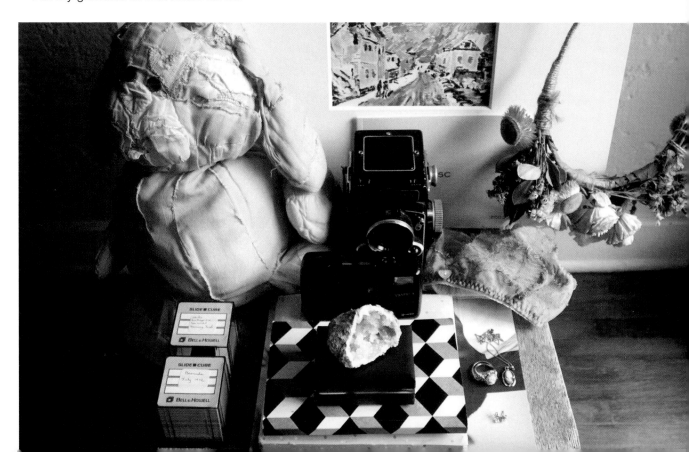

# LOCKYI

**AGE:** 22
**LOCATION:** Kuantan, Malaysia
**OCCUPATION:** Designer
**WEBSITE:** lockyi.tumblr.com

- Canvas bag
- Vintage game console
- Rabbit pencil case
- Carbonated drink
- Holga 120 camera

- Notebook and colored pencils
- Yellow watch
- A box of chewing gum
- Keys
- Handkerchief

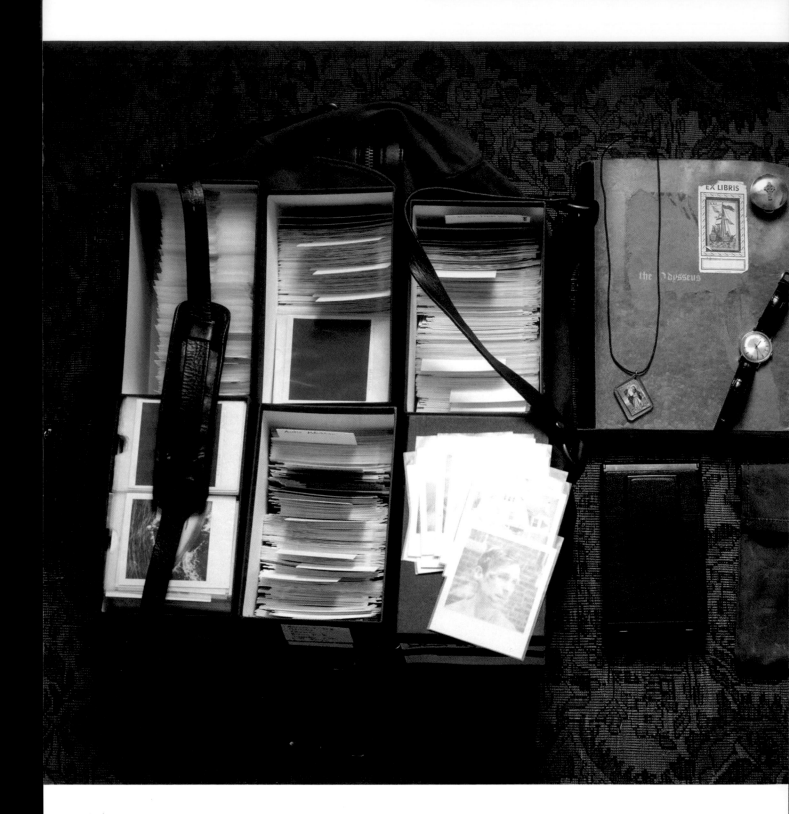

# MIKAEL KENNEDY

**AGE:** 31
**LOCATION:** Brooklyn, New York
**OCCUPATION:** Photographer
**WEBSITE:** www.mikaelkennedy.com and
  www.passporttotrespass.com

- Large olive-green Filson duffel
- Six boxes of my Polaroids. I only could fit six out of the eighteen that are full. Priorities include edits for next show and *Passport to Trespass* book edits.
- Workbook from "The Odysseus" photo series
- St. Christopher necklace given to me by an old friend when he was done traveling and had settled down
- Grandfather's Timex (still broken)
- Small tin of dirt from the Santuario de Chimayo in Chimayo, New Mexico
- Black Polaroid SX70 Limited Edition camera
- Custom Polaroid case from Strawfoot Handmade
- Two bricks of the last Polaroid 779 batches ever made, expiration date 2009
- Wallet
- Keys to my Chevy
- Hard drive with latest backup from computer
- iPhone
- First edition of Johnny Dark's *People I May Know*, published by Little Bear Press

# JASON MCCARTHY

**AGE:** 32
**LOCATION:** Washington, DC
**OCCUPATION:** GORUCK military gear

- Java, my dog
- Green Beret and Yarborough knife
- Family scrapbook I had in Iraq
- One-of-a-kind camo duct-tape wallet, made by a friend
- Java's finisher medal from the Chicago half marathon
- Grandfather's burial flag

# ANA ERTHAL

**AGE:** 36
**LOCATION:** Rio de Janeiro, Brazil
**OCCUPATION:** Teacher
**WEBSITE:** www.anaerthal.com.br

• A single letter, a memory forever

# MANUEL PLATZER

**AGE:** 27
**LOCATION:** Vienna, Austria
**OCCUPATION:** Digital media
**WEBSITE:** www.manuelplatzer.com

- *Behind the Zines: Self-Publishing Culture* book
- Book jacket and a book
- Notebook
- Headphones
- Polaroid camera
- Photo of girlfriend
- "The Impossible Project" dark slide
- Drawing tools
- iPad
- T-shirt handmade my girlfriend

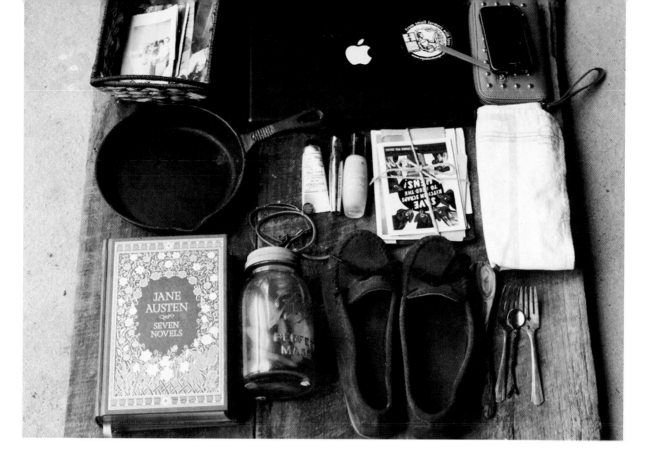

# HANNAH QUEEN

AGE: 20
LOCATION: Blue Ridge, Georgia
OCCUPATION: Photographer
WEBSITE: www.honeyandjam.com

- Basket of family photos, old and new
- MacBook
- iPhone
- Wallet
- Cast-iron skillet
- Leather bracelet with my grandmother's mustard-seed charm
- Leather bracelet, a gift from my mom
- L'Occitane lavender hand cream
- L'Oreal Voluminous Million Lashes mascara
- Lancôme Teint Idole Ultra makeup
- Letters and postcards from friends
- Favorite tea towel, which was a gift
- The complete works of Jane Austen
- Blue Ball jar, filled with river rocks (souvenirs from a perfect day)
- Minnetonka moccasins
- Favorite wooden spoon
- Two forks from old family silverware
- Twig spoon, a gift from a friend
- Canon 5D Mark II camera (not pictured)

# SEAN CROWLEY

AGE: 30
LOCATION: Brooklyn, New York
OCCUPATION: Neckwear designer

This list is of "the bare essentials," what Wellington's army on campaign is to a camping trip, but I suppose we all have a different idea of which things are "essential." Note: the carpet underneath is not merely decorative, as the idea is that all these bits would be rolled up in it and carried out the front door in one go.

(*counterclockwise from top left*):

- Striped college scarves, to secure the rolled-up carpet and because I like them
- Leather collar box and stiff wing collars
- Loose organic Assam BOP tea in silver caddy, which goes in the blue pot to the right
- Royal Lancers mess dress, and why not?
- Green silk formal waistcoat of the Porcellian Club with jacquard boars' heads, circa 1931
- *Apparel Arts* magazine, first issue, Christmas 1931
- Paper silhouette of my royal consort, Lady Meredith
- Johnnie Walker Black, circa 1950s, from a case found in an uncle's basement
- Old Thurston braces
- Carved wooden school plaque
- Pour le Mérite medal given to me by a World War II era veteran friend
- Coldstream Guards Color Sergeant's scarlet coat
- Old striped ties
- Wedgwood plate, circa 1870s, and RAF crested officer's mess cutlery
- French 1930s military-style hairbrushes (use 'em every day)
- Royal Artillery zigzag needlepoint slippers

- Black silk Fox umbrella
- English purple leather suitcase, circa 1930s
- Gray topper. Every inch of the silk lining is covered in autographs and witty handwritten sayings from various garden parties, circa 1932–34.
- Smith Woodhouse vintage 1977 port, part of a mixed case of vintage port my uncle gave me when I graduated college
- Equestrian mounted leather pouch with fitted sandwich case and flask. I don't ride, but it comes in useful for a ramble.
- Wedgwood (huge) mug marking the investiture of Prince Charles, circa 1969
- Silver toddy/punch ladles, circa 1750s. The handles are twisted whale bone and the bowls are fashioned out of George II silver shillings.
- Gold Krugerrand given to me by an uncle upon graduating college
- *Topsy-Turvy*, The Criterion Collection DVD
- Christ's College, Cambridge, carved wooden box
- Battle Creek Sanitarium silver souvenir spoon
- Ancient Order of Froth Blowers silver pin for the rank of "Blaster," in the shape of a foaming mug
- Musket ball I dug up in Fort Greene Park

- Gold monogrammed cufflinks. They were worn by three generations of Burbidges before me—with the history written on a tiny piece of paper. Each owner wore them during a momentous occasion in their lives.
- Old English molds for making fancy meat pies
- Pipe, tobacco, and a humidor my brother made for me for Christmas. The matches are from an old hunt club near where I grew up—they have polo and fox hunting.
- *The Gentleman's Companion: Around the World with Beaker and Flask* book

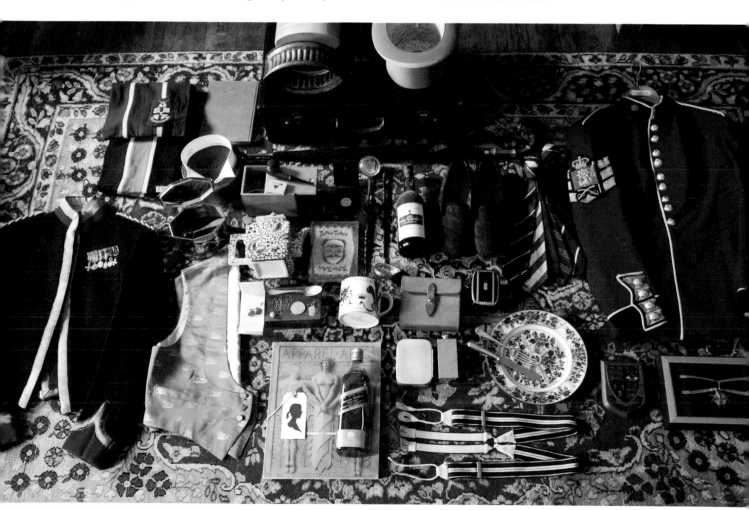

# MARIA HELENE HEGG

**AGE:** 18
**LOCATION:** Norway
**OCCUPATION:** Student
**WEBSITE:** runlikefuck.tumblr.com

- Nordlands *bunad*—traditional rural garment of Nordland, Norway—and silver accessories
- Cardholder
- Forty-six–page list of beautiful things in life
- My obese cat (not pictured)

# DEREK BRAHNEY

**AGE:** 25
**LOCATION:** New York
**OCCUPATION:** Designer, artist
**WEBSITE:** www.derekbrahney.com

- My dad's Baracuta jacket from the 1960s, my favorite jacket
- Passport
- Plaque with my family crest
- Miniature working toy bicycle that I've had for as long as I can remember
- Photo of my grandfather from World War II
- Engraving of Irish blessing that hangs near my bed
- Sketch I bought in London at an anonymous art auction, which turned out to be worth some money

# BROOK

**AGE:** 21
**LOCATION:** Winona Lake, Indiana
**OCCUPATION:** Graphic design student
**WEBSITE:** nothanksihaveabike.tumblr.com

- Box filled with letters, notes, and other saved things, to remind me I am loved
- Headphones and iPod, to keep my mind calm
- Journals, past and present, to remind me where I've been
- Bible, to remind me of what I need
- Laptop, to save my photos
- Keys, to remind me not all is lost
- Quilt made by my great-grandmother, passed on to my grandmother, and then to me, to keep me warm
- Wallet, to be practical
- Film camera, to remind me of what is tangible
- The very camera and lens I used to take this photo, to keep living life

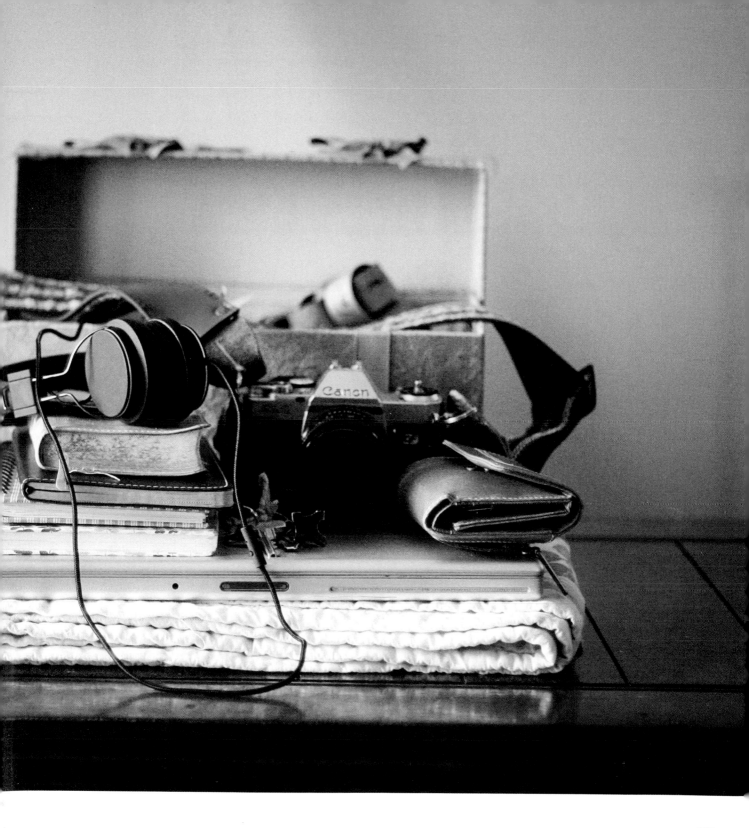

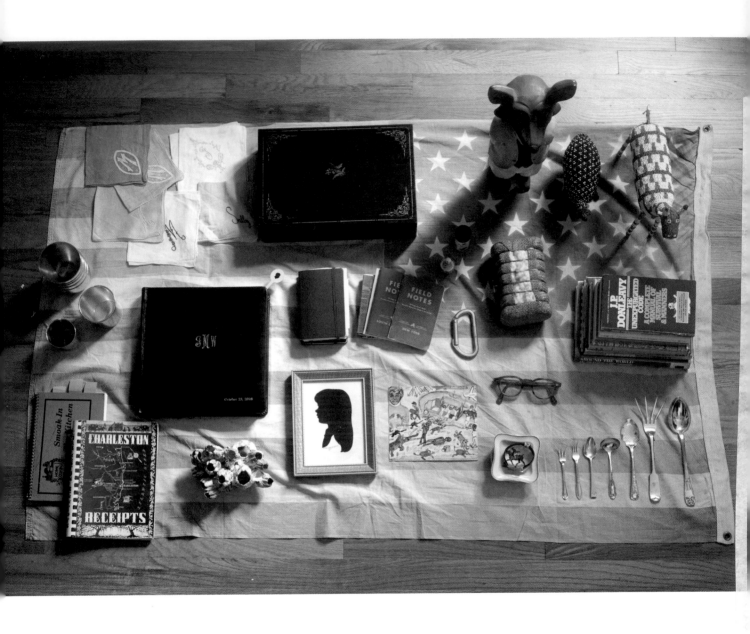

# JESSICA MISCHNER

AGE: 29
LOCATION: New York City, New York, and Charleston, South Carolina
OCCUPATION: Freelance writer, contributing editor for *Garden and Gun* magazine

- A few of the antique handkerchiefs in my collection
- Antique wooden writing box that my mother-in-law gave to me
- Sly Fox garden ornament and beaded animals from Monkeybiz that Will and I got on our honeymoon in South Africa
- Eight of the pewter and sterling julep cups from our collection, which have been accumulated over the past twenty-eight years
- Our wedding album with a wooden stir stick from our reception
- Red day planner and various notebooks
- Chouinard carabiner from the 1980s (I think), given to me by my biological father
- Cotton music box that plays "Dixie"
- Collection of etiquette books
- Family cookbooks passed down to me
- Dried barnacles from my favorite beach
- Silhouette of my biological mother
- Peter Beard exhibit card
- Glasses. I'm *blind*!
- Antique butter pat in my favorite pattern
- Antique Cartier watch that my husband restored for me
- Collection of sterling spoons and forks

# GEORGE YANAKIEV

**AGE:** 23
**LOCATION:** Sofia, Bulgaria
**OCCUPATION:** The online guy at an ad agency
**WEBSITE:** www.niteversions.com

- Junk food
- Junk food

- Junk food
- Coffee

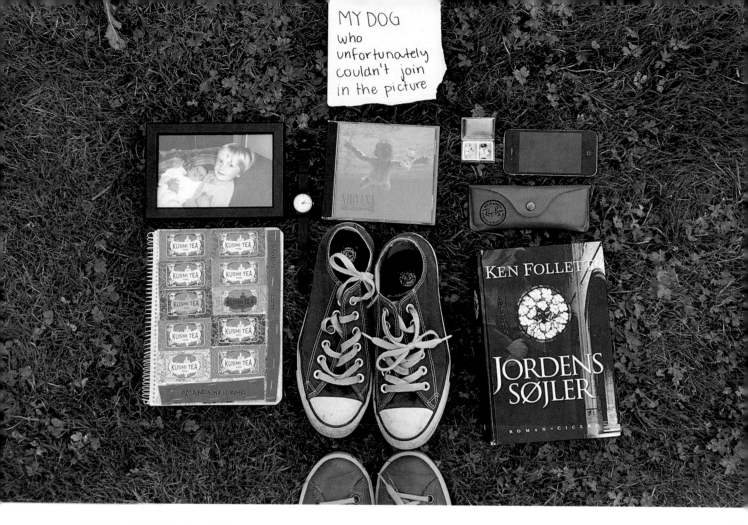

# AMANDA HVIDRASS

**AGE:** 12
**LOCATION:** Denmark
**OCCUPATION:** Student
**WEBSITE:** hvidrass.blogspot.com

- Diary
- Picture of me and my sister
- Favorite wristwatch
- My dog, who unfortunately couldn't join in the picture
- One of my favorite CDs, Nirvana's *Nevermind*
- Converse shoes
- Box with teeth I lost skateboarding
- Cell phone
- Ray-Ban sunglasses
- Favorite book of all time, *The Pillars of the Earth*
- My campers, the shoes you see down in the bottom of the picture

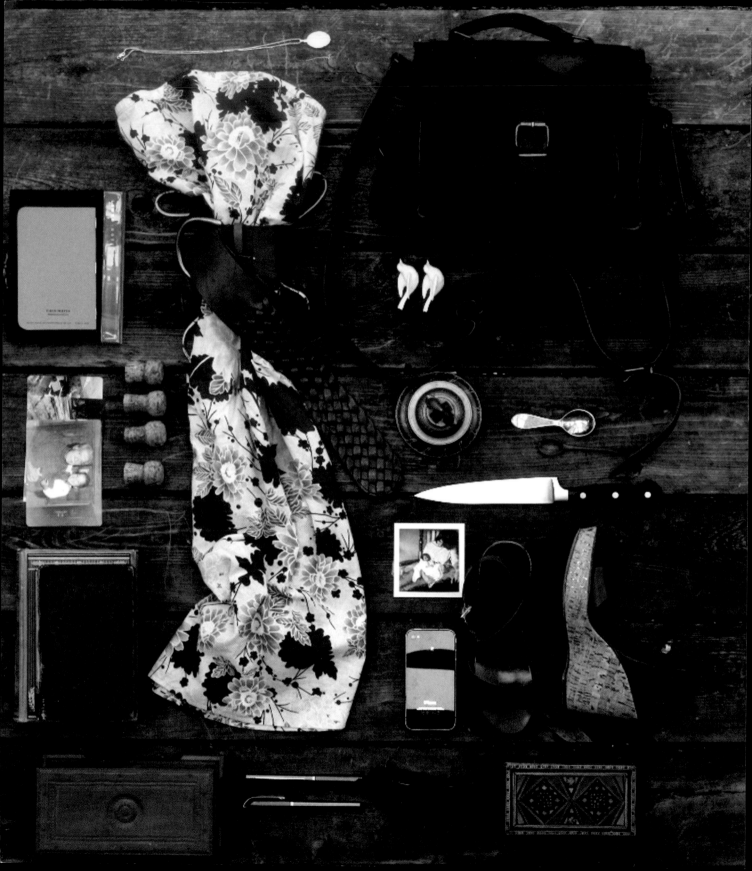

# TARA O'BRADY

AGE: 34
LOCATION: Niagara, Ontario, Canada
OCCUPATION: I cook a lot, and sometimes write about it. I take pictures, too.
WEBSITE: www.sevenspoons.net

With the assumption that my husband and children were safe and sound:

- Camera bag, with a hard drive, passport, and my grandmother's recipe notebooks inside. (My camera is around my neck.)
- A pair of doves from my parents' wedding cake
- A brass bell from India that rings pure and true
- The baby spoons we had made upon the birth of each of our sons
- The chef's knife I use the most
- My favorite sandals
- A Polaroid of my mother and me, fresh from the hospital. We're in the rocking chair that, decades later, welcomed my lads home.
- Phone
- Inlaid box of tiny treasures
- Sunglasses, because I squint terribly in glare
- The pens I like
- A sandalwood box of slightly larger treasures
- Collected Shakespeare from 1882 underneath an early edition of *Great Expectations*
- Champagne corks from important days
- More personal photographs
- Notebooks, one from Japan that I've just finished filling, another that I've just begun
- A dress with some history
- A belt that I can say the same for
- The locket my husband gave me the day we were married

# LAWRENCE GARWOOD

**AGE:** 37
**LOCATION:** London, England, UK
**OCCUPATION:** Creative Director and Founder at Picture
**WEBSITE:** www.picture-lt.com and www.lawrencegarwood.com

- Photos
- Hasselblad camera
- Leica I camera and the M8 I took the shot with
- Negatives (completely irreplaceable)
- Digital backups
- MacBook (to be honest, not critical)
- Ganesh. I'm not religious but I like what he stands for.
- Napoleon the Third twenty-franc gold coin, 1856 (a gift from my grandmother)
- Shades
- Records (the first handful as I'm rushing out). Hopefully since they are at the front of the pile they are my favorites.
- Heuer Camaro 1968 watch
- Car keys
- Passport
- Moleskine day book and sketch book
- Lamy pen (have to write)
- A bottle of Château Lynch-Bages, 1982

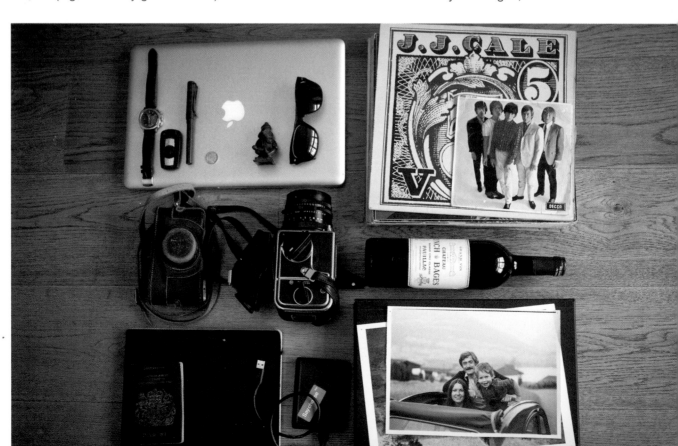

# CRIS SULAY

**AGE:** 61
**LOCATION:** Born and raised in Watsonville, California
**OCCUPATION:** Retired U.S. Post Office custodian

• I chose not to come out of a burning house with anything other than my boxers and my prayer beads. I believe there is nothing more valuable than life itself. The beads are for a prayer of thanks for the safety of me and all—that we live another day to rebuild, experience, learn, and explore within and without.

# HELEN STUTTARD

**AGE:** 19
**LOCATION:** England
**OCCUPATION:** Student photographer
**WEBSITE:** helenstuttard.wordpress.com

- My pheasant, Frankie
- My favorite notebook
- Quote from my grandma
- Poem from my sister
- Car keys
- Wallet
- Purse from Grandma
- Phone
- iPod
- Photo of me and Grandma
- My bunnies
- My first project book I made out of portraits of strangers
- Pottery chickens from Grandma
- My grandad's epaulettes and cap badge
- Passport
- My dad's first shoe
- 24–105 lens
- Camera and 50mm lens
- Locket with photo of my grandad in it
- Teddy

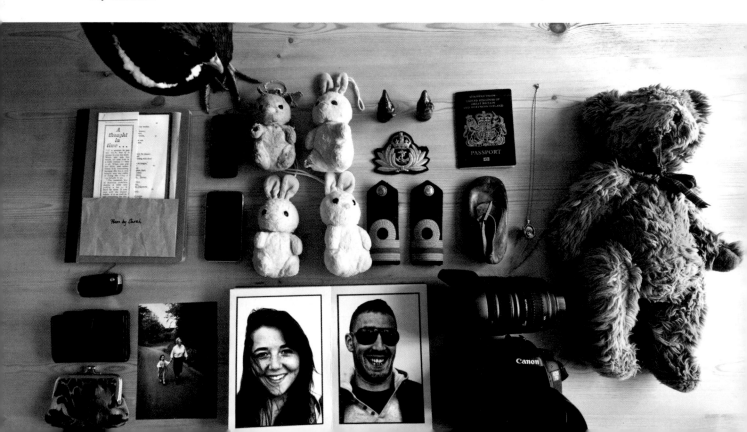

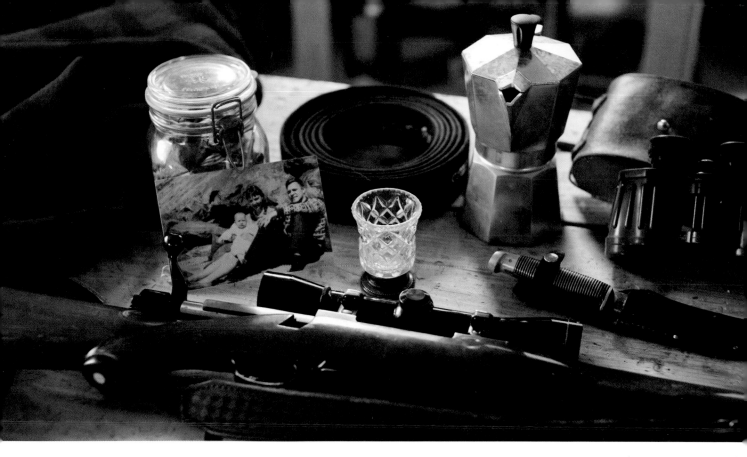

# STEVE SEE

**AGE:** 49
**LOCATION:** Underwood, Washington
**OCCUPATION:** Owl-pellet collector

- Espresso pot, for the morning after the fire
- Old family photo of my mom, my dad, and me in 1962
- Black Belt, a third-degree traditional Tae Kwon Do, by way of master Gary Mumma, Hood River, Oregon. The only diploma I have.
- Hunting rifle, an unremarkable Rugger bolt action with a simple scope. I have many vivid memories of snowstorms and bushwhacking at dusk in the Cascades.
- Swarovski binoculars. What can I say, it's my hunting rifle's best friend.
- A jar of trinkets: old coins, poker chips; flakes of obsidian, opal, and quartz; bits of bone, horn, and teeth; arrowheads, rattlesnake rattles; small bits of truck parts from memorable backroad breakdowns
- A very warm wool jacket and hunting knife, a very practical item for life after the fire, and they're gifts from my girlfriend
- Shot glass from my great-grandfather, an early orchardist in the Hood River valley, because after that fire I am going to need a good drink

# RAÚL CIRUJANO SEGURA

AGE: 34
LOCATION: Madrid, Spain
OCCUPATION: Unemployed

● Exfaex fire extinguisher

# SONIA GUAZZONI

**AGE:** 44
**LOCATION:** Milan, Italy
**OCCUPATION:** Secretary and amateur photographer and dancer

- One of my Polaroids
- Tango shoes and their red bag
- Hard drive
- The Book of Ruth, translated from the Bible by Erri De Luca
- The book *Il peso della farfalla*, with the dedication of the author
- A book by Christian Bobin
- Some CD of tango and one of The Cure
- Pen and notebook
- Favorite red lipstick
- Canon camera (not pictured)

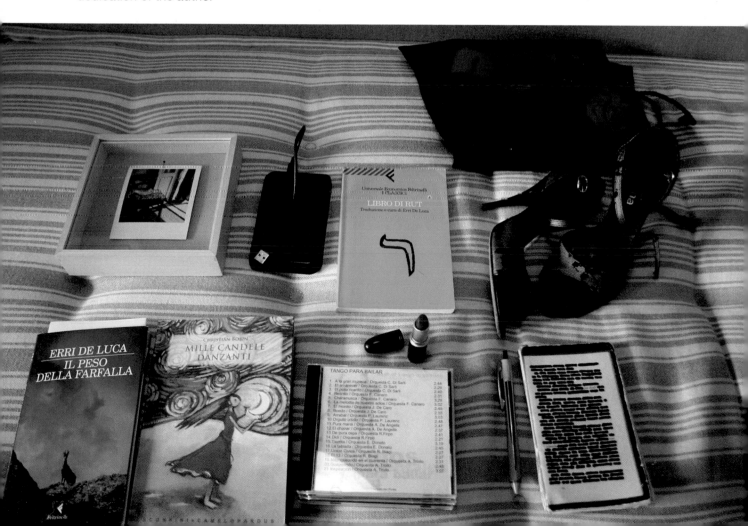

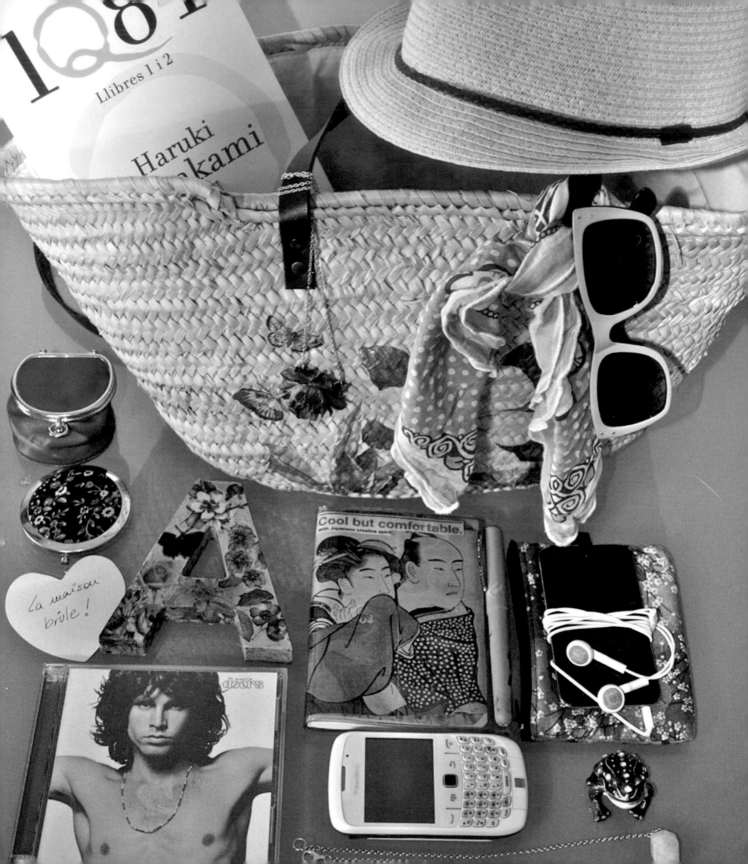

# ANNA MEIKO

AGE: 26
LOCATION: Barcelona, Spain
OCCUPATION: Biology Student

- Custom bag
- Borsalino hat
- Pink sunglasses
- Après-ski rose necklace
- *Petit carré* from Nice Things
- Haruki Murakami's *1Q84*
- Fuchsia coin holder
- Pocket mirror from Accessorize
- Homemade decoupage letter "A"
- Mark's customized agenda
- Jordi Labanda pen
- Japanese material case
- iPod Touch
- *The Best of the Doors* CD
- White BlackBerry
- Pink quartz necklace
- Little frog from Galicia

# RYAN TATAR

**AGE:** 32
**LOCATION:** San Francisco Bay area
**OCCUPATION:** Photographer
**WEBSITE:** www.ryantatar.com and www.shakasandsinglefins.com

- Filson bag containing original negative sheets and Polaroids
- iPad 2
- Journal/notebook—my notes on photography, places, expenses, and travels
- Polaroid SX–70 camera
- Nikon F Series 35mm camera
- Nikonos diving camera
- Slide film
- Strawfoot Handmade camera satchel
- Canteen
- Case knife
- Tanner wallet
- Ray-Bans
- Mechanical pencil
- Thomas Campbell original made in my presence
- Wife, cat, 9'6" Michel Junod single fin log surf board (not pictured)

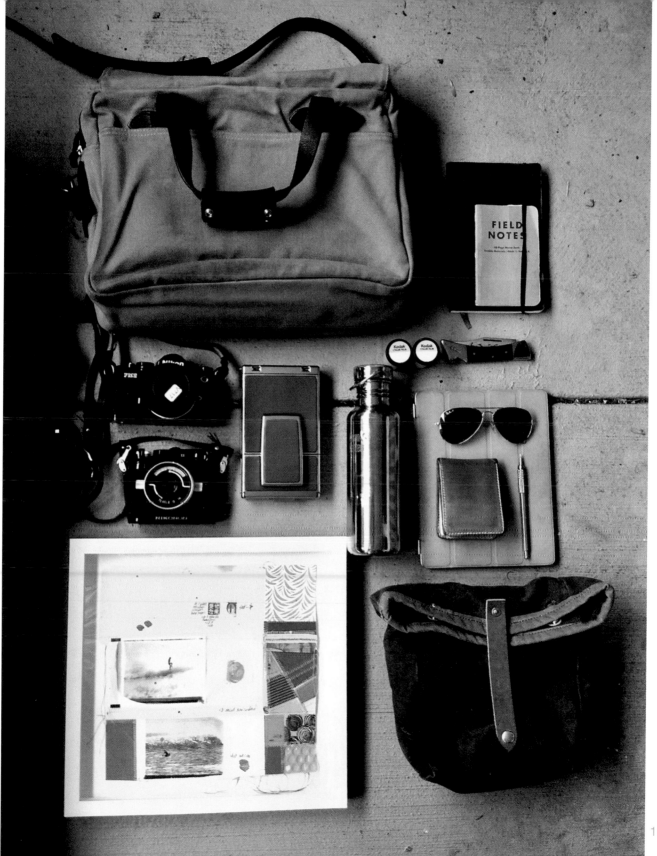

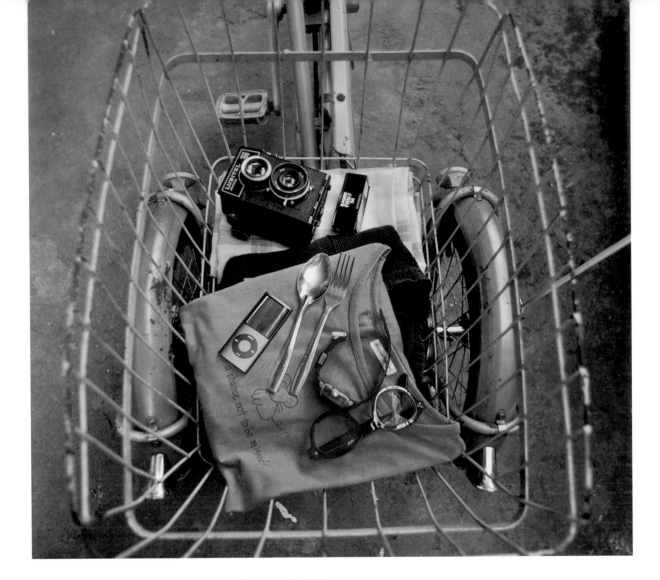

# YONGKI HERMAWAN

**AGE:** 30
**LOCATION:** Jakarta, Indonesia
**OCCUPATION:** Photographer
**WEBSITE:** mxtind.tumblr.com/

- Tricycle from the 1970s (Bridgestone Picnica )
- Lubitel 166 camera
- 120 film
- iPod
- Sarong for prayer
- Blue sweater
- Pink t-shirt
- Spoon and fork
- Casio Baby-G watch
- Vintage glasses
- ID (not pictured)
- Cell phone (not pictured)

# SAM STRAUSS-MALCOLM

**AGE:** 28
**LOCATION:** Crown Heights, Brooklyn, New York
**OCCUPATION:** Fashion designer
**WEBSITE:** www.strauss-malcolm.com

- Original painting by Francesco Longenecker
- Personally modified Kawasaki W650 motorcycle

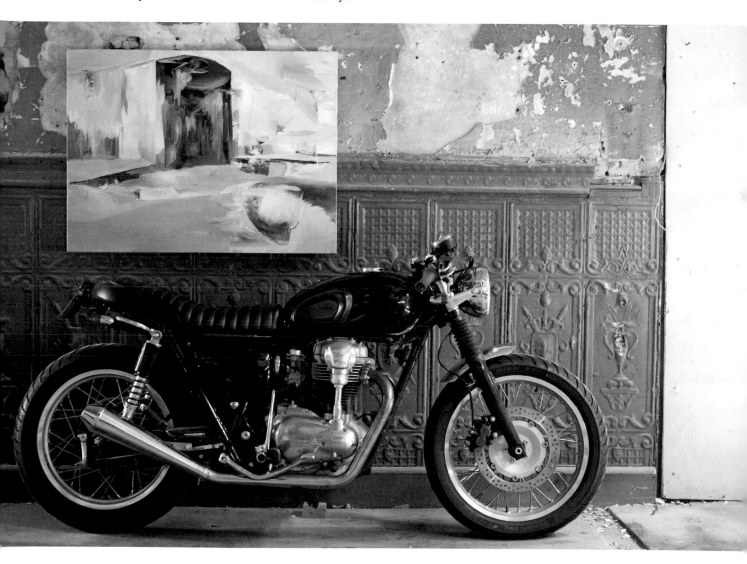

# BETHANY MARCIAL

AGE: 26
LOCATION: New York City, New York
OCCUPATION: Musician
WEBSITE: www.daughtersofgoodmen.com

- Martin guitar. This one is special because my dad bought it for me on Bleecker Street years ago when I first moved to New York. When most kids' parents were buying them textbooks, this meant much more.
- Vintage L.L. Bean wool hat
- Hard drive of all my photos
- Vintage Wrangler jeans
- Necklace of collected charms I always wear, including a gold chair and anchor, the state of Michigan, two pistols, and three vintage sterling knives
- My grandmother's ID bracelet from the 1930s
- A coffee-stained, dog-eared, underlined copy of G.K. Chesterton's *What's Wrong with the World*
- Turquoise squash-blossom necklace
- A knife and a tit-like crustacean given to me as a gift, which is usually housed in my exclusive tree-fort treasure box
- Minolta Maxxum 5 camera I bought when I was sixteen. It's un-fancy but never takes a bad picture.
- Vintage blue-striped blouse
- Worn-to-death lace-up Frye boots I've had for nearly ten years

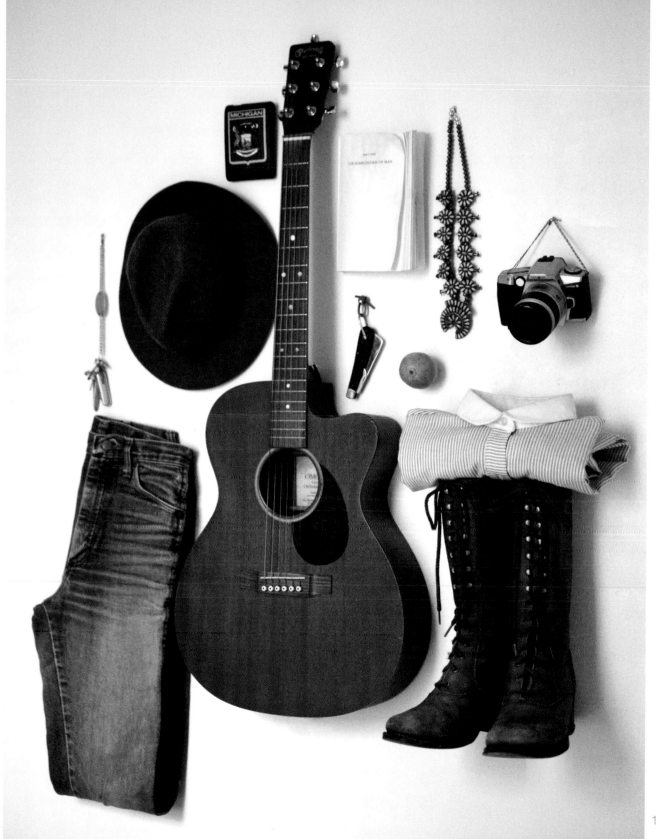

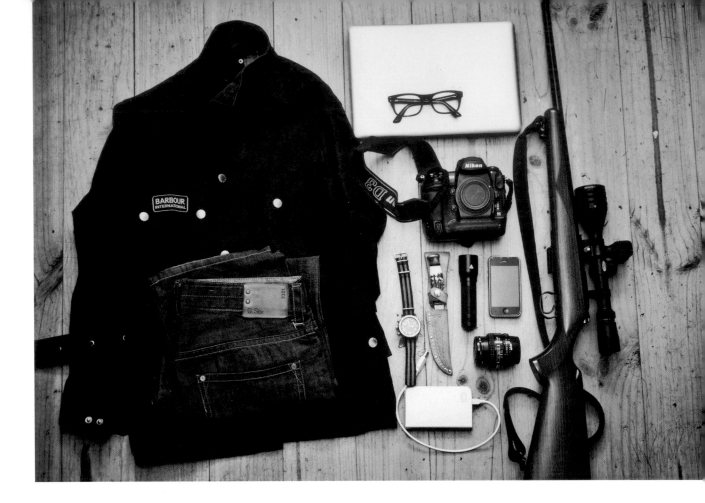

# ROHAN L. ANDERSON

**AGE:** 35
**LOCATION:** Ballarat, Australia
**OCCUPATION:** Photography and design
**WEBSITE:** www.wholelarderlove.com and www.rohananderson.com.au

- Nixon Chrono dive watch
- Japanese bone handle knife (had it for twenty-two years)
- LED Lenser torch
- iPhone
- Nikon 50mm f/1.4 lens
- 500GB Time Machine backup
- MacBook

- My glasses. I can't see without 'em, so I may as well grab 'em! (Yes, they have real lenses in them.)
- One of my Nikon cameras
- CZ 22 magnum. It's my favorite hunting tool.
- Barbour International jacket
- G-Star Raw jeans, circa 2004. Love these guys. I haven't bought G-Star since. I'm happy just to keep these as the best pair of jeans I've ever owned.

# JEFF WILLIAMS

**AGE:** 58
**LOCATION:** Portland, Oregon
**OCCUPATION:** Advertising

• Lockbox with something very special inside, something that fire can't be allowed to touch

# JEFF THROPE

**AGE:** 27
**LOCATION:** Clinton Hill, Brooklyn, New York
**OCCUPATION:** Consultant, writer
**WEBSITE:** www.coldsplinters.com

- Crazy Creek Adventure chair
- Cold Splinters / Fjällräven brass necklace made by Fort Standard
- Copy of *Desert Solitaire* by Ed Abbey
- MSR Pocket Rocket stove
- Collection of *Arizona Highways* magazines from the 1960s and 1970s
- L.L. Bean River Driver shirt
- American Park Network hat
- Picture of my girlfriend, Kalen, and I taken a couple of years ago by Daniel Arnold
- Europe 1972 Grateful Dead t-shirt
- Wallet with initials, made by Chris Adamiak

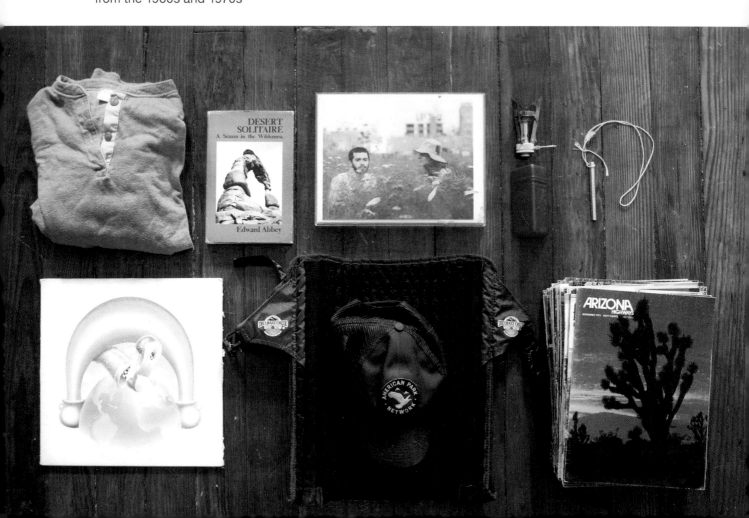

# LOÏC LE GOFF

**AGE:** 40
**LOCATION:** Paris, France
**OCCUPATION:** Modeler of dreams
**WEBSITE:** www.thepateamodeleur.com

*(in order of importance)*:

- My ass
- The one I love
- My pictures
- My drawings
- Computer

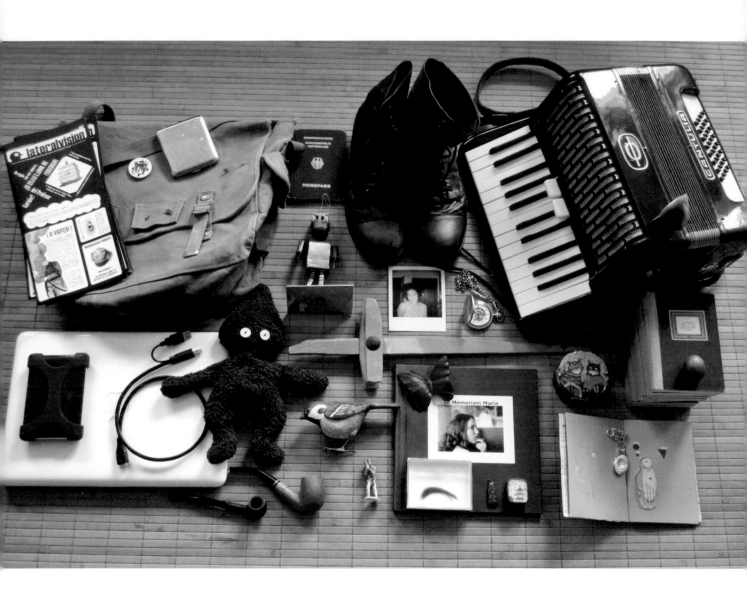

# PABLO LUKAS

AGE: 32
LOCATION: Valencia, Spain
OCCUPATION: Living

- First of all the cat, but he doesn't appear in the picture because he was eating
- The eight issues of *Lateralvision* magazine, edited by two friends and myself
- Favorite bag, inherited from my aunt
- My grandfather's cigarette case
- Passport
- Robot figurine, made by my uncle
- Favorite shoes
- Polaroid of my love
- My inseparable pocket watch
- Accordion
- On the accordion, the first thing my father bought in his life with his own money when he was a boy
- A stone
- Mac and external hard drive
- Flambo, the first puppet I ever had, made for me by one of my aunts when I was born
- Wooden sword my grandpa made for me when I was a kid
- Wooden bird made by me last year
- My grandfather's smoking pipe and my little smoking pipe
- Little "Super 8 filmmaker" figurine, varnished by my father when he was a child
- Butterfly hairpin
- Photograph book from my mother, and a little box with her hair
- A little green jade Buddha pendant my mother gave me
- My mother's Tiny Chinese music box
- Russian cat box I bought in a street market
- My writing books
- On top of them a rounded stone my grandpa gave me
- An illustrated book my love made when she was in France
- A silver pendant my love gave to me, with a tiny photograph of herself in it

# BRYAN T. BOWIE

**AGE:** 27 (feel 77)
**LOCATION:** Southeast Virginia
**OCCUPATION:** Designer, artist
(designer of The Burning House logo!)
**WEBSITE:** blog.tiptonandco.com

- Leatherman PST, their first model, and my first Leatherman, handed down
- Dad's Bollé sunglasses from early 1980s
- Grandfather's World War II leather photo pouch
- Final prototype of first/flagship Tipton & Co. wallet
- Parker 51 fountain pen
- Moleskine with dog tag and footprint from my best—and one of my oldest—friends, Buster (a Plott Hound). We had to put him down last year.
- One of my grandfather's smaller ink pieces
- Small portfolio stuffed with my own work and select negatives
- Small wooden box with things that have poured out of my head from the last two to three years, cards from parents, and miscellaneous things like that
- "The Thing," natural driftwood sculpture
- 3TB hard drive in Rosewill enclosure
- *The Yearling*, a first edition from my grandmother
- Grandfather's issued Navy watch cap and blanket
- Camera bag
- Nikon F3HP camera. It's hard to find one in good shape; otherwise I wouldn't care.
- Leica M3. I could let this go, honestly, but it's always in the camera bag so I included it.
- Weston Master V meter. If you find one, buy one. I've never had a better meter.
- Leica M6 camera and 40 Cron lens. I've had a camera in my hand since I was a teenager. The lens was a gift.

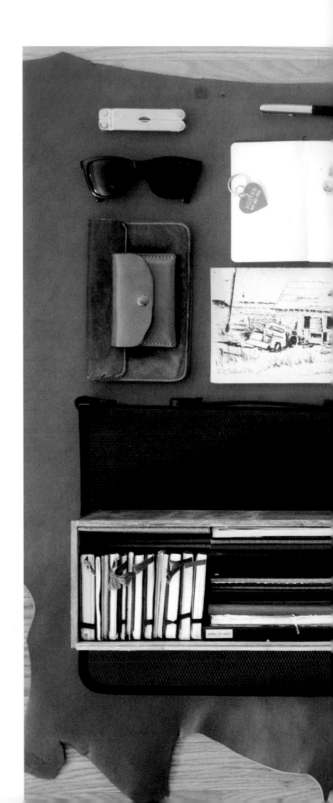

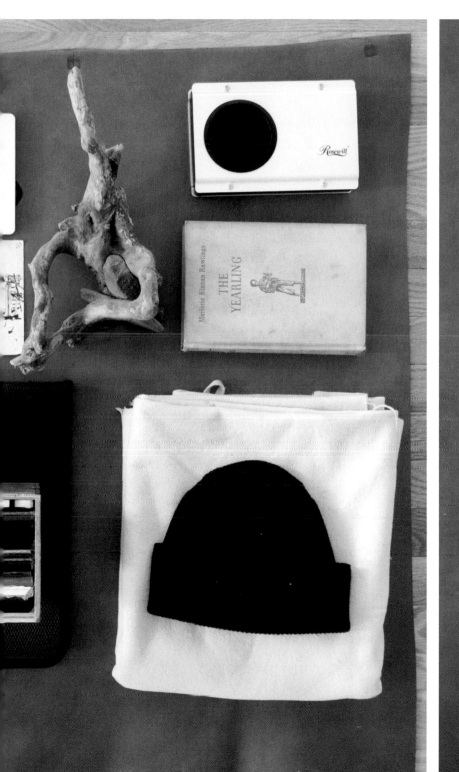
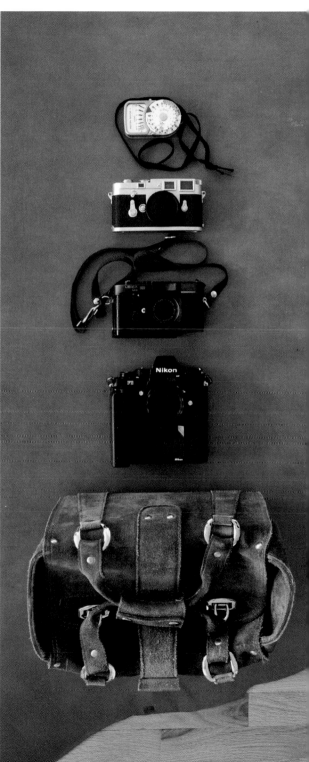

# FRIDA VEGA SALOMONSSON

**AGE:** Withheld
**LOCATION:** Stockholm, Sweden
**OCCUPATION:** Student
**WEBSITE:** www.vardagsbrus.com

- My bunny, Tingeling
- Konica Pop camera
- External hard drive
- MacBook
- Urbanears headphones
- iPhone

- Passport
- Favorite blouse
- The book I'm currently reading
- Picture of me with my brother, who was stillborn
- The camera I used to take this picture

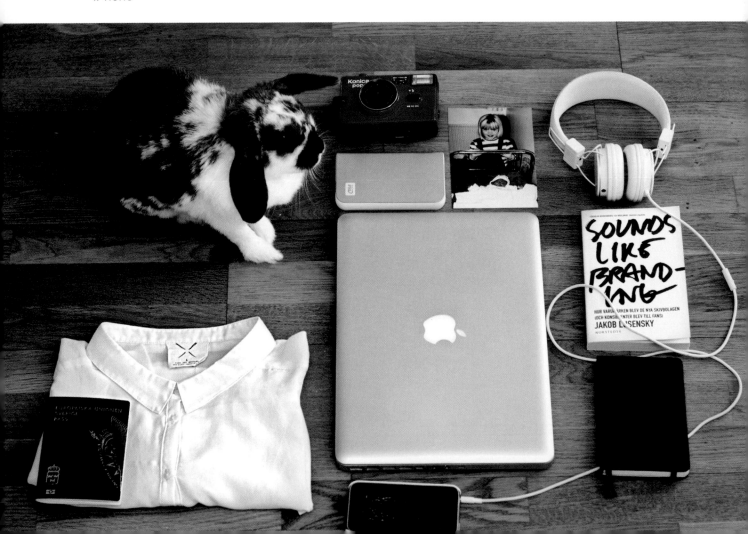

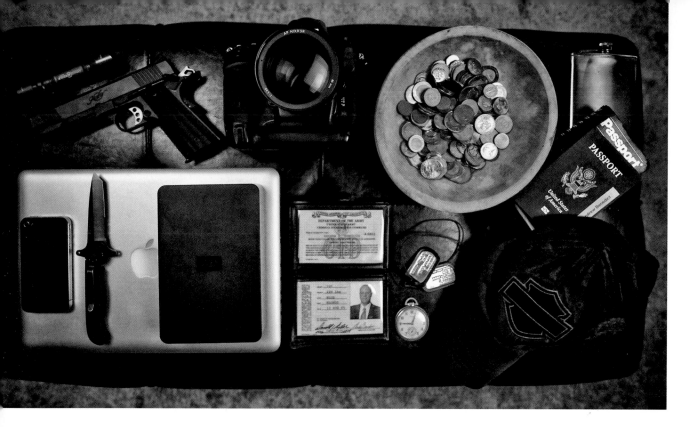

# ANDREW BENEDICT

**AGE:** 32
**LOCATION:** Alexandria, Virginia
**OCCUPATION:** U.S. Army soldier, part-time photographer
**WEBSITE:** www.framehousephotography.com

- Surefire flashlight. It's amazing what you can do when you can see through the darkness.
- Kimber .45 pistol. You'll want one, too, when the zombies arrive.
- Nikon D3 camera with 85mm 1.4 lens. It taught me to look at the world in a new light.
- Wooden bowl that has been handed down in my family. It's approximately a hundred years old.
- Coins from the more than thirty countries I've visited
- Flask with whisky. I'll need it if my house actually burns down.
- MacBook Pro (essential)
- iPhone 4 (more essential)
- U.S. passport and U.S. National Park Passport. I'm trying to visit all the U.S. national parks before I die.
- Hard drive with my photos and music
- Pocketknife that has accompanied me all over the world
- Badge and credentials for my job. Because getting new ones is a pain in the ass.
- Grandfather's pocket watch
- My army dog tags, to remind me where I've been and what I've seen
- Favorite hat. And I love my Harley-Davidson.

# DANIELLE GAGE

**AGE:** 29
**LOCATION:** Pending, soon Switzerland via USA
**OCCUPATION:** Storyteller

- My house was burning once. It kept on burning until the top of my house met the smoky earth.

  I didn't take anything.

  It made taking long trips with small bags possible and easy.

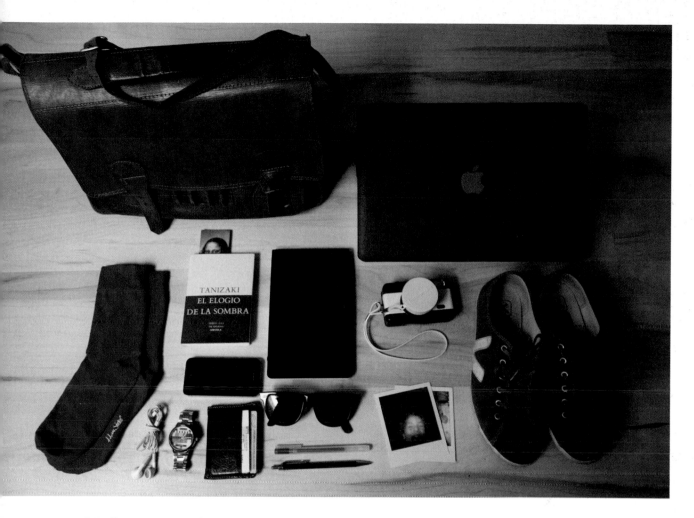

# MIGUEL A.

**AGE:** 23
**LOCATION:** Barcelona, Spain
**OCCUPATION:** Architecture student
**WEBSITE:** miguelangelaguilo.tumblr.com

- iPhone
- MacBook
- Red socks
- Leather sneakers
- Moleskine notebook and two pens
- Xena watch

- Wayfarer sunglasses
- My old bag
- *El elogio de la sombra* book
- Lomo Fisheye camera
- Polaroid photographs of my family

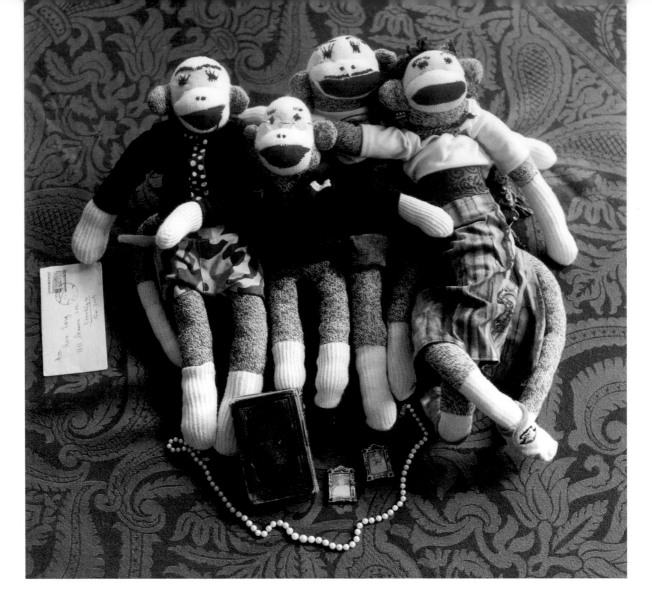

# LAURA EWIG GARNIER

**AGE:** 59
**LOCATION:** Portland, Oregon
**OCCUPATION:** Artist

- Sock monkeys I made for my family as a holiday gift
- My mother's pearls
- A book in Hebrew from the old country
- Tiny photos in beautiful little frames
- My favorite blanket, given to me years ago by my husband
- A letter in Polish written by my paternal grandmother

# LOGAN CYRUS

**AGE:** 28
**LOCATION:** United States
**OCCUPATION:** Student, photographer
**WEBSITE:** www.logancyrus.com

- Hard drive
- Ideas
- Keys
- Coffee mug
- Wristwatch
- Dad
- Wallet

- Phone
- Bible
- Second photo of Dad
- Boots
- Flag
- My military discharge papers

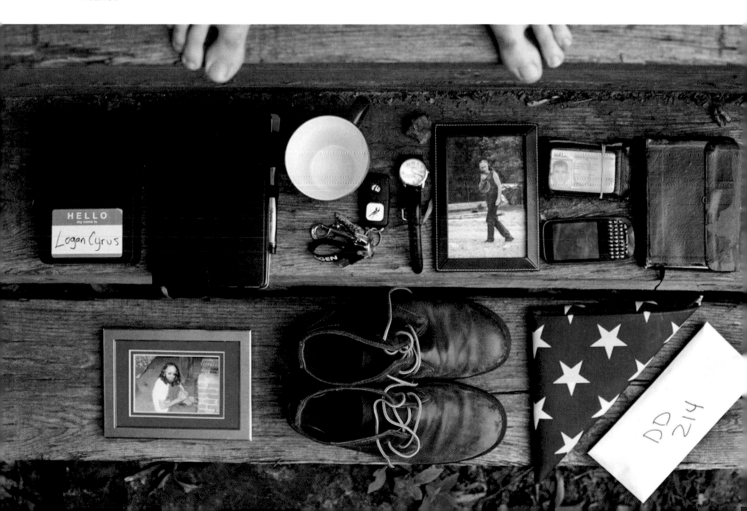

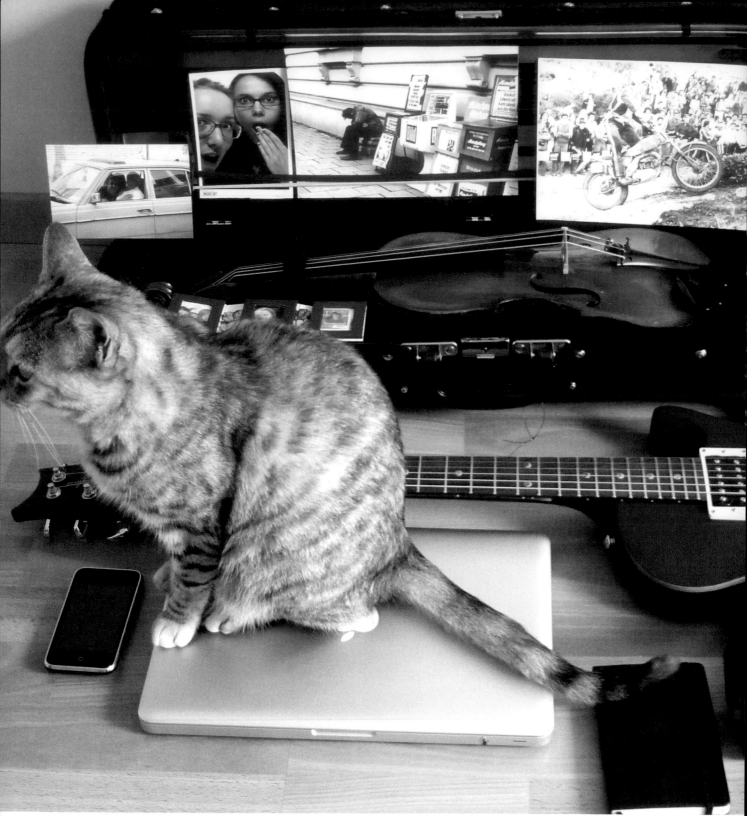

# MARGOT KOHL

**AGE:** 18
**LOCATION:** Rennes, France
**OCCUPATION:** Student
**WEBSITE:** traveleatandwearyourclothes.tumblr.com

- Violin
- MacBook
- iPhone
- Pictures of my friends
- Picture I took in Albania (*left*)
- Pictures my dad took when he was younger (*right*)
- Moleskine
- Guitar
- Polaroid
- My cat
- Two rings

# MELIA MARDEN AND FRANK SISTI, JR.

**AGE:** 30s
**LOCATION:** New York City, New York
**OCCUPATION:** Chef and filmmaker

- Plastic bottle-cap collection
- Childhood elephant toy
- Favorite frying pan
- Favorite "Have a Heart" pin from our pinback collection
- Gound photo of screaming child on Santa's lap
- Vintage hand-printed "Animal Band" wallpaper from the 1930s
- Frankie's broken and "resewn" discontinued red glasses
- "Stuff" painting

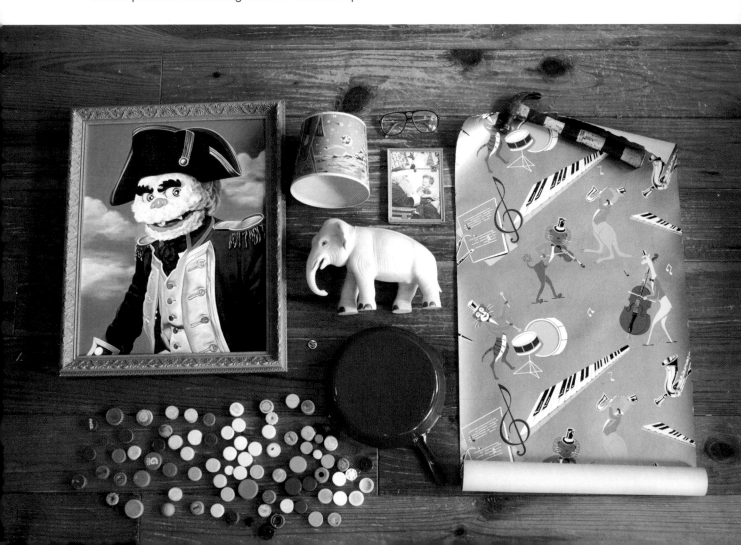

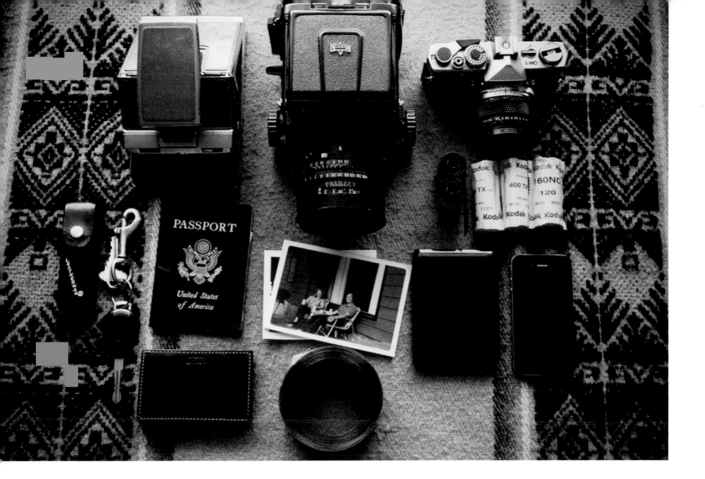

# ALAN HUNTER

**AGE:** 25
**LOCATION:** Seattle, Washington
**OCCUPATION:** Photographer
**WEBSITE:** www.ahunterphoto.com and blog.ahunterphoto.com

Assuming family, friends, and dogs are already out safely:

- Olympus OM–1 camera (originally my dad's, and the first camera I ever used)
- Mamiya RB67 camera (workhorse)
- Polaroid SX–70 camera. With these three cameras, who needs anything else?
- Whatever film I can grab
- Mom's vintage alpaca poncho
- Family photos
- Negative boxes, represented here by a few rolls
- Hard drive
- Passport
- Normal pocket contents: keys, wallet, phone, and multi-tool
- Backpack to carry everything in (not pictured)
- Sleeping bag for living in my car (not pictured)
- Rain jacket. It is Washington after all. (not pictured)
- Change of clothes (not pictured)

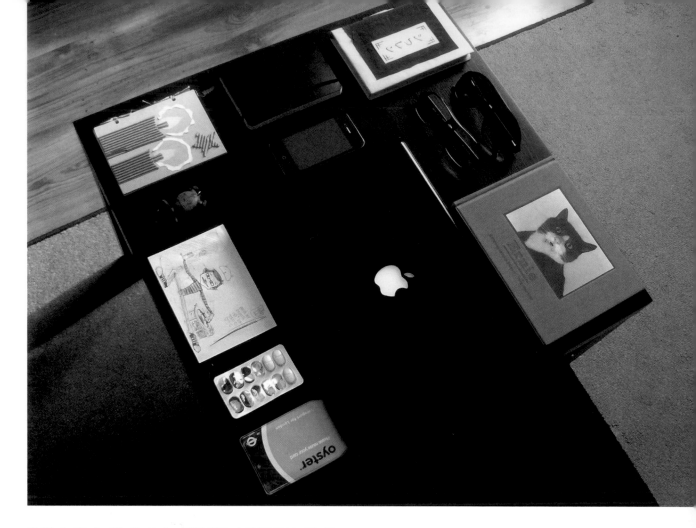

# ISAIAS MACHIAVELLI

**AGE:** 26
**LOCATION:** Madrid, Spain
**OCCUPATION:** Journalist, photographer
**WEBSITE:** isaiasmachiavelli.blogspot.com

- My first photo serial
- Glasses and sunglasses
- *Ernie* book, bought at the Tate Modern. It reminds me of my life in London.
- Agenda
- Phone
- Laptop
- Christmas present made by one of my best friends
- Ringaey doll. I bought two of them, one for myself and another for my ex-boyfriend when we were together.
- A caricature of myself made by my cousin
- Some aspirin
- Wallet. It originally held my Oyster card.

# RAFAEL EIFLER BARBOSA

**AGE:** 17
**LOCATION:** Porto Alegre, Brazil
**OCCUPATION:** Student
**WEBSITE:** www.flickr.com/photos/rafael_barbosa

- Taylor guitar
- iPod
- iPad
- Phone
- Holga camera
- Moleskine
- Beats headphones
- Vans shoes
- The Nikon that took the picture

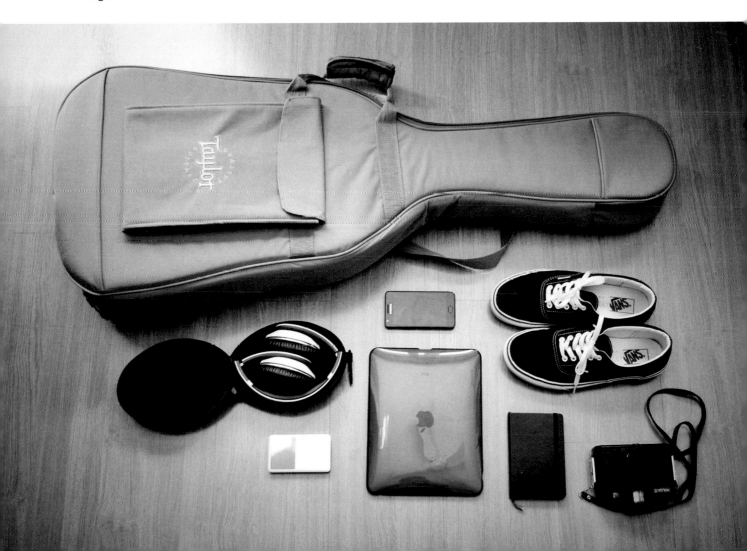

# ERIC HEINS

**AGE:** 24
**LOCATION:** Boston, Massachusetts
**OCCUPATION:** Leathersmith
**WEBSITE:** www.corterleather.com

- Purebred Canadian Sphynx cats, Gilby and Finn (not pictured). Really the only priority in an emergency.
- Childhood blanket
- First couple of wallets I made
- Product sketch journals from the last few years
- Current written journal. The old ones can burn— I throw them out when full anyway.
- Passport
- Keys, but I'm not really sure I'd need them afterward.

# STEPHANIE HUNTINGTON

**AGE 50**
**LOCATION:** Underwood, Washington
**OCCUPATION:** Jill of all trades

- Glasses
- Round rocks from Missouri River canoe trip
- Pottery from son
- Wallet with ID and pertinent details
- Bamboo basket to carry all my possessions
- Two pans to cook with

- "The Captain" flashlight
- Favorite red and white striped shirt
- Mushrooming knife
- Favorite box filled with letters from my family
- Opal necklace from loved one
- Colorful Mexican blanket

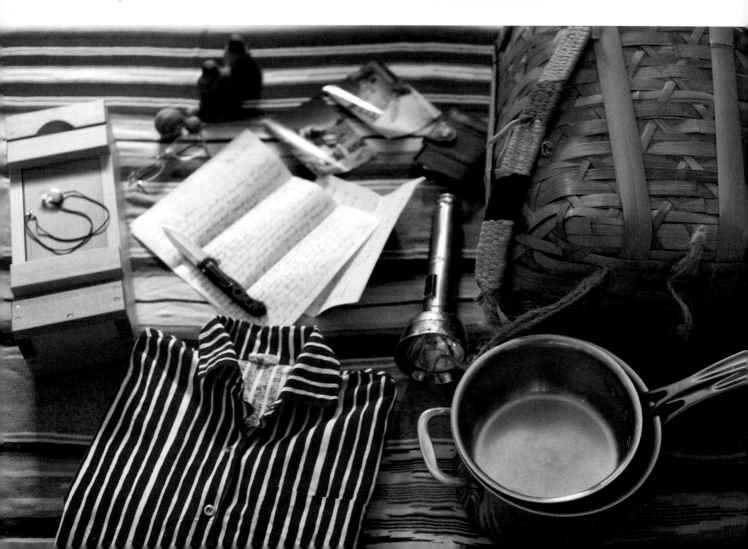

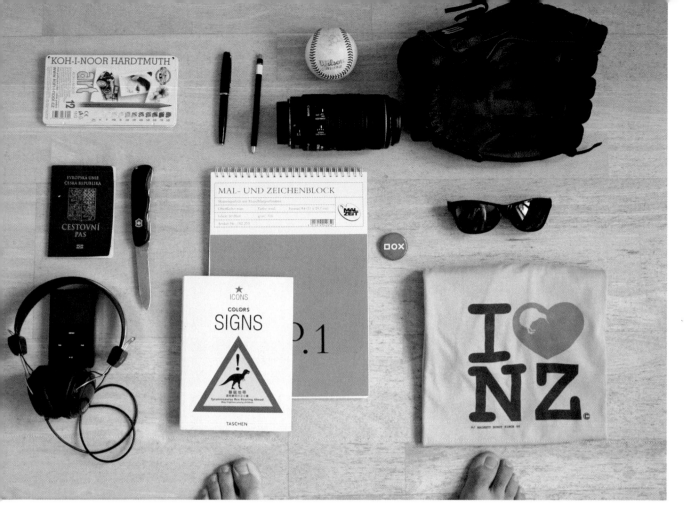

# ALEŠ MORAVEC

**AGE:** 20
**LOCATION:** Prague, Czech Republic
**OCCUPATION:** Student of architecture and design

- Baseball glove and ball
- Oakley Jupiter sunglasses
- Favorite t-shirt from New Zealand
- "DOX" button from the DOX Centre for Contemporary Art in Prague
- My grandmother's pen from 1902
- Sketchpad with case of pencils
- Knife
- Passport
- iPod Classic with WeSC headphones
- Canon EOS 500D camera with Tamron 17–50mm lens (not pictured)
- Canon 70–300mm lens
- Book about signs given to me by my design teacher from New Zealand

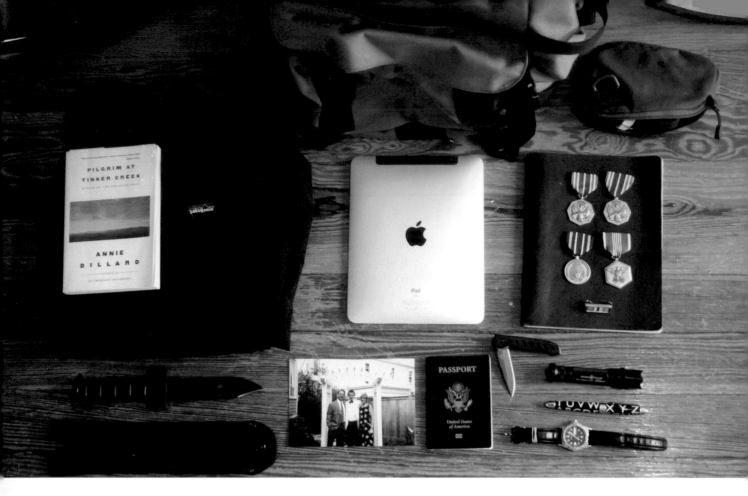

# BRIAN THOMAS

**AGE:** 28
**LOCATION:** Chicago, Illinois
**OCCUPATION:** Copywriter
**WEBSITE:** www.thewordfurnace.com

- KHS Pursuit track bike
- Seagull custom backpack
- Bike repair tools and pouch
- *Pilgrim at Tinker Creek* by Annie Dillard
- Patagonia Torrentshell jacket
- iPad
- Army medals from my time in the service
- Moleskine sketchbook
- Pocketknife
- Surefire E2D Defender flashlight
- Acme pen
- Wegner watch (it just won't die)
- Passport
- My last photo of my parents together
- My army combat knife, with flint and whetstone in sheath pocket

# MEGAN WILSON

**AGE:** Post Kennedy, pre–Man on the Moon
**LOCATION:** Manhattan, New York City, New York
**OCCUPATION:** Proprietress of ancient industries
**WEBSITE:** www.ancientindustries.com

- Henry Lamb, my cat
  (post Princess Di, pre-Bush)
- Portrait of Henry Lamb, by my boyfriend,
  Duncan Hannah

- Pajamas
- Espadrilles

# MARION MARTY

AGE: 23
LOCATION: Paris, France
OCCUPATION: Student
WEBSITE: yamok.blogspot.com

- Framed Shreddies cereal box and framed picture of a dog and a nurse, to make me smile when I'm sad
- Chocolate. I need magnesium.
- Tea cupboard and my thermos, to keep hydrated
- My "You're so lovely" card (and the boy who gave it to me)
- Jean Guy Poulet (my Mac)
- *Froth on the Daydream*, to read and re-read
- Y-A-M-O-K letters, to motivate me
- Melodica, to play my sadness over seeing my house burn (not pictured)

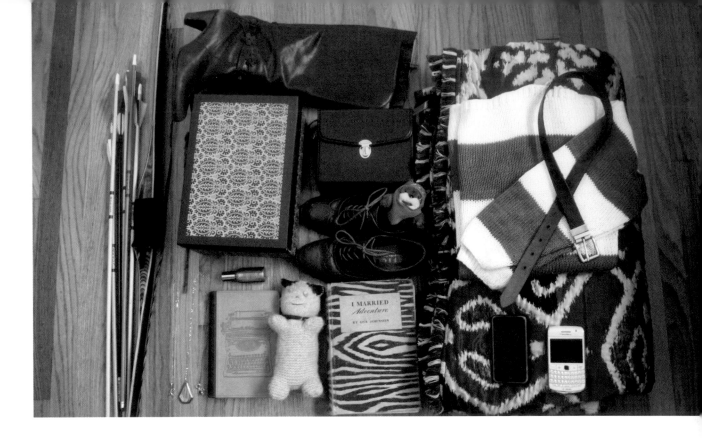

# KERI DAWN

**AGE:** 19
**LOCATION:** Los Angeles, California
**OCCUPATION:** Product development student at the Fashion Institute of Design and Merchandising
**WEBSITE:** velourspamplemousse.blogspot.com

- People first (not pictured), and my two cats, Pickles and Rocket
- Office Frank Sinatra brogues
- Beautiful boots
- Ewok named Nom, a gift from my boyfriend
- First edition of my favorite book, *I Married Adventure*
- Perfume from Fragonard Perfumery in the south of France (the perfect scent)
- Kitten, which was my mum's when she was little
- Wand from when I was little (to remind me not to lose my childlike wonder)
- Custom-made longbow and arrows
- Three necklaces, including the blue butterfly wing one. They were all gifts from brother, mum, and nanny.
- Box of pictures
- Dad's old binocular case, which makes the best purse
- Silk *ikat* quilt handmade in India
- Sweater my mum knit when pregnant with me
- Mum's vintage belt, which goes with everything
- Kindle
- iPod Touch
- BlackBerry Bold
- The Canon Rebel XS I used to take the picture

# LAURA MILLWARD

**AGE:** 28
**LOCATION:** Nottingham, England, UK
**OCCUPATION:** Creative designer
**WEBSITE:** makedo-and-mend.blogspot.com

- Photo-booth pictures of my parents in the 1970s
- My favorite Polaroids
- Frank doll, made for me by Tom
- "What I Did Today" traveling journal, filled in by amazing people from around the world
- My mum's sketchbooks and diaries
- My travel sketchbook
- A letter from Tom and a handmade book
- My fisheye camera
- Passport
- Phone to call for help (not pictured)
- Glasses to find my way outside (not pictured)

# TRUDY HUNTINGTON

AGE: 85
LOCATION: Kennett Square, Pennsylvania, or Kendal-at-Longwood, Pennsylvania
OCCUPATION: Retired anthropologist

- A tray from Turkey's Süleymaniye period in the 16th century
- An insect necklace bought by my aunt in Paris in the 1920s
- Collection of protest buttons: against nuclear weapons, nuclear testing, the Vietnam War, and the draft. Not included here are contemporary protest buttons against wars in Iraq and Afghanistan.
- Two of my grandmother's birthday spoons, given to her each year by the woman after whom she was named (the mother of the founders of Armstrong Linoleum)
- A Cuna Indian doll from the San Blas Islands, given to me by women who had never seen a young (prepubescent) white girl
- A doll my mother made me because I had brought no toys with me when we were accompanying my father on a zoological collecting trip in Chiriqui
- A photograph my son took of me and my husband
- A photograph of me and my daughter when we were living with the Hutterites in Alberta
- Squash-blossom necklace an Indian friend sold us when he needed money to fix his car. His wife said the necklace looked better on me than it did on her.
- A painted ivory belt I got in Isfahan, Iran
- A sloth carved out of a palm nut that reminded me of the pet baby sloth I had as a child
- A book I wrote on the Michigan Amish
- Silver knife and spoon bought in Baghdad in 1949
- Hindustani pin brought to me from Pakistan by my parents

# HECTOR CORTES

AGE: 22
LOCATION: Guadalajara, México
OCCUPATION: Student, photographer
WEBSITE: www.flickr.com/dark_tom

- *Caja fuerte con recuerdos* (Strongbox with memories)
- Sketchbook
- *Pañuelo* (Scarf)
- *Cargador para* Mac (Mac charger)
- *Cable para* iPod (iPod cable)
- *Mochila* Golla (Golla backpack)
- *Disco duro* (Hard drive)
- MacBook Pro 13"
- iPod Nano
- *Celular* (Cell phone)
- *Llaves* (Keys)
- *Audífonos* PIIQ (PIIQ headphones)
- *Llaves para la caja fuerte* (Strongbox keys)
- *Pluma, lápiz, y portaminas* (Pen, pencil, and mechanical pencil)
- *Cartera* (Wallet)
- *Navaja* Victorinox (Victorinox scanner)
- *Estuche para cámara* Golla *con* Nikon D40X *y equipo* (Golla camera bag with Nikon D40X and equipment)

# GLENN SILBER

**AGE:** 61
**LOCATION:** Verona, New Jersey
**OCCUPATION:** TV newsmagazine producer, documentary director

- Several family photo albums
- My father's Rolex Oyster watch, which he bought in Switzerland while on vacation with my mother in 1960
- Nikon camera
- Laptop
- Our loving little dog, Lani

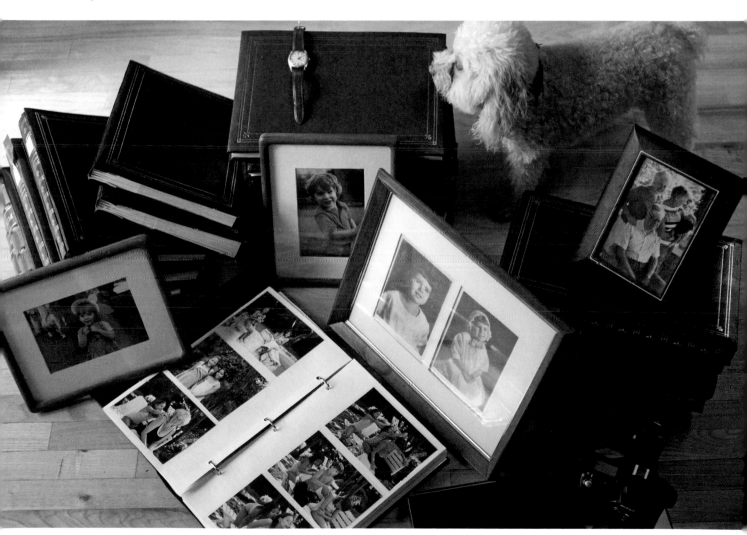

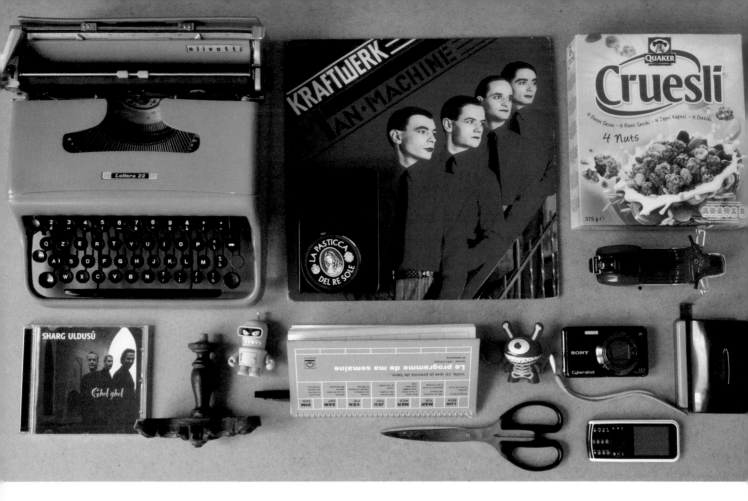

# STEFANO MENEGHETTI

**AGE:** 47
**LOCATION:** Treviso, Italy
**OCCUPATION:** Creative director
**WEBSITE:** www.comeonline.it

- Olivetti Lettera 22 typewriter
- Kraftwerk's *The Man-Machine* LP
- Moleskine
- La Pasticca del Re Sole candy
- Quaker Cruesli cereal
- Model Vespa 200PX
- Sharg Uldusù CD
- Old hanger

- Kidrobot figurine of *Futurama*'s Bender
- Mark's ink
- Another Kidrobot figurine
- Sony DSC-W290 digital camera
- Padded two-hole hole puncher
- Scissors
- MOMODESIGN phone

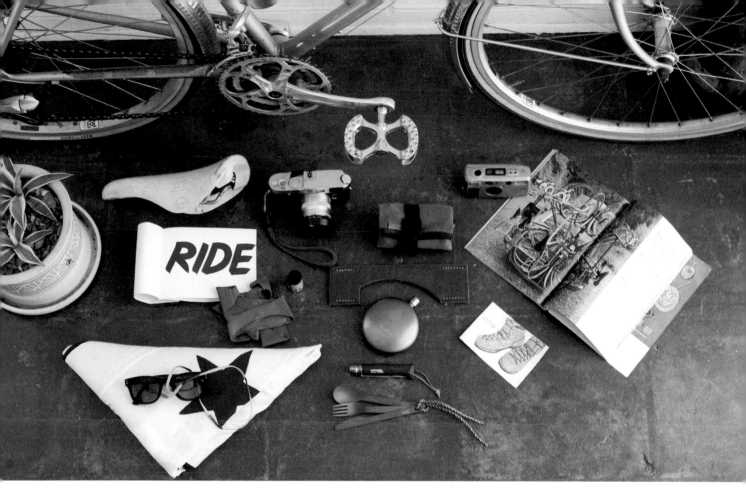

# KYLE KELLEY

**AGE:** 29
**LOCATION:** Los Angeles, California
**OCCUPATION:** Bike shop

- Rivendell Saluki bicycle with front Rasta skewer
- Agave plant
- Concor America saddle
- *Let's Go Ride Bikes* by Cari Carmean
- CCP gloves
- California flag
- Sunglasses
- Leica M7 camera
- Exposed film

- Ramblin' Roll
- FLOCKone u-lock holster
- Flask
- Opinel No. 08 knife
- Eating utensils
- Sony Cybershot DSC-T5
- *National Geographic* magazine
  (Bike Boom Issue)

# FERNANDO MARTIN CALERO

**AGE:** 31
**LOCATION:** Córdoba, Argentina
**OCCUPATION:** Administrativo

- *Mis cámaras*: Pentax K1000 *y un* Pentax ME *mas lentes* (My cameras: Pentax K1000 and a slower Pentax ME)
- *Posillo con el regalo de la chica mas linda* (Mug with a gift from the most beautiful girl)
- *Brújula que me regalo mi abuelo* (Compass that my grandfather gifted me)
- *Cortadora de pelo* Remington *de mi viejo* (My grandfather's Remington hair trimmer)
- *Uno de mis libros preferídos*, Forastero en Tierra Extraña *de* Robert Heinlein. (One of my favorite books, *Stranger in a Strange Land* by Robert Heinlein)
- *Lentes para leer subtítulos de películas y anime* (Glasses to see the subtitles of movies and anime)
- *Dinero* (Money)
- *Cortaplumas* Victorinox (Victorinox penknife)
- MP3 *algo anticuado* (A somewhat dated MP3 player)
- *Celular* Nokia 1100, *el mejor de todos* (Nokia 1100 cell phone, the best of all)
- *Película color* 200 ASA (200 ASA color film)
- *Billetera con tarjetas de crédito, documento y un recuerdo muy especial.* (Wallet with credit cards, ID, and a very special memento)
- *Cigarrillos y encendedor* Mini BIC (Cigarettes and Mini BIC lighter)
- *Alfombra* (Carpet)

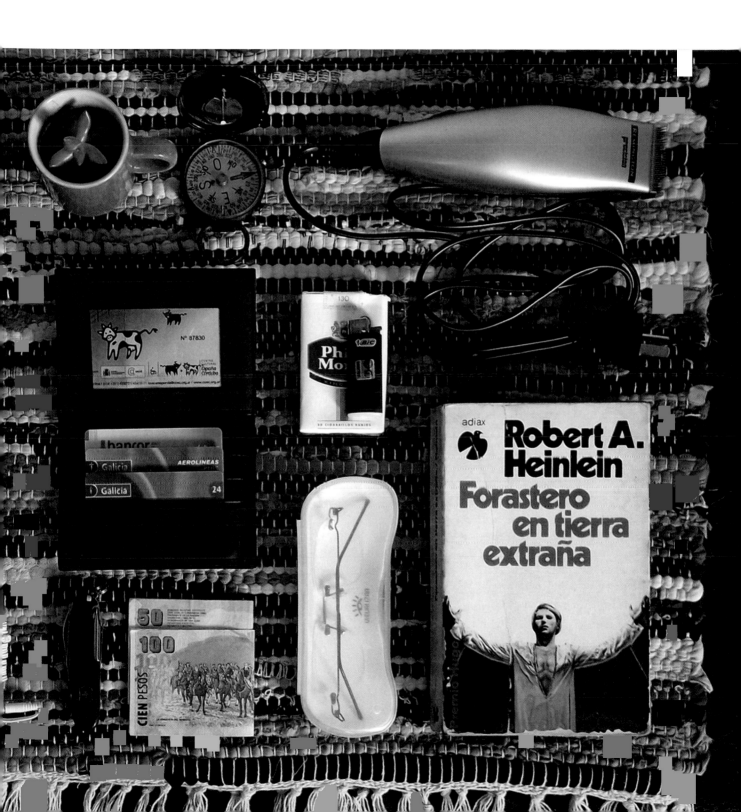

# PATRICK O'CONNOR

AGE: 72
LOCATION: Modified Ford E350 4x4
 for the last ten years
OCCUPATION: Retired land surveyor

- Backpack with tent, sleeping bag, sleeping pad,
  change of clothes, and water filter

# MATS HAGE EIKEMO

**AGE:** 25
**LOCATION:** Torino, Italy
**OCCUPATION:** Student
**WEBSITE:** www.matshageeikemo.com and www.flickr.com/photos/matshageeikemo/5751320644/

- Tivoli PAL radio
- Lubitel medium-format camera
  I got from my girlfriend
- Leatherman
- Some rolls of 120 film
- Wallet
- Phone
- Hard drive with a backup of everything
  on my computer
- Passport
- Moleskine journals
- Pen and pencil
- Calendar my girlfriend made
- Messenger bag to carry it all

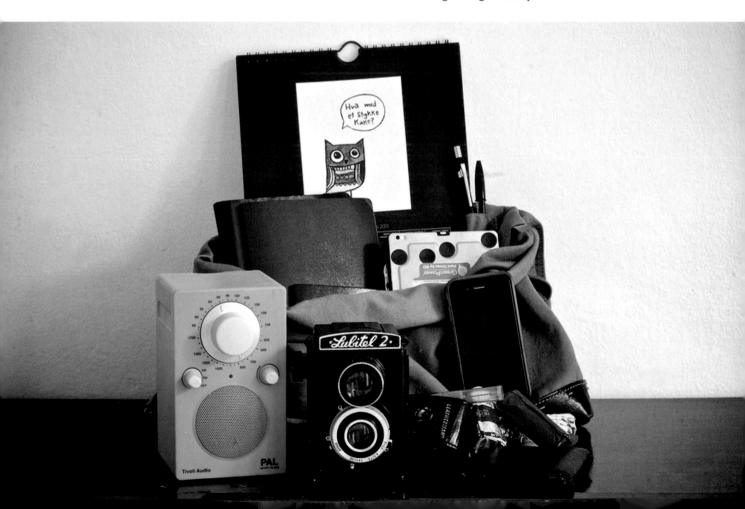

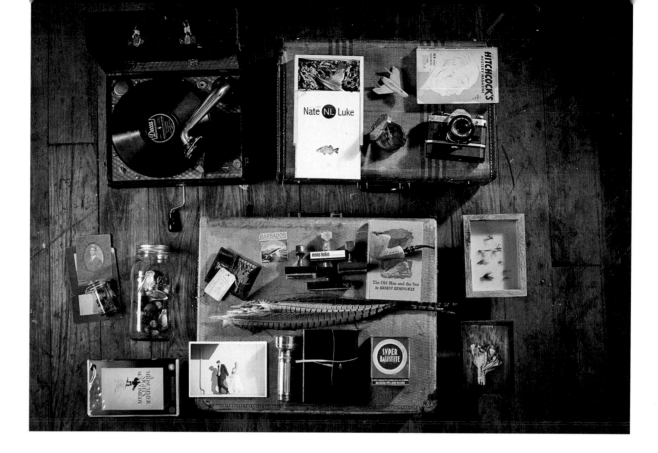

# NATE LUKE

**AGE:** 36
**LOCATION:** Springfield, Missouri
**OCCUPATION:** Advertising photographer
**WEBSITE:** www.nateluke.com

- Portable phonograph I used to court my wife
- Promo box I used to grow my photography business
- Toy planes
- Old Hitchcock magazines
- First camera given to me by my dad
- Nautical compass
- Thai red-pepper seeds
- Jar of items collected from travels
- Some old keys
- Luggage
- Some rubber stamps
- Favorite Erik Nording pipe
- Favorite book, *The Old Man and the Sea*
- Shadow box of old dry flies
- Pheasant feathers from birds my dog has pointed
- Favorite movie, *A Midsummer Night's Sex Comedy*
- Wedding photo with my wife
- Flashlight
- A book of a hundred handwritten things my wife likes about me
- Can of gun powder from Grandfather
- Some photos of food from the CSA farm

# DAVID DING

AGE: 27
LOCATION: Dublin, Ireland
OCCUPATION: Postgraduate student
WEBSITE: www.davidding.com

• Without trying to sound like an obnoxiously idealistic hippie, I don't think I'd take anything. Or at least not anything specific—I might just grab whatever is closest to me at the time.

Next month, I will move for the sixth time in five years. With every move, I become more detached from physical possessions. They inevitably become just extra weight to lug around.

My first move was to the other side of the planet. When I made the move, the airline(s) allowed me to check only twenty kilograms of luggage and carry on another ten kilograms. I packed what I could—and that was that. I choose not to send over any additional belongings of mine, nor have any sent over at a later stage. Having managed to survive quite easily and comfortably for a sustained period of time, it was readily apparent to me that nothing I'd left behind was in any way essential to my life. Subsequent moves only compounded this line of thought.

As such, when I returned to my childhood home after being away for three and a half years (Move #4), I donated or dumped just about everything that had remained in my absence. This thinking has continued to inform the way I feel about the things I possess: most practical items I own can be easily replaced. I don't own (and tend to avoid purchasing) items of significant monetary value—certainly nothing worth delaying an escape from a burning house for.

Of course, I'm as prone to sentimentality and nostalgia as anyone. Had I been asked this question fifteen or twenty years ago, I might have had a substantial list of things I couldn't bear to part with. But technology now allows me to cater to these feelings without having to hoard *stuff*. These days, everything can be photographed or scanned or digitized in some other way—and then stored online securely. All my old tokens and letters and photos could go up in flames, but their memories (and my memories of them) would be preserved forever.

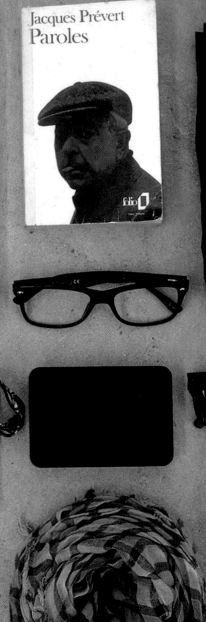

Jacques Prévert
Paroles

folio

COMET S
CMF

iPad

iPhone

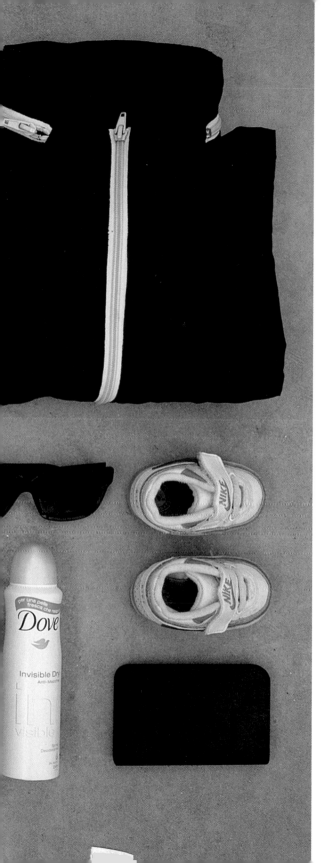

# ALESSANDRO MAZZERO AND CHIARA MORO

**AGE:** 27 and 22
**LOCATION:** Between the mountains and the sea, Italy
**OCCUPATION:** Graphic designer and visual-art employer
**WEBSITE:** www.flickr.com/photos/alessandromazzero
 and chiaramoro.wordpress.com

- His MacBook Pro. (He says "Super Pro.")
- Her iPad
- His iPhone
- Her old camera collection. She couldn't really carry off all of these in the case of a fire.
- His wallet with cash and credit cards
- Her French book, Jacques Prévert's *Paroles*, found in a crazy Venetian antiquarian book store
- His glasses, to be so cool
- Her portable hard drive, full of pictures
- His foulard scarf, ever to be so cool
- Her sunglasses, used by both even when it's not sunny
- His K-Way jacket, found in a spaghetti takeout box
- Shoe one: her gorgeous seven-year-old niece
- His Dove Original deodorant spray
- Shoe two: her smiling four-year-old nephew
- His portable hard drive (his life, in other words)
- Her Nikon D5000 camera (not pictured)

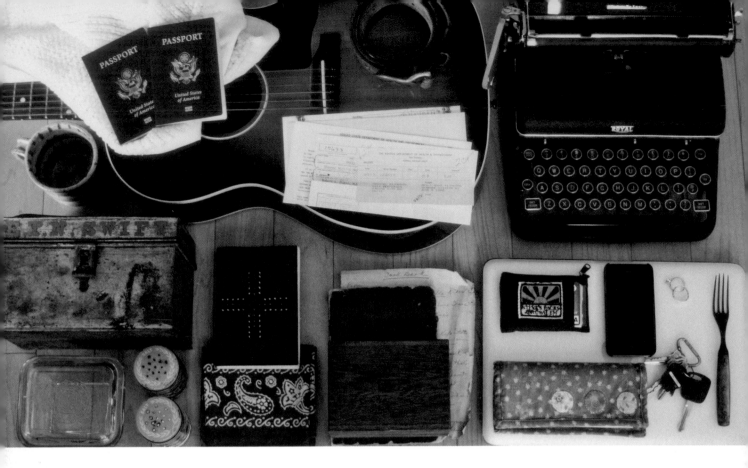

# EMILY LOERKE

**AGE:** 30
**LOCATION:** Dallas, Texas
**OCCUPATION:** Blogger, writer, clergy
**WEBSITE:** www.todaysletters.com

- Childhood woobie blanket (for cape wearing and fort building)
- Favorite coffee mug
- Passports
- My mom's 1962 Gibson guitar
- Favorite thrifted belt
- Birth certificates and marriage license
- 1941 Royal Quite DeLuxe portable typewriter, a gift from dear friends
- MacBook and iPhone
- Wallet, checkbook, keys
- Antique bone fork, a gift from my dad
- My grandmother's oak recipe box and recipe book
- Leather journal. My husband and I have been writing letters to each other in it for the past five years.
- My mom's 1960s blue bandana
- Favorite thrifted salt-and-pepper shakers that remind me of my twin sister
- Vintage Fire King dish, a gift from my mom
- Antique E.T.N. Swift box filled with cash we've been saving for our twenty-fifth wedding anniversary
- The Canon 40D used to take this photo

# JOU-YIE CHOU

AGE: 29
LOCATION: Cobble Hill, Brooklyn, New York
OCCUPATION: Cultural engineer at Ace Hotel

- Box of matches from Jeffrey's Grocery
- Keycard to a room at Ace Hotel NYC
- Rite in Rain water-resistant notebook
- Blue Sharpie
- Black Unibal
- Old Arizona Grayhawk cap
- FM 21–76 field manual issued by the army in October 1970
- Air plant named Bob
- iPhone

- Shun chef's knife
- Old Bay seasoning
- Vintage Vasque hiking boots
- Brown leather monogrammed card holder by Janelle Sing, with some cash, ID, Metrocard, and other plastics
- 2007 Mike Southern "Cat and Mouse" etching, one of two hundred made
- The "Cloud" (not pictured)
- Backdrop: Pendleton for Levi's jacquard blanket

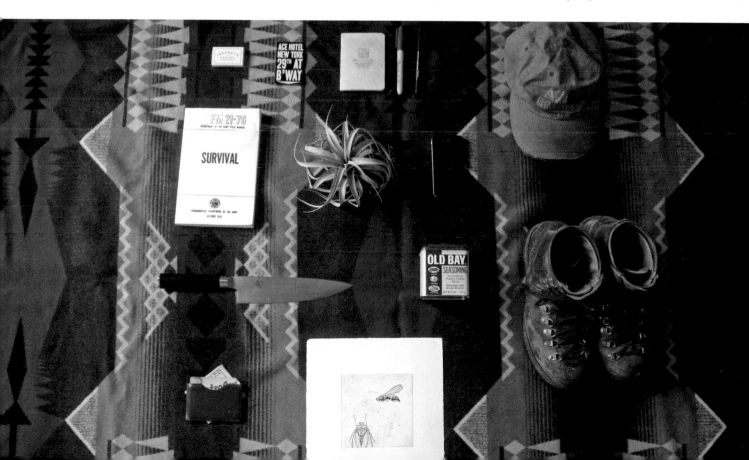

# KIM JANNI SANNA

**AGE:** 22
**LOCATION:** Halmstad, Sweden
**OCCUPATION:** Slacker or something
**WEBSITE:** diaryandherself.blogspot.com

- Striped skirt
- A great movie on DVD
- *The History of Love* by Nicole Krauss
- Photographs
- Tickets from travels and concerts

- My cat and best friend, Isis
- Festival bracelets
- Favorite shoes
- Mumford & Sons tote bag

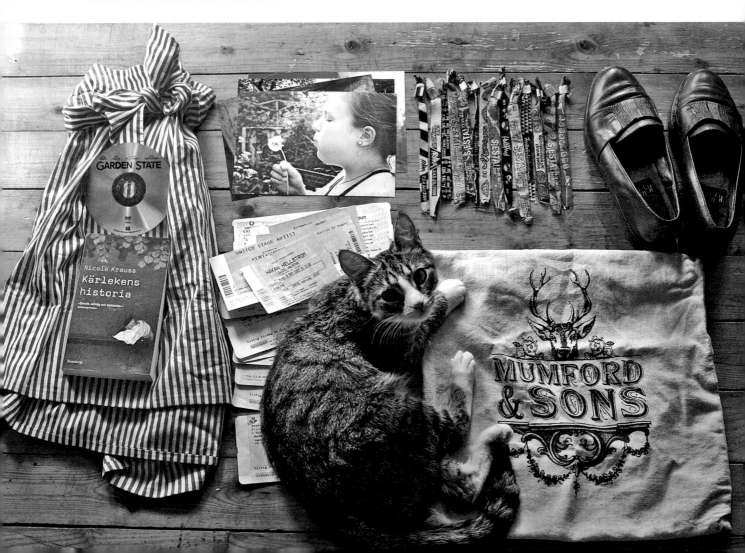

# CLAIRE

**AGE:** 24
**LOCATION:** Louisiana
**OCCUPATION:** Barista
**WEBSITE:** carolynmax.tumblr.com

• Just my daughter, Maddie, and maybe my phone

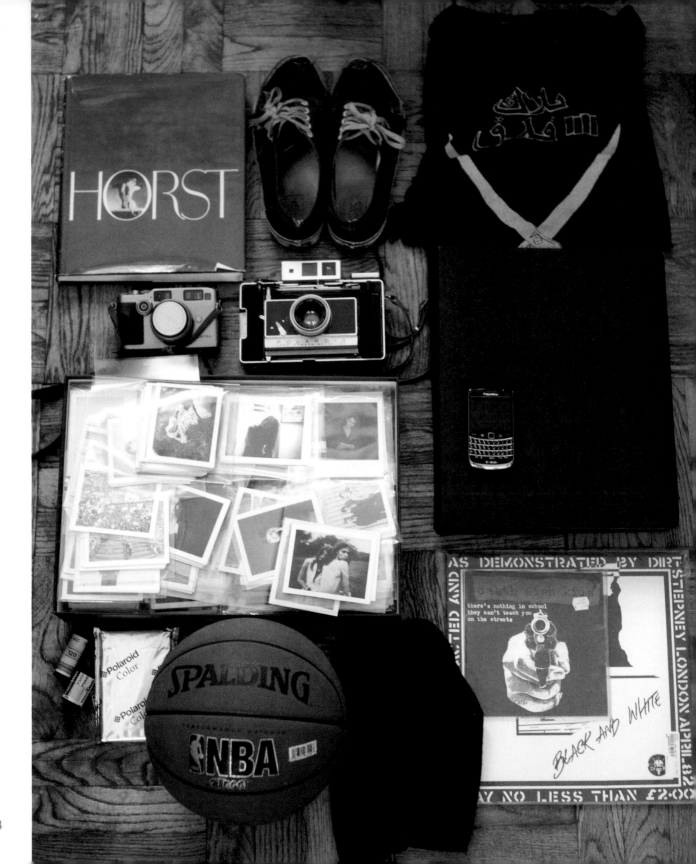

# JIMMY FONTAINE

**AGE:** 31
**LOCATION:** New York City, New York
**OCCUPATION:** Photographer

- Horst P. Horst photo book
- Vans Authentics shoes
- Brendan Donnelly Black Flag shirt
- Contax G2 camera
- Polaroid Land camera
- Portfolio
- BlackBerry
- Shot Polaroids
- Two of my favorite records from the Death Wish Kids and Dirt
- Black hat
- Basketball
- Some film and Polaroids

# DIRK GONZALES

**AGE:** 55
**LOCATION:** San Francisco, California
**OCCUPATION:** Banker, experience architect

- Box of cufflinks
- iPad
- Painting reminiscent of my father, circa 1947
- Cash
- High-resolution camera
- Notebook
- Ohto fine-point pen
- Juice multi-tool
- Ibuprofen
- Bronze mouse sculpture, "Squeekie"
- iPhone
- Portable rugged hard drive

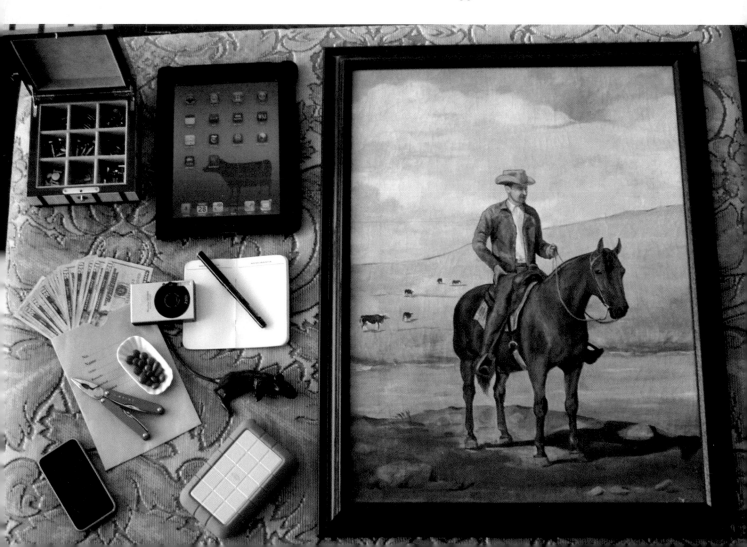

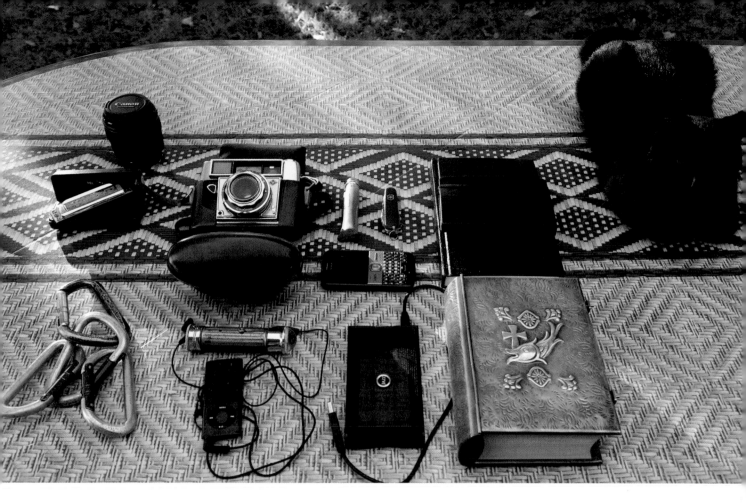

# GIAMPIERO

**AGE:** 42
**LOCATION:** Rome, Italy
**OCCUPATION:** Computer programmer

- My two children (not pictured)
- Carabiners from when I was a mountain climber
- Hohner blues harp
- Canon 85mm 1.8 lens (not pictured: other photo gear I'd take)
- Agfa Optima 500S from my German grandfather
- Victorinox knife
- Opinel No. 9 knife
- Cell phone
- *Carnets de voyage* (travel books)
- Vintage metal flashlight (from my German grandfather)
- MP3 player
- Hard disk with vital files, including all my digital pictures
- Holy Bible of Jerusalem
- My cat

# KASIA LISIAK

AGE: 26
LOCATION: Wrocław, Poland
OCCUPATION: Designer, photographer
WEBSITE: www.haveasign.pl

I strongly believe that it would be an extremely slow fire:

- Umbrella
- Current Nikon camera and a Zenit, my first analog camera
- Diaries and letters from my life
- A little suitcase full of treasures (witnesses of my past adventures and relations)
- Box of pencils from my boyfriend's grandfather
- Favorite jacket and a bag to pack up all my things
- Bottle of gin to reassure me during the fire. The same goes for box of cigarettes and matches.
- My most comfortable shoes
- Beloved necklace
- Passport made by me when I was ten
- Picture of my brother Bartek (framed), my father (on the beach), and me as a child
- Book from my childhood: *Ferdynand Wspaniały* (*Ferdinand the Magnificent*)
- Special diary
- Book from an old friend
- Earrings in the shape of foxes, made by my best friend for my birthday. My surname means something like "foxy lady."
- Wallet, a gift from my boyfriend
- Glasses from my boyfriend, and important rings
- The simplest (and greatest) version of a Casio watch (my mother used to wear the same) from Santa Claus
- A piece of the cosmos from my beloved on my twenty-fifth birthday

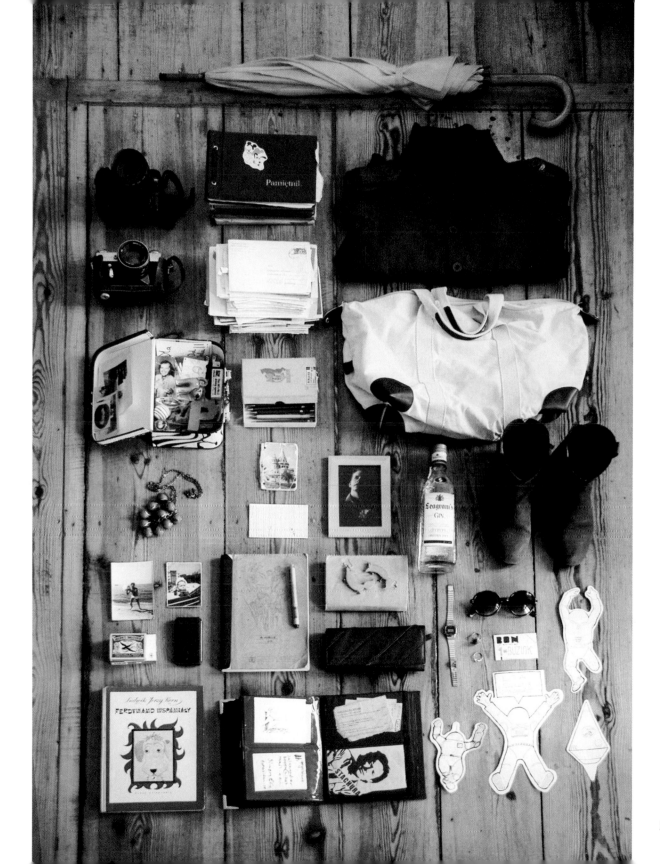

# LIL' YUSSEF

**AGE:** 15 months
**LOCATION:** Setif, Algeria
**OCCUPATION:** Baby

- Mini Converse sneakers
- Sponge Bob bag
- Baby phone
- Hair brush
- Nipple
- Milk bottle
- Teddy bear
- Baby diapers

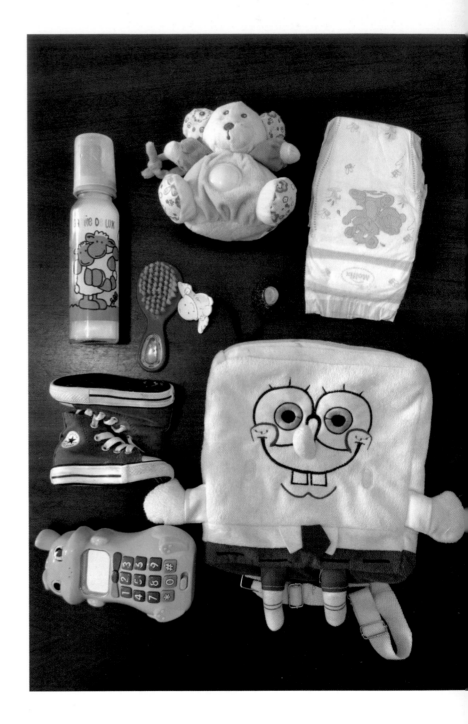

# SHAWNA ERNST

**AGE:** 30
**LOCATION:** Spokane, Washington
**OCCUPATION:** Geographic-information-systems analyst

- Copy of *Peter Pan* that my dad gave me when I was seven and we lived in Italy
- Favorite picture of my darling son
- Lucky bamboo that I've somehow managed to keep alive for four years
- Scarf that my son gave to me for my birthday
- The only hat that has ever fit my gargantuan skull
- A pebble-pot my son made
- My Olympus PEN lens (lens cap pictured here)
- A 1940s forget-me-not bracelet
- Stone pendant
- A piece of the Earth's mantle
- Ceramic bunny that lives in a pink ceramic apple
- Not pictured are: my fiancé Clinton, my son Noah, and Felix our kitten (he's camera shy), and, if possible, I'd have a feat of strength and push my grandmother's upright piano right out the door

# CORY GROVE

AGE: 36
LOCATION: Portland, Oregon
OCCUPATION: Small-business owner

- Ship drawing. I am obsessed with all things nautical. Not by choice—it is in my blood. I was born on the coast, and my family has a long history on the docks. That stays with you. My really good friend Desire made this for me. She is a beautiful human and I love it. I need to get it framed.

- Field notes. I most likely have really important shit in there that I need. My good friend and graphic designer Aaron Draplin makes these. I use these on the regular, and I would grab my entire collection if I had time.

- Captain statue. My grandpa built the house I live in now, and it has been here as long as I can remember.

- Minolta 35mm. My grandpa's old camera. I still shoot with it from time to time. It's built like a tank, and I miss that in pretty much everything made these days.

- Lumix GF2 camera. This is what I use on the regular. I'm not in love with it, but I know it and use it all the time.

- 8mm movie camera. My grandpa carried this with him during World War II. He stormed the beaches of Omaha and was the nicest, kindest person I ever met. I have run a roll of film through it and it turned out great. I need to do that again.

- Coffee mug. I have a big collection, so I would grab what I could.

- Journal. This was sent back and forth from Portland to France with someone I love dearly. It has lots of great content and has seen some miles.

- Hatchet. A good friend gave this to me for my birthday. I love it, and the customization she did to it is amazing.

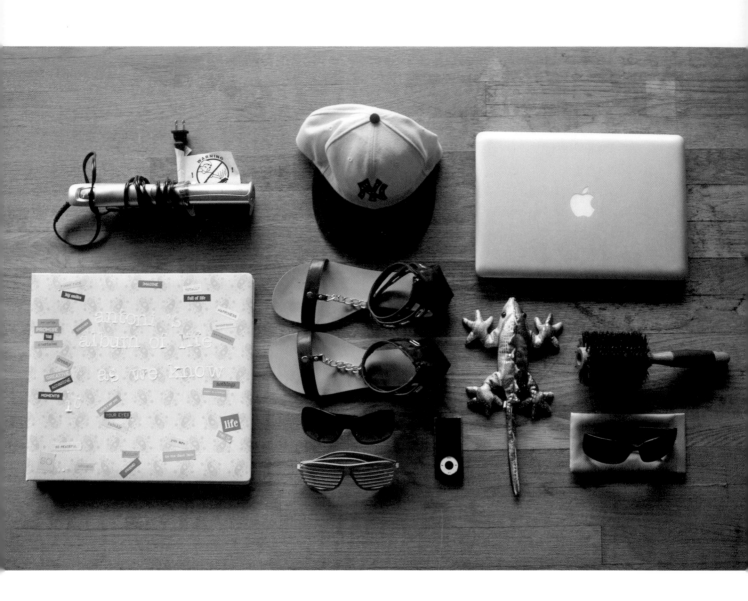

# ANTONIA BLANCHETT

AGE: 10
LOCATION: Briarcliff Manor, New York
OCCUPATION: Student

- Yankees Memorial Day playing hat. I love wearing and showing it to people, so not having it around would be just plain different.
- My handy-dandy hair brush. I literally bring that brush with me everywhere. It's sort of like a good-luck charm.
- MacBook Pro. I cannot live without my MacBook. It has all of my things on it.
- My scrapbook, which I've titled *Antonia's Album of Life as We Know It*. I spent so long trying to make it look perfect. Plus, it has most of my memories of friends and family in it.
- Colorful metallic lizard ("Burt the 5th"). Burt is like a special artifact of my life and friendships.
- Kanye West pink, orange, and yellow glasses. I got those for my tenth birthday, and it was one of the best birthday presents I ever got.
- Lady Gaga–style glasses with indented flowers on the side. I got them from my best friend, and I would never even think of losing them.
- Black sunglasses from Paris with tiny pink and black checkerboard
- Spikes. I got them on my favorite vacation, and I'm trying to keep them in perfect condition.
- Sliver InStyler hair straightener. It is the best straightener I have ever used. Plus, my friend gave it to me as a gift.
- Sandals from Paris with brown leather and a chain. Having them is almost like having a souvenir from my favorite vacation.

# ERICK ELLIOTT

**AGE:** 22
**LOCATION:** Brooklyn, New York
**OCCUPATION:** Musician, designer, music hoarder
**WEBSITE:** www.erickarcelliott.com and www.theloveinus.com

- Michael Jackson's *Thriller* and *Moonwalker* on VHS
- OBEY GIANT handkerchief
- Precious memento-ish pictures of my family: dad, brothers, uncle, etc.
- Isaac Hayes's *Shaft* on vinyl
- Curtis Mayfield's *Superfly* on vinyl
- Photo of my cat Morris, who passed away
- Roland Juno–106 synthesizer, circa 1984
- Yamaha DX7 synthesizer, circa 1983
- Axiom 49 keyboard, circa whenever I started making music
- Native Instruments Maschine instrument, circa two months ago

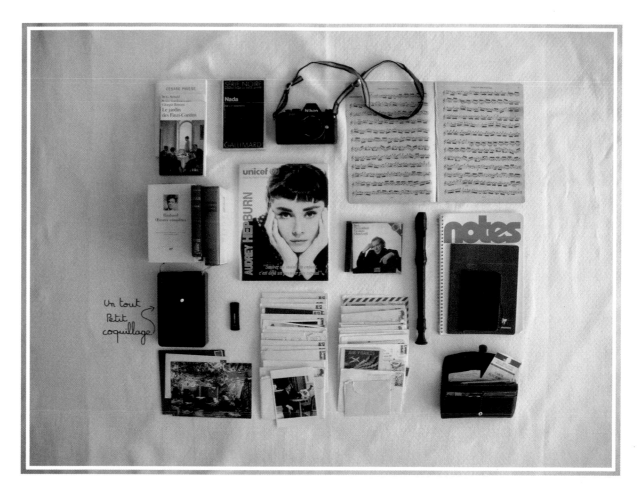

# JEAN-MICHEL VIGO

AGE: 49
LOCATION: Nice, France
OCCUPATION: Civil servant

- Three special pocket books
- Three volumes from the *Bibliothèque de la Pléiade* series: Rimbaud, Shakespeare, and Dostoyevsky
- *Essais de Montaigne*, Volume 3 (1935 edition)
- *Nada*, a noir by Jean-Patrick Manchette
- Audrey's album
- Sheet music of Johann Sebastian Bach's Violin Concerto, BWV 1041
- *Goldberg Variations* by Glenn Gould (1981 recording)
- Recorder
- Letters and postcards I've received
- My Moleskine and diaries
- PC backup
- A very small seashell
- USB flash drive for work
- My second Nikon. The first is broken.
- Wallet with ID, voter registration card, driver's license, etc.
- The carpet

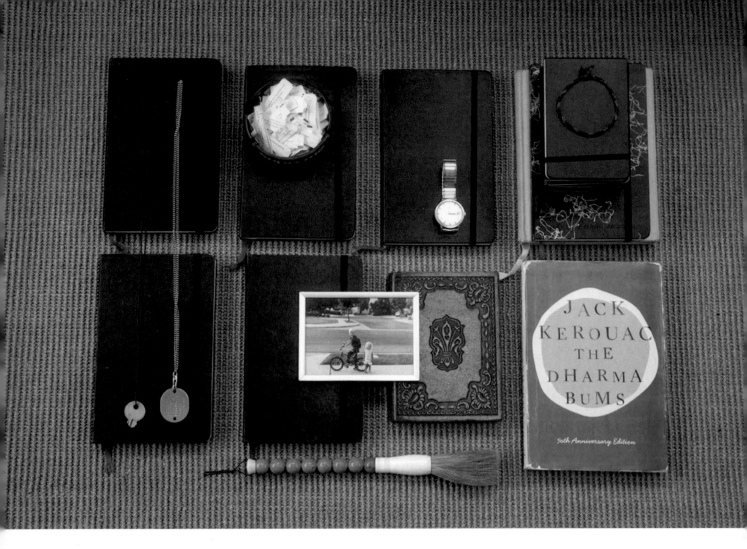

# TY MOONEY

**AGE:** 26
**LOCATION:** Orange County, California
**OCCUPATION:** Designer, student
**WEBSITE:** www.tyandtess.com

- Journals from the ages of twenty-one through twenty-six, chronicling my life in New York
- Key necklace
- Grandfather's World War II dog tag
- Fortunes collected from the Chinese place in front of my old apartment
- Grandfather's Bucherer watch
- Woven bracelet found on 23rd Street
- Picture of me and my sister on my first day of kindergarten
- Jack Kerouac's *The Dharma Bums*, my favorite book of all time
- Paintbrush from a trip to China

# WES DOWNING

**AGE:** 24
**LOCATION:** Newport, Rhode Island
**OCCUPATION:** Business owner
**WEBSITE:** www.breakwatersurfcompany.com

- University of Connecticut hat
- External hard drive
- Blanket that was a gift from girlfriend
- Surfboard I got in Australia
- Collection of koozies from my travels since 2008 (nineteen total)
- Picture of grandfather
- Ticket stubs from Phish shows and sporting events
- First bottle of batch beer I brewed
- Swiss Army knife
- Knife made from deer antler that I've had since I was eight

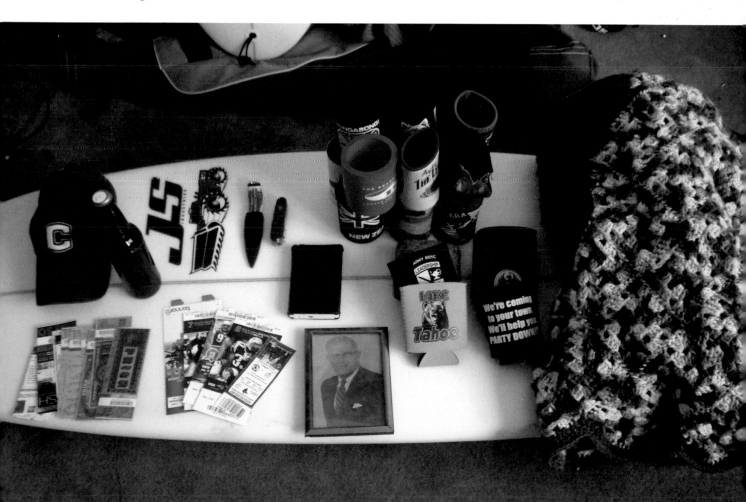

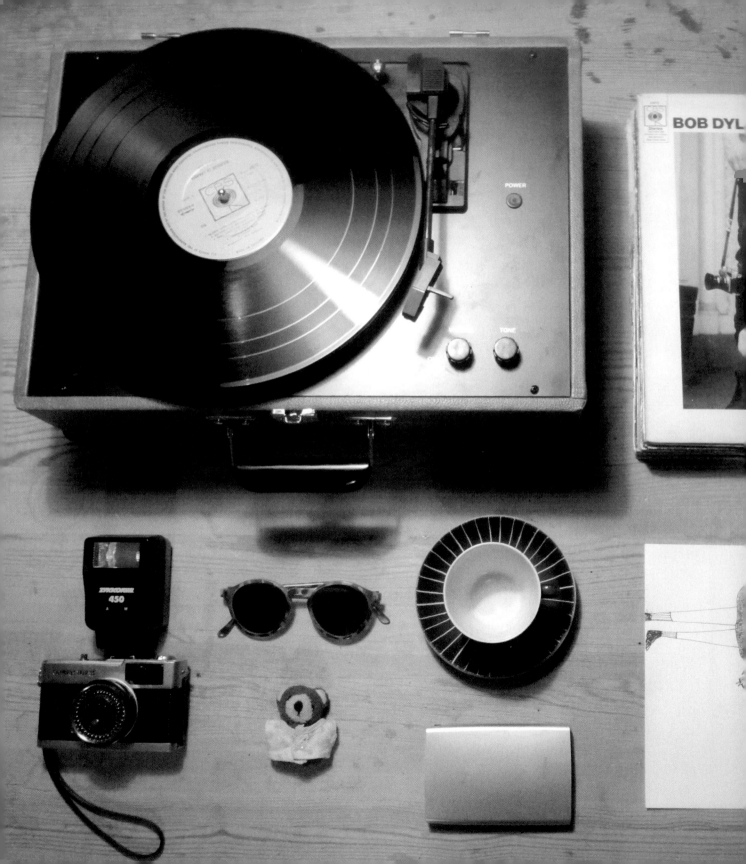

# JOHANNA NYBERG

**AGE:** 19
**LOCATION:** Uppsala, Sweden
**OCCUPATION:** Art student
**WEBSITE:** johannaochjennifer.webblogg.se

- Turntable
- Mom's vinyl records
- Camera
- My grandmother's glasses
- Favorite cup
- Little teddy bear
- External hard drive
- Some drawings of mine

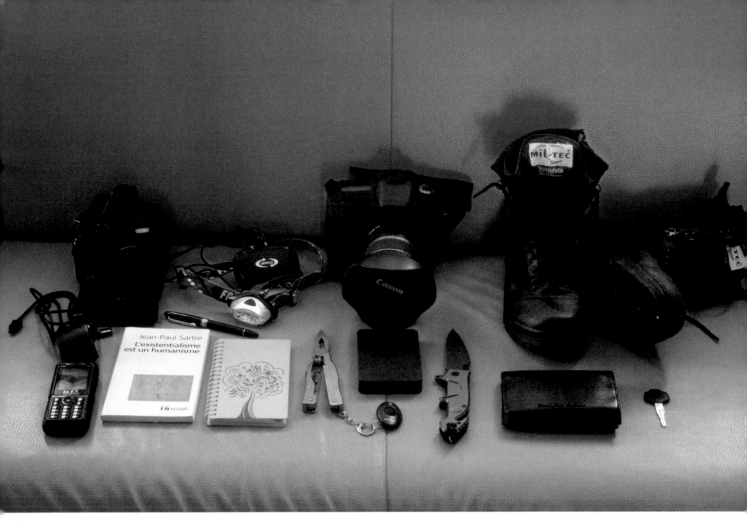

# VINCENT ROK

AGE: 34
LOCATION: Montpellier, France
OCCUPATION: Photographer, videographer
WEBSITE: www.vincentrok.com and www.youtube.com/user/VincentRok

- Canon EOS 7D camera and 10–22mm zoom lens
- Canon PowerShot G10 camera
- Portable hard disk with all my works
- Notebook. I'm lost without it.
- Waterproof mobile phone and dynamo (charger)
- Headlamp and dynamo (charger)
- Leatherman and microlamp
- Favorite knife
- Miltec SWAT boots
- My current book
- Key to my van
- Pen
- Neck warmer, for the smoke

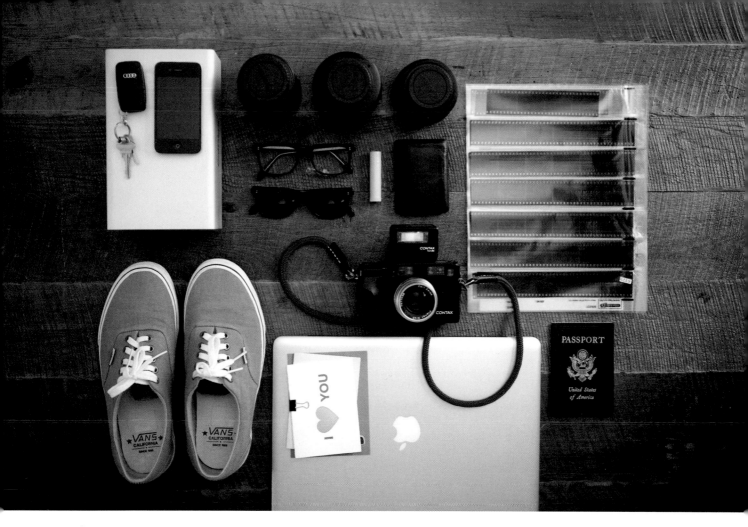

# LOU MORA

**AGE:** 38
**LOCATION:** Los Angeles, California
**OCCUPATION:** Photographer
**WEBSITE:** www.loumora.com

- 2TB RAID hard drive
- Keys to the car
- iPhone
- Three favorite lenses (50mm 1.2, 85mm 1.2, and 135mm 2.0)
- Oliver Peoples glasses/sunglasses
- Burt's Bees lip balm
- Wallet
- Endless amount of negatives
- My favorite camera: Contax G2 with 45mm lens
- My favorite pair of Vans (at the moment)
- Laptop
- Love notes from my fiancé
- Passport

# MICAIAH VON WALTER

**AGE:** 33
**LOCATION:** San Francisco, California
**OCCUPATION:** Musician, recordist
**WEBSITE:** sweetidiot.tumblr.com

- Martin acoustic guitar, which a friend and I saved from certain doom and has been everywhere with me
- Leather field coat, given to me as a teen from a crazy old father-figure type I won't ever forget
- Florsheim wingtip brogues. I've got to get to work somehow.
- 1954 Minolta Autocord twin-lens camera, my favorite shooter
- Deerskin pouch with stone marbles from Bergen Castle, Norway
- Coin purse that belonged to my great-grandfather, and my grandmother loved that it meant something to me
- Yellow aviator sunglasses to shield my pride
- Cascade Fat Head ribbon microphone, because it captures the sounds I like most
- Horsehair shaving brush from someone who taught me to be a man
- Silver cup. It was my mother's favorite noisemaker as a child.
- Stockholm Moleskine with pin from the Stadhusset, to help me navigate my favorite city
- DVD-Rs of all my music-session takes
- iPhone, because I no longer remember how to get hold of people without it

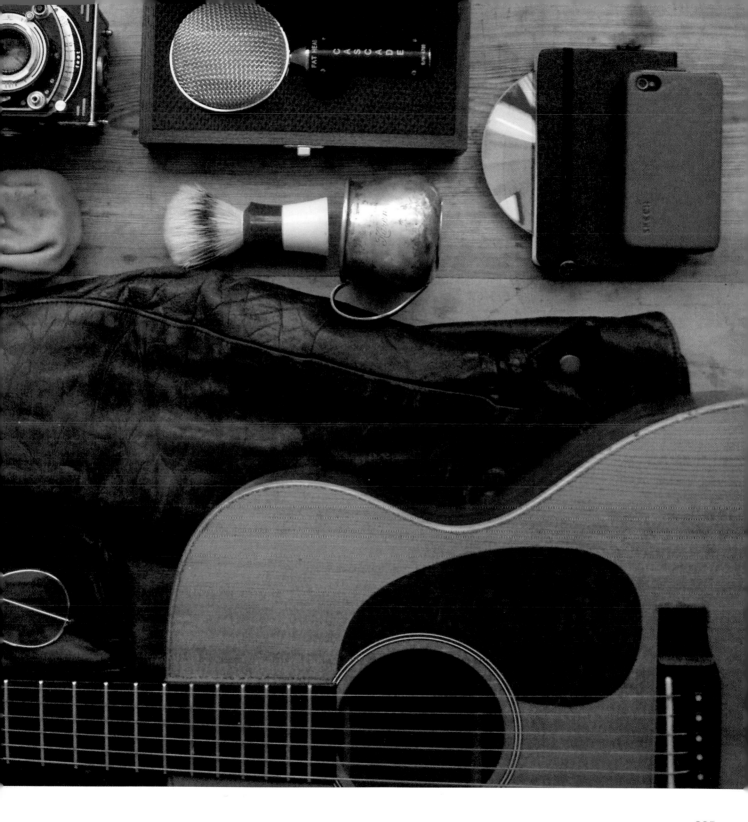

# TOM BONAMICI

**AGE:** 27
**LOCATION:** New York and Oregon
**OCCUPATION:** Designer
**WEBSITE:** www.archivalclothing.com

- Knife that my dad made for me, the most useful tool
- Pliers, the second most useful tool
- Lucky giant fishhook
- Little stone bear I found on Mount Moosilauke
- Little lead cyclist
- Trangia stove and matches
- Baked beans. "Beans are a roof over your stomach." —John Steinbeck
- Pocket handkerchiefs. As Bilbo Baggins knew, you can never have enough.
- Favorite sweater
- Extra socks (crucial for happiness)
- Favorite cap, for rain or shine

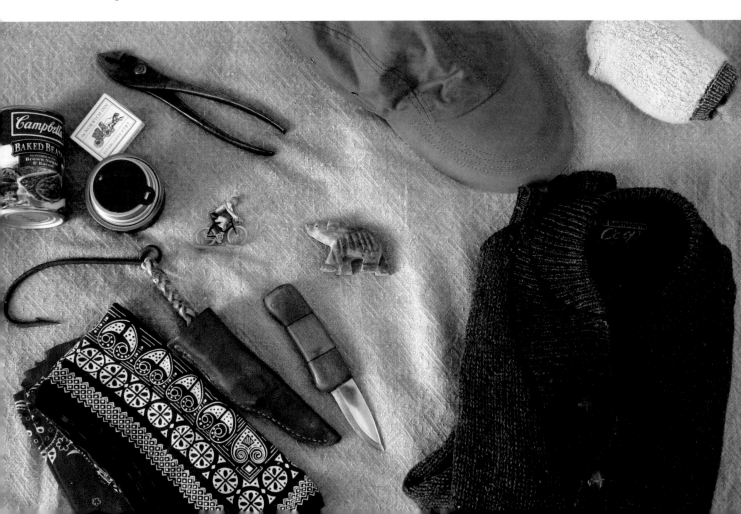

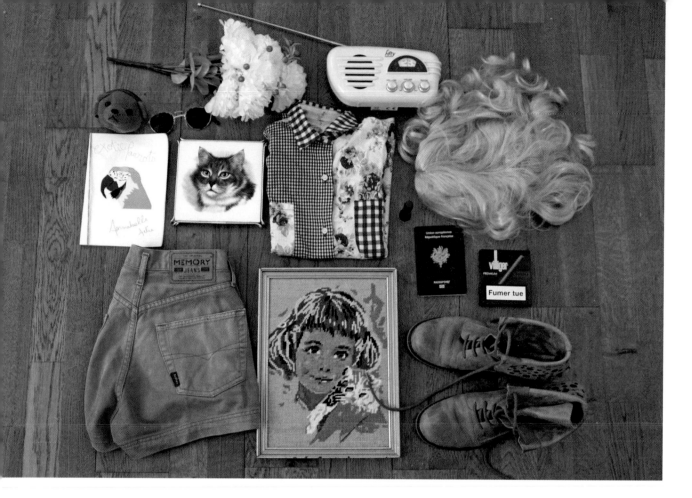

# ANNABELLE ARLIE

**AGE:** 24
**LOCATION:** Brussels, Belgium
**OCCUPATION:** Art school student
**WEBSITE:** cargocollective.com/annabellearlie

- *Porte Monnaie bracelet nounours vintage*
  (Porte Monnaie vintage teddy bear bracelet)
- *Lunettes de soleil Emmaus* (Thrift-store sunglasses)
- *Fleurs en plastiques* (Plastic flowers)
- Radio Fifty
- *Perruque* (Wig)
- *Chemisier vintage* (Vintage blouse)
- *Mon édition* Exotic Parrots (My edition of
  *Exotic Parrots*)

- *Dessous de casserole chat* (Print of cat)
- *Short rose* Memory (Pink shorts from Memory)
- *Canevas* (Embroidery)
- *Rouge à lévres* (Lipstick)
- *Passeport*
- *Cigario* Villiger *à la vanille* (Vanilla cigars from
  Villiger)
- Jonak boots
- My cat

# MARIA

**AGE:** 50
**LOCATION:** South Africa
**OCCUPATION:** Reluctant draughtswoman

- If my house were burning, I would take nothing. I am a hoarder, married to a minimalist, and it would take a burning house to allow me to start anew—with no inanimate objects holding me their prisoner.

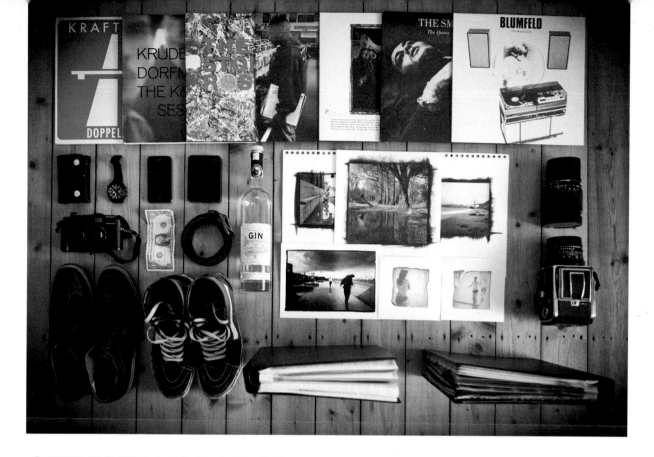

# CHRISTIAN BARON

**AGE:** 39
**LOCATION:** Bonn, Germany
**OCCUPATION:** CT apps specialist, photographer
**WEBSITE:** www.tageswerk.net and www.flickr.com/photos/triggerflanke

- Favorite vinyl: Kraftwerk, Kruder and Dorfmeister, Stone Roses, DJ Shadow, Pixies, Smiths, and Blumfeld
- Bag with all my life in little plastic cards (not pictured)
- Sinn watch
- Phone
- Hard disk with most of my photography stuff
- Leica M7 camera with 35mm Summicron lens
- The one and only dollar left from my first trip to the United States twenty years ago
- Favorite belt
- Ramone jeans (not pictured, since I'm wearing them right now)
- Limited edition Old Tom–style gin from Mosel River (fantastic stuff)
- Ben Sherman Budapesters, and, of course, my Vans
- Collection of my favorite prints, vandykes, and emulsion lifts
- Hasselblad camera with 80mm and 180mm Sonnar Prime lenses
- Two folders with my most important negatives

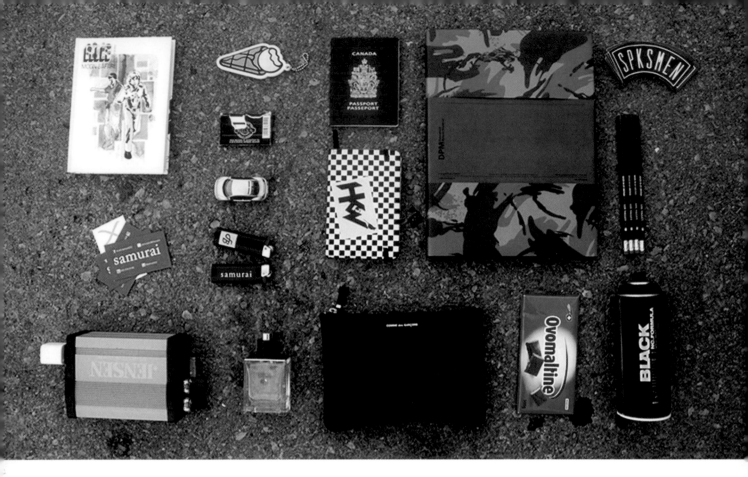

# MUDASSER ALI

**AGE:** 28
**LOCATION:** Hamilton, Ontario, Canada
**OCCUPATION:** Screen printer
**WEBSITE:** www.ffffanboy.com

- Copy of *DPM: Disruptive Pattern Material*, Maharishi's magnum opus
- SPKSMEN slaps (stickers)
- Lee Valley pencils, "Made in Gt. Britain" (the working man's pencil)
- Montana BLACK marker
- Ovomaltine. That's right, Ovaltine in solid form.
- CDG pouch, a place for receipts and traffic tickets.
- Supreme Moleskine, where ideas organize themselves
- Canada passport that will work in most countries
- Ice-cream keychain
- Rizla rolling papers
- Die-cast model of VW Beetle
- Two BIC pens, because one always gets lost
- Terre d'Hermès cologne, a sophisticated experience
- Jensen power inverter to charge/recharge
- Samurai business cards (rep a brand, any brand)
- Air's *Moon Safari* (perfect smoking music)

# JUSTIN R. SWABY

**AGE:** 25
**LOCATION:** Los Angeles, California
**OCCUPATION:** Student of architecture

- My dog, Rooster
- Childhood toy truck
- Vintage suitcase, a gift from my aunt
- Nikon EM 35mm camera
- Sewing machine

- Baby doll head mug, a gift from a dear friend
- Favorite gun-toting marionette
- Small bird carved from bone, a gift from my boyfriend
- Vintage porcelain black lady salt shaker

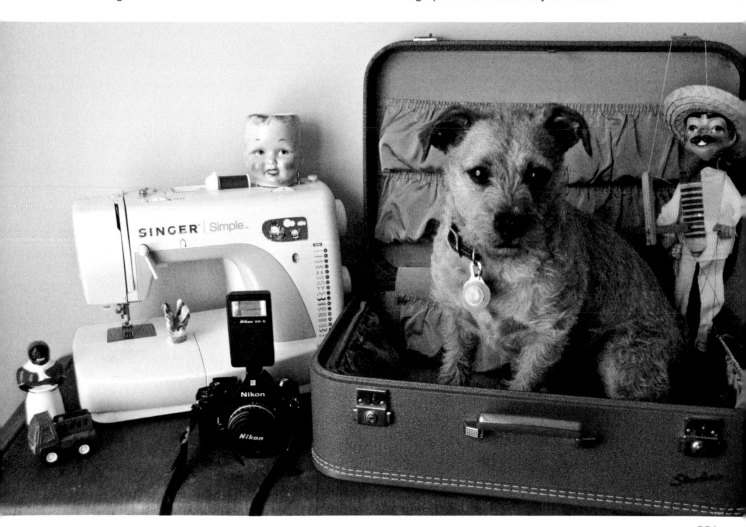

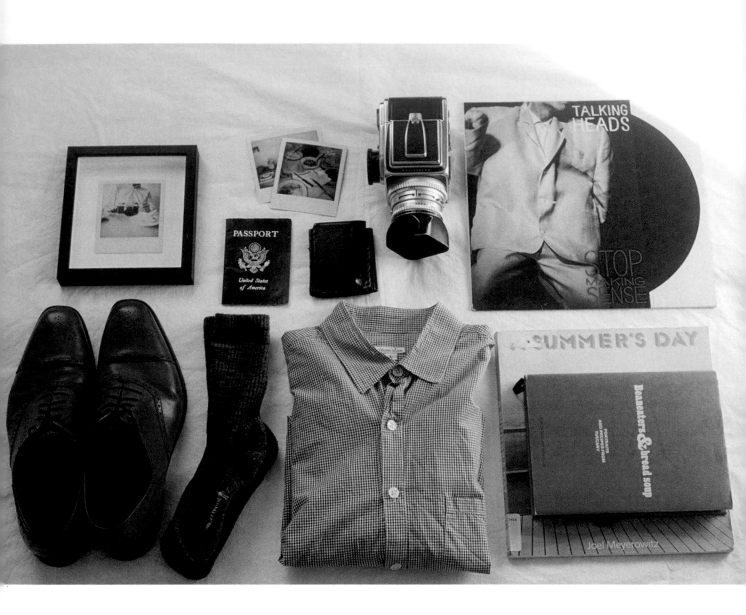

# BRIAN FERRY

AGE: 31
LOCATION: London, England, UK
OCCUPATION: Lawyer by day, photographer by night
WEBSITE: bferry.wordpress.com

- Gingham shirt. I own a lot of button-down shirts, but this is a well-loved favorite and it's come with me on many adventures.
- Grenson x Albam city brogues. You never know when you'll want to look sharp, house or no house.
- Framed Polaroid taken by my friend Molly Wizenberg
- Smartwool socks. No matter what, I'm always comfortable when I'm wearing a pair of these.
- Hasselblad 500 C/M camera
- Wallet (very necessary)
- Passport
- Two favorite books, both of them out-of-print and tough to replace: *A Summer's Day* (photos by Joel Meyerowitz) and *Beaneaters and Bread Soup* by Lori de Mori and Jason Lowe, my photo hero
- Polaroids from friends
- The Talking Heads' *Stop Making Sense* on vinyl. I have a long history with this album, my all-time favorite.
- Pentax K1000 camera (not pictured)

# BECCA WEBSTER

**AGE:** 20
**LOCATION:** Fredericktown, Ohio
**OCCUPATION:** Student
**WEBSITE:** patienceunlikedew.tumblr.com

- My cat (not pictured)
- Six journals, the first starting on March 22, 2008, when I was sixteen
- Wallet
- My (broken) glasses

# MICHAEL MUNDY

**AGE:** 48
**LOCATION:** Manhattan, New York City, New York
**OCCUPATION:** Photographer
**WEBSITE:** www.anafternoonwith.com

- Billingham bag with Nikon cameras
- Brooks Brothers white oxford, my go-anywhere shirt
- Tripod
- Cigar box with personal memorabilia
- My old peacoat (about fifteen years old)
- Horns from African safaris
- Books: Hemingway, J.P. Donleavy, and Borges
- Space pen

- My old Minox Camera. I took some of my favorite photos with it.
- Twenty-three-year-old Merrell boots
- Sculpture my sister made in grade school
- My pocketknife
- Gift from a great friend (see no evil, speak no evil, etc.)
- A few of my vintage bandannas

# MORGAN AND KIM

**AGE:** 23 and 24
**LOCATION:** Queensland, Australia
**OCCUPATION:** Chaplain and public relations
**WEBSITE:** morganandkim.blogspot.com

In December we are moving to France and are currently deciding what to bring with us. This is the closest we have come to a "burning house" experience.

Morgan's list:

- Pentax K1000 camera
- Felt fox Kim gave me on our first Christmas
- iPod
- Face painting my uncle gave me the last time I was in France
- Mandolin banjo bought at a market in Melbourne
- Lordman Italian leather shoes I have had for six years
- Skate deck art by Claire Matthews, the first art piece Kim and I bought together

Kim's list:

- Engagement ring
- Vintage brooch Morgan brought me back from France
- MacBook and hard drive
- Quilt my parents bought us as a wedding present
- Louis Armstrong, *Hello Dolly* vinyl

Both of us:

- The record player we would both be carrying an end of

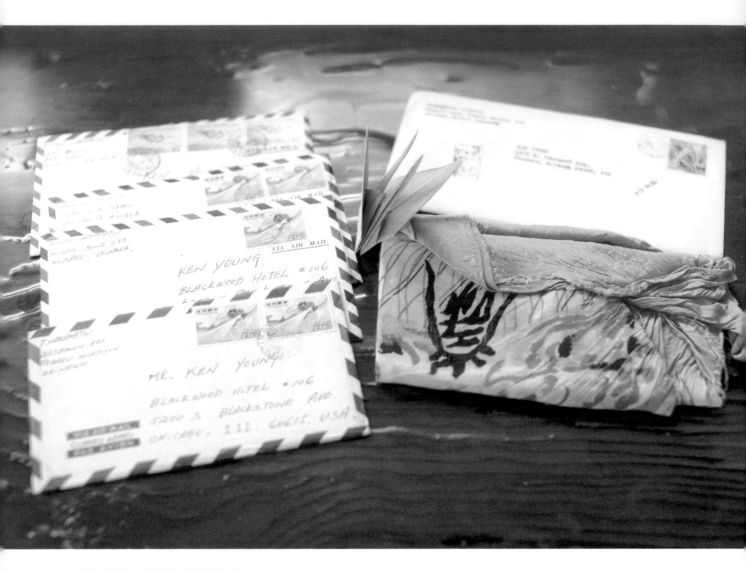

# KEN YOUNG

**AGE:** 70
**LOCATION:** Petrolia, California
**OCCUPATION:** Retired professor

• Letters and objects from a person very dear to me

# MINDY RAMAKER

**AGE:** 26
**LOCATION:** Los Angeles, California
**OCCUPATION:** Filmmaker's assistant
**WEBSITE:** www.mindyramaker.com

- Glasses
- Old notebooks and journals, to be reread when the courage is found
- *Manhood for Amateurs: The Pleasures and Regrets of a Husband, Father, and Son* by Michael Chabon
- Signed and dedicated *Dark Night of the Soul* photo book from one of my favorite projects that I worked on, the third of five thousand printed
- Matches for situational irony
- Rare edition *Fahrenheit 451* signed by Ray Bradbury, who unsuccessfully tried to steal the book from me
- A zine I was published in
- Car keys
- Stuffed dinosaur from childhood
- MacBook Pro
- Current journal
- Special correspondence

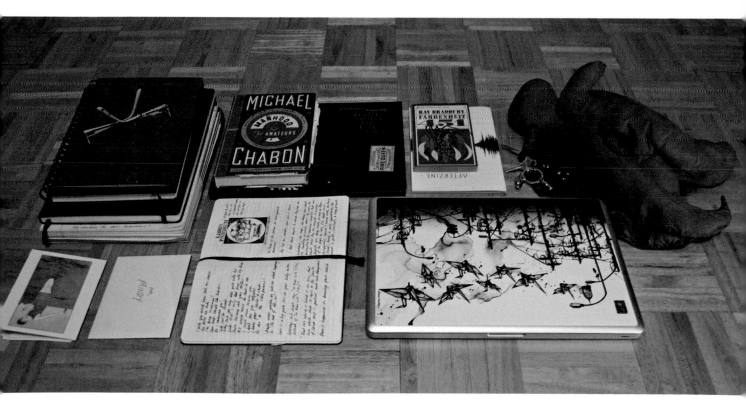

# ALBERTO MONTI

AGE: 26
LOCATION: Reggio Emilia, Italy
OCCUPATION: Fashion designer assistant
WEBSITE: www.facebook.com/albemonti

- Boy Scout neckerchief
- My favorite *Vogue Italia* issues
- The shirts I'll never leave: the Piombo, the MaxMara, and the Raf Simons
- Favorite book: *L'homme qui plantait des arbres*, by Jean Giono
- Caran d'Ache pastels
- Madonna discography
- Armani watch, a gift from my sister
- Armani cologne
- My indispensible yellow Converse All Stars
- Nutella
- A picture from my childhood
- Certainly the Sony camera I used to take this photo

# KIT KLEIN

**AGE:** 25
**LOCATION:** Doylestown, Pennsylvania
**OCCUPATION:** Sales support, photographer
**WEBSITE:** cklein32.wordpress.com

- Favorite J. Crew shirt
- Sigma 50mm f/1.4 lens
- GORUCK GR1 rucksack
- GORUCK Brick Bag
- Headlamp
- GORUCK GR TAC hat
- Survival Straps paracord bracelet

- My great-grandfather's pocket watch
- Ray-Ban glasses
- iPhone 4
- MacBook
- Wallet with credit cards, license, etc.
- Stuffed Billy the Goat Navy mascot
- Wife, dog, Canon 7D (not pictured)

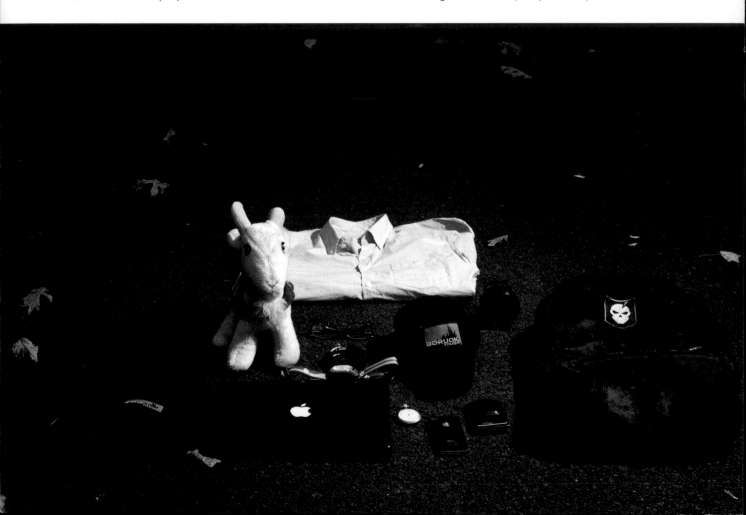

# MIKE DONALD

**AGE:** 36
**LOCATION:** Glasgow, Scotland, UK
**OCCUPATION:** Marketing
**WEBSITE:** thecroft.wordpress.com

- Small ceramic lamb from now-defunct Coll Pottery, Isle of Lewis, Outer Hebrides, bought to mark my first lambing season on the island
- Bright yellow, weathered fishing net float found on a hidden beach on a beautiful evening in Carnish, Isle of Lewis, with my girlfriend, Jane
- A small vial of new-make Abhainn Dearg (Gaelic for "Red River") whisky from the first cask of the spirit to legally leave the Isle of Lewis in the Outer Hebrides in 170 years

- A stone plucked from the seashore following a midnight swim with my girlfriend. It's tied with heather rope from the thatch of a two-hundred-year-old "blackhouse" we were staying in.
- Three rolls of genuine Harris Tweed, spun and woven by hand by crofters of the Scottish Outer Hebrides
- A Japanese Daruma doll my girlfriend gave me. The doll carries a wish to return home to the islands to live and start a family. When it's granted to him he'll be given a second eye to see.

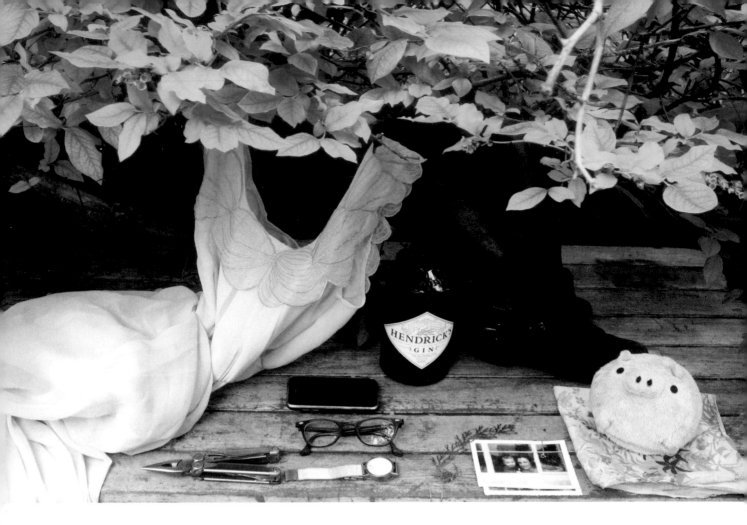

# ARIELA GITTLEN

**AGE:** 27
**LOCATION:** Brooklyn, New York
**OCCUPATION:** Museum staff
**WEBSITE:** arielawonders.blogspot.com

- Pair of sturdy leather boots
- Leatherman, which includes a bottle opener, pliers, nail file, knife, etc.
- Favorite handkerchief
- Piggy, a white stuffed pig
- Photographs of my father and grandmother when they were young
- Glasses
- Watch
- iPhone, which includes my calendar, address book, camera, finances
- Silver necklace, a gift from someone precious
- Floor-length dress I love, but haven't worn yet
- Bottle of really good gin, to drink while I watch my house burn down

# LINA ÖINERT

**AGE:** 31
**LOCATION:** Gothenburg, Sweden
**OCCUPATION:** Photographer
**WEBSITE:** www.linafoto.se

- My wedding dress
- Overly cute panda teapot and tiny bunny milk jug
- Canon AE-1 camera
- New wheels for my quad skates. When not photographing, I'm a roller derby player.
- Tin box with letters from my teenage days
- My wedding rings
- Polaroid camera
- My mum's old *Moomin* comics from the sixties. They contain all the wisdom you could ever possibly need.
- Book by Sophie Calle
- Promarker pens
- Myself
- Canon 5D Mark II (not pictured)
- My cat (not pictured)

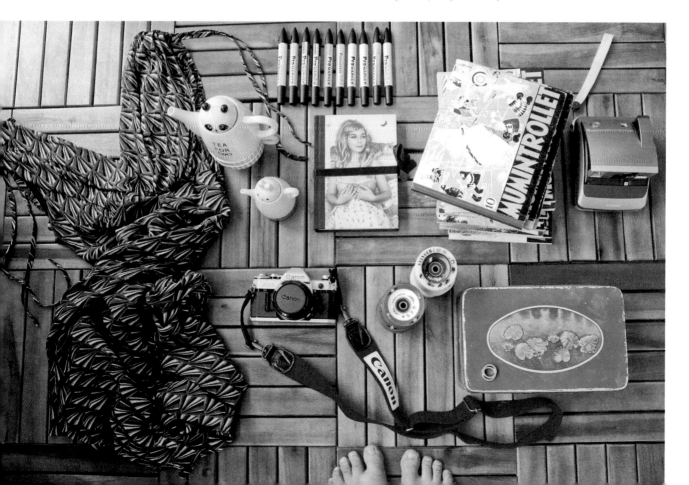

# DAN OPALACZ

AGE: 23
LOCATION: Arcata, California
OCCUPATION: self employed
WEBSITE: www.bedrocksandals.com/sandals.php

- Vintage bamboo Bayshore fly fishing rod
  (Portland, Oregon)
- Pair of Bedrock running sandals
- Estwing rock hammer
- Rite in the Rain geological field book
- Phish stubs from memorable shows
- Bottle of Shelter wine from Napa Valley,
  the first wine I helped bottle
- Polo suede elbowed shirt
- RRL jeans worn since 2008
- Patagonia board shorts that I have
  shredded in Maine, New Jersey, Nicaragua,
  and Northern California

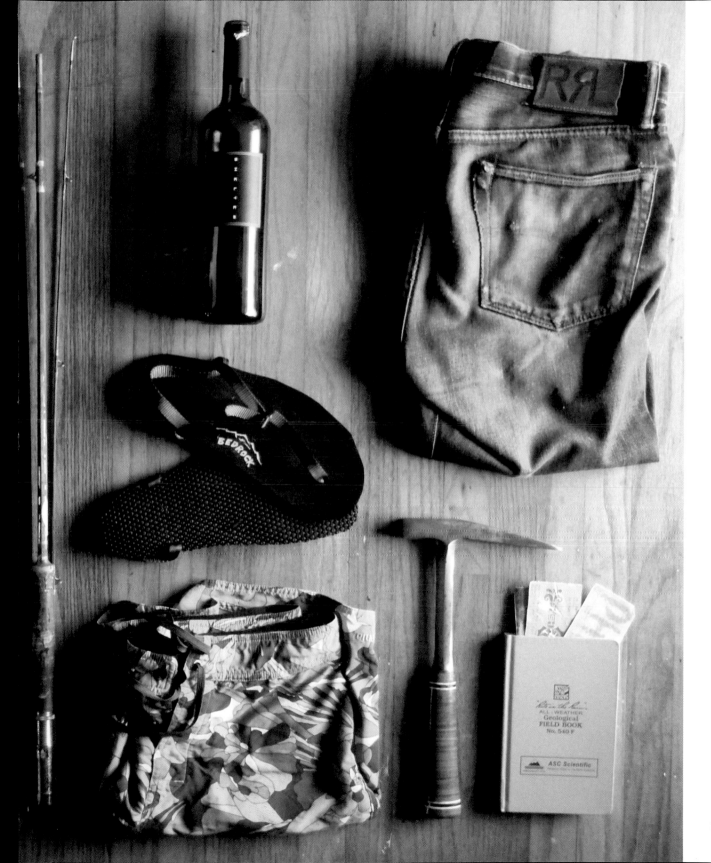

# PETER R. FRORER

AGE: 80
LOCATION: Kennet Square, Pennsylvania
OCCUPATION: Geological engineer

- Turquoise (or dyed howlite), purchased in an off-street, upstairs shop in Hangshou, China, in 2006 on my last big trip with my wife. It might be from Hubei province and should be X-ray diffracted or chemically tested.
- Mineral log, a dated catalog with descriptions of each mineral in my collection inherited from my father's first cousin, along with the rest of his minerals
- Apatite, a doubly terminated crystal collected at Otter Lake, Québec, in 1983. I only had about an hour and a half hour at the site before needing to drive south. I was lucky to do this well in so short a time.
- Native copper, probably from the old Quincy Mine in Upper Michigan. It was given to James R. Frorer in 1952 and has a label showing the three previous owners to me, back to about 1900. It's a fine specimen of partially formed crystals in overall wire structure.
- Pyrite on magnetite from the French Creek Iron Mines in St. Peters, Pennsylvania. It's as fine a specimen as I've ever seen of uniquely curved clusters of cubes of pyrite on a matte of magnetite.
- Prehnite that Cousin Jim obtained from Dr. Runge in 1930. It's a historic type specimen from the old New Street Quarry in Wes Patterson, New Jersey. This was an outstanding piece in 1930 and is irreplaceable today.
- The rock hammer my parents gave me in junior high school and that I've used ever since
- Topaz, crystals in rhyolite from near the Topaz Japanese Internment Camp in western Utah. I collected it in the summer of 1952 with a local retired miner as a desert guide. I sent one of these crystals back east to my girlfriend and teased her that if she were so smart, maybe she could identify it. Darned if she didn't go to a library, look at a bunch of crystal diagrams, name it, and send me back a crystal of sugar. Wow. Marriage followed.

# DAVID TORELL

AGE: 31
LOCATION: Linköping, Sweden
OCCUPATION: Photographer, writer, translator
WEBSITE: www.vanpeltfoto.com

- Facit Privat typewriter from 1967
- The book *Aniara* by Harry Martinson, illustrated by Bo Beskow
- Moleskine notebooks
- *Peanuts* comic books
- *The Catcher in the Rye* by J.D. Salinger
- Nikon F3 50mm f1/8 camera
- A wristwatch a friend gave me
- A pen for signing an important future document, given to me by the same friend
- Another good pen, excellent for quick notes
- Mozart's "Requiem in D minor" CD
- Passport
- Ashtray from my maternal grandmother's village, complete with two-digit phone number to a local company
- External hard drive
- Leather suitcase that used to belong to my paternal grandfather
- Canon 5D Mark II camera (not pictured)

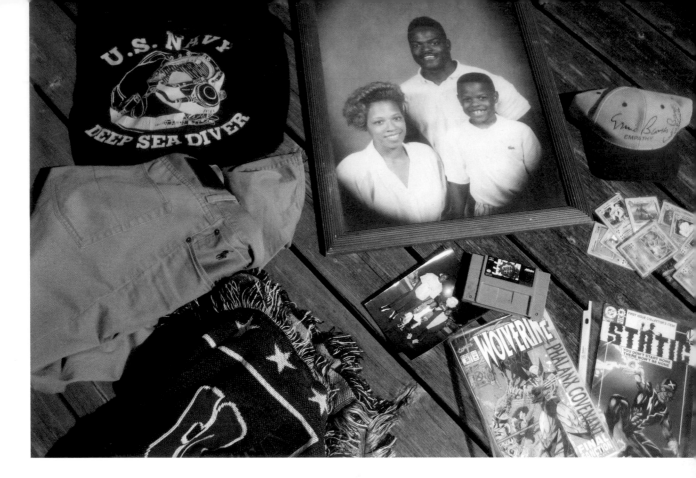

# JUSTIN MCCLINTON

**AGE:** 19
**LOCATION:** Matteson, Illinois
**OCCUPATION:** Student, TV salesmen, underachiever

- U.S. Navy Diver t-shirt. My father was a SEAL. He used to wear it, and now I do.
- Portrait of my family from the 1980s, the closest thing we got to a typical family photo
- Picture of me and my two brothers. The older brother has on the size-thirteen Nike Air Jordan Bred OGs.
- New Balance 999 shoes. Forrest Gump would call it a comfortable shoe. (not pictured)
- Ralph Lauren twill five-pocket jeans. I sacrificed my A.P.C. New Standard jeans for comfort instead.
- Favorite comics: *Static* before cartoon popularity, and an 1980s *Wolverine*
- *NBA Jam* videogame for Super Nintendo (family heirloom)
- Pokémon cards: (T206 Honus Wagner; Holographic Charizard)
- Ernie Banks–autographed baseball cap. I'm not a Cubs fan, but it's freaking Ernie Banks.
- My custom high school blanket, given to me for being a four-year athlete

# MARIE W MATTA

**AGE:** 25
**LOCATION:** Detroit, Michigan
**OCCUPATION:** Architect in training

- Selected sketchbooks from architecture school + WD hard drive containing every drawing I've ever made
- B+L red cat-eyes
- Ever-present turquoise rings
- Assorted personal ephemera, mostly photographic history
- Minolta SLR camera, formerly my mother's
- Gifted leather Klein tools tool bag

- Dog-eared selection of favorite books
- Trusted phone and well-worn wallet
- Italian knit fisherman's sweater from Salvation Army
- Two most-loved pairs of shoes: beat-up brogues and Converse All Star high-tops
- Architectural model from my senior thesis, made of paper and gold leaf
- Feline companion

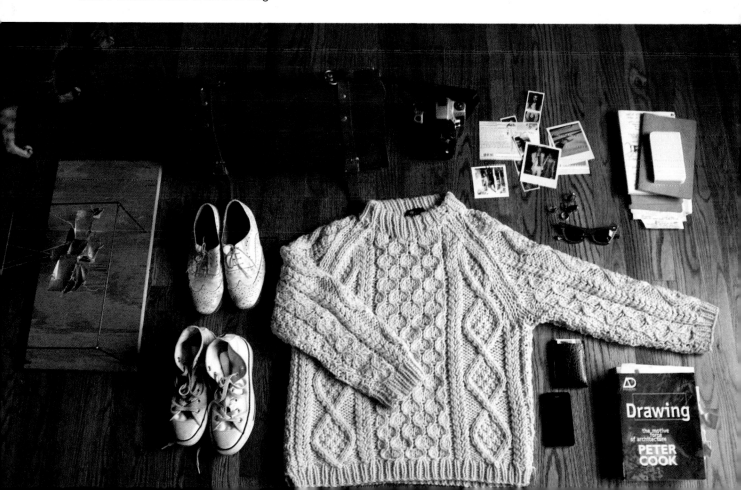

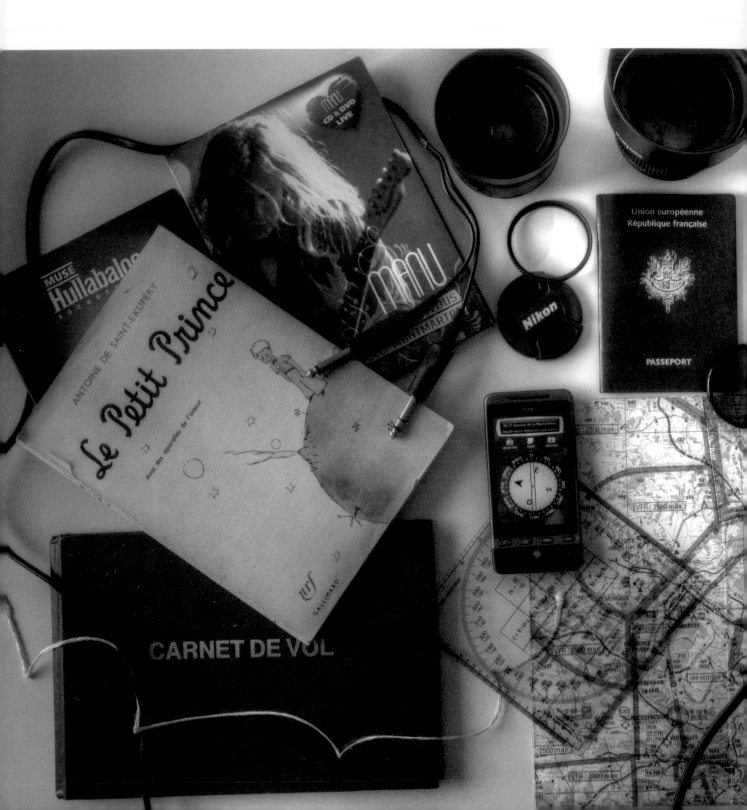

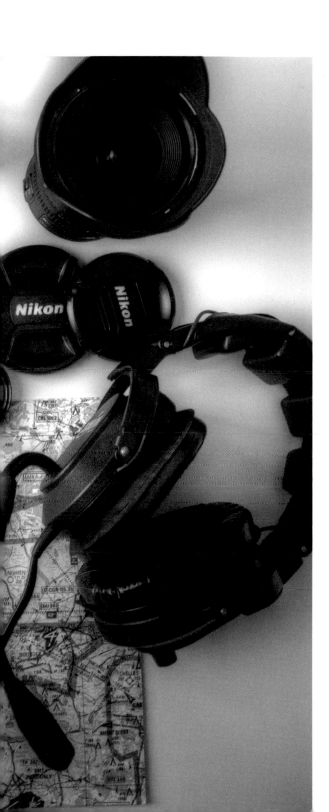

# OLIVIER VANHOUCKE

**AGE:** 29
**LOCATION:** Nantes, France
**OCCUPATION:** Engineer
**WEBSITE:** olivier.vanhoucke.com

- Something to read: *The Little Prince*
- Something to listen: Muse, Manu
- Something for flying: headset, map, logbook, and passport
- Something for taking pictures: my Nikon D7000 and 35 1.8, 85 1.4, 10–24 lenses
- Something to stay connected: my phone

# LAURA PRITCHETT

**AGE:** 24
**LOCATION:** Southern Delaware
**OCCUPATION:** Artist
**WEBSITE:** www.lauraepritchettart.com

- The unglamorous but practical galoshes that I wear most often
- A painting I am (almost) satisfied with
- An irreplaceable blouse. It has no tag and I have no idea who made it, but I love it.
- The wooden clothes hanger from my grandfather's closet
- The perfectly weathered belt I am rarely without
- Candid shot of my grandfather and his car
- The last remnant of family plaid my grandmother brought back from Ireland
- Keys from my childhood scavenging
- 1957 edition of the *The Fanny Farmer Cookbook* with my grandmother's and mother's recipe alterations handwritten in the margins
- The bit I trained two horses with
- Klein bag with my broken–in sable brushes
- The hatchet my great-grandfather used to build his house
- The Ball jar that I keep all of my flash drives in
- Family Bible
- Moleskine journal I kept while traveling in Uganda
- First fabric sample produced by Tukula.org with my design for Ugandan tailors
- iPhone

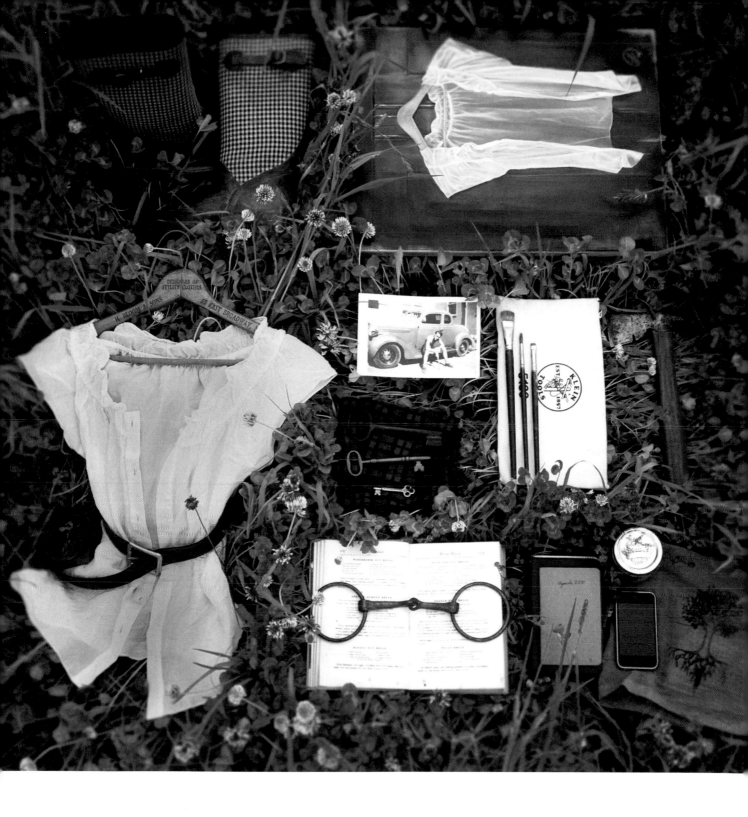

# KIM McCANN

AGE: 43
LOCATION: Indianapolis, Indiana
OCCUPATION: Historical interpreter, writer

- I'd never visited this site before, but this morning I followed a link at the end of this week's Post Secret post.

  The pictures are all gorgeous, and I laughed a little when I saw most of them were by designers and artists of one kind or another—not that it matters, just interesting—but I was amazed by the number of things in each photograph. I looked around my own little apartment and thought to myself, "Cat and laptop would do me fine."

  About forty-five minutes later, I heard a bunch of thumping and banging in the halls of my apartment building. Then someone pounded on my door and yelled, "Everybody get out! The building's on fire!"

  I stood up, heart beating, a bit of panic coming on. I grabbed my cat (after quietly cursing the lack of a proper carrier) and my keys (so I could put the cat in the car) and ran outside.

  Long story short, the fire was contained and about an hour later we were all allowed back into the building, except for the resident two floors above me, whose unit was consumed. While a lot of things are worth saving and dear to us, in the event of a real fire—unless all those beloved items are in one place—you'll get out with what's truly the most important to you.

# LOUIE McPHERSON

**AGE:** 24
**LOCATION:** Haderslev, Denmark
**OCCUPATION:** Graphic design student
**WEBSITE:** www.louiemcpherson.com

- My Curious George doll
- Han shirt (good with everything)
- Grado headphones (vital part of my life!)
- *Fantastic Man*, so I have something to read
- Beach Boys *Greatest Hits* LP, so I have something good to listen to, and to cheer me up now that everything has burned
- Weekday sunglasses, since I'm now homeless
- Pencil case, so I can practice my drawing
- Sandqvist bag! (essential to have a bag when you don't have a home)
- MacBook Pro (can't live without it—literally)
- Casio watch (waterproof so I can tell the time even when it rains)

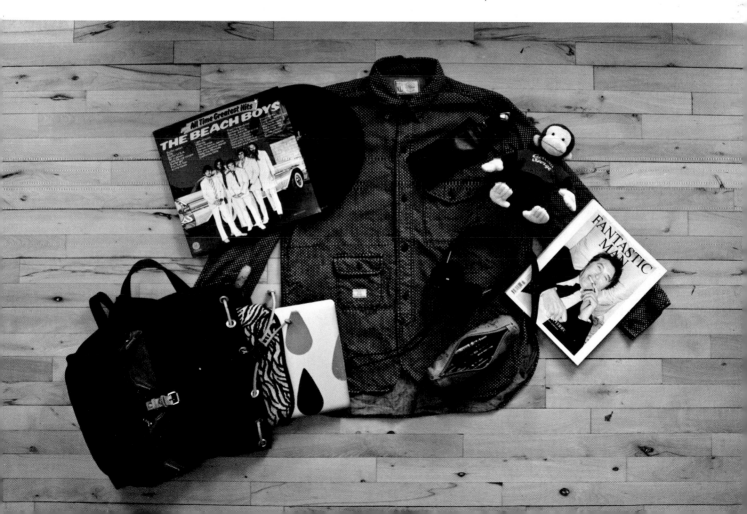

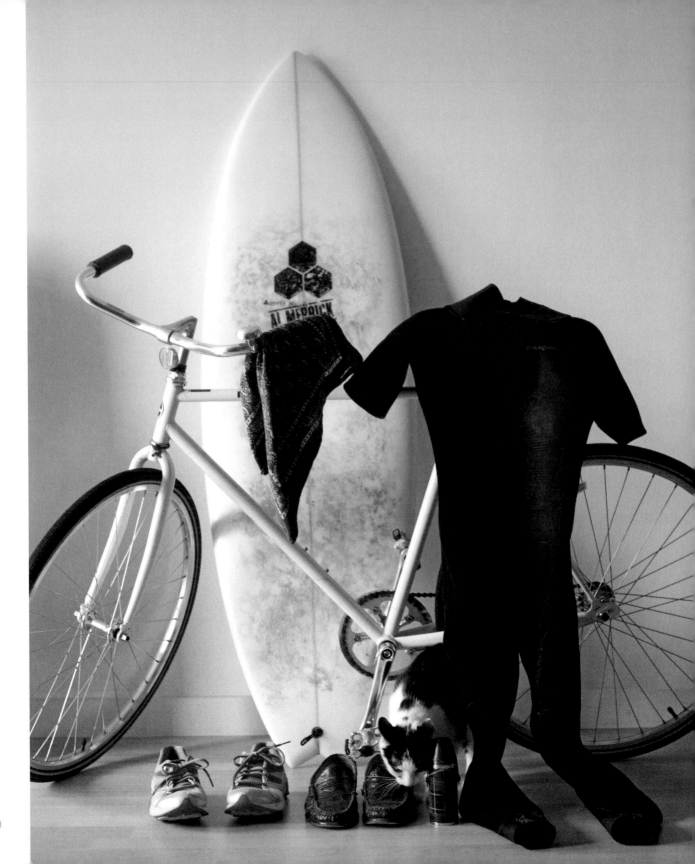

# BRENDON BABENZIEN

**AGE:** 39 years old for another two and a half weeks. Yikes.
**LOCATION:** Brooklyn, New York / my living room
**OCCUPATION:** Design Director at Supreme

- Al Merrick surfboard, the number one item on my list. I don't get to surf as much as I used to, but when I do, it saves my life.

- Patagonia wetsuit. Notice I pulled a short-sleeved suit. I guess I thought it would be more versatile. Their suits are amazing: super-soft rubber, chlorine-free, and light and warm.

- Linus bike with coaster breaks. I try to stay out of doors as much as possible, and, since I got this bike, I rarely ride the subway to or from work anymore. My mood has benefited greatly from this little fact.

- My cat, Tallulah. I'm not even a cat person, but I do love animals and would never think of leaving her in a burning house. That would be awful.

- Croc loafers, a gift from my friend Mark. He makes them up in Maine. I love them because they don't have a pointy toe.

- My Newton running shoes. They changed my life. I can run forever and fast without pain.

- My flask. Preferably it will be filled at the time of the fire because, Lord knows, I'll need a drink. It will most likely contain Macallan or Oban.

- A bandana. I use them for everything: as a sweatband when I run, as a scarf when it gets cold, to clean up a mess, or to tie off an injury. It's one of the most useful things you can have.

- Somewhere in there should be an iPod too. It may have fallen into the shoe. I bring music with me everywhere.

# JORDAN BROWN

**AGE:** 17
**LOCATION:** Australia
**OCCUPATION:** Student
**WEBSITE:** lilmissmessy.tumblr.com

- My first quilt I ever made
- My sleeping-bag liner from when I backpacked through Cambodia and Vietnam. I still sleep in it now.
- Thai silk scarf that I adore
- Bottle of origami made overnight by some friends in Thailand
- Scrapbooks
- Rose quartz and lapis lazuli that a friend gave me for empathy, support, and love
- My charm bracelet. It reminds me of what is important, where I have been, and what I have achieved.
- Positive thoughts from the Blossoming Thought Project
- My pirate voodoo doll to protect me while traveling
- Passport (not pictured)
- Handmade Venetian mask
- Travel journals
- Letters from loved ones that make me smile
- *The Arrival* by Shaun Tan
- Diary
- Favorite photo of all time

FREE POSITIVE THOUGHTS, PLEASE TAKE ONE…

WWW.THEBLOSSOMINGTHOUGHTPROJECT.TUMBLR.COM

# FOSTER HUNTINGTON

**AGE:** 23
**LOCATION:** My 1987 VW Syncro
**OCCUPATION:** Hopefully I will figure that out someday

- External hard drive with memories from the past, including all of the photos from The Burning House project
- Canon 5D Mark II to help me capture memories in the future

# TOP 25 ITEMS PULLED FROM THE BURNING HOUSE

cameras and accessories

photographs

articles of clothing and accessories

books (includes 9 bibles and 7 comic books)

notebooks, journals, and diaries

jewelry (includes 7 engagement and wedding rings)

hard drives and backups

glasses and sunglasses

laptops and tablets

wallets

pets

passports

watches

phones (includes 6 BlackBerries and 32 iPhones)

pens and pencils

dolls and stuffed animals

figurines and statues

artwork

knives

musical instruments

family members

letters

iPods and other music players

blankets

cups, mugs, and drinking glasses

# A COMPLETELY UNSCIENTIFIC SURVEY

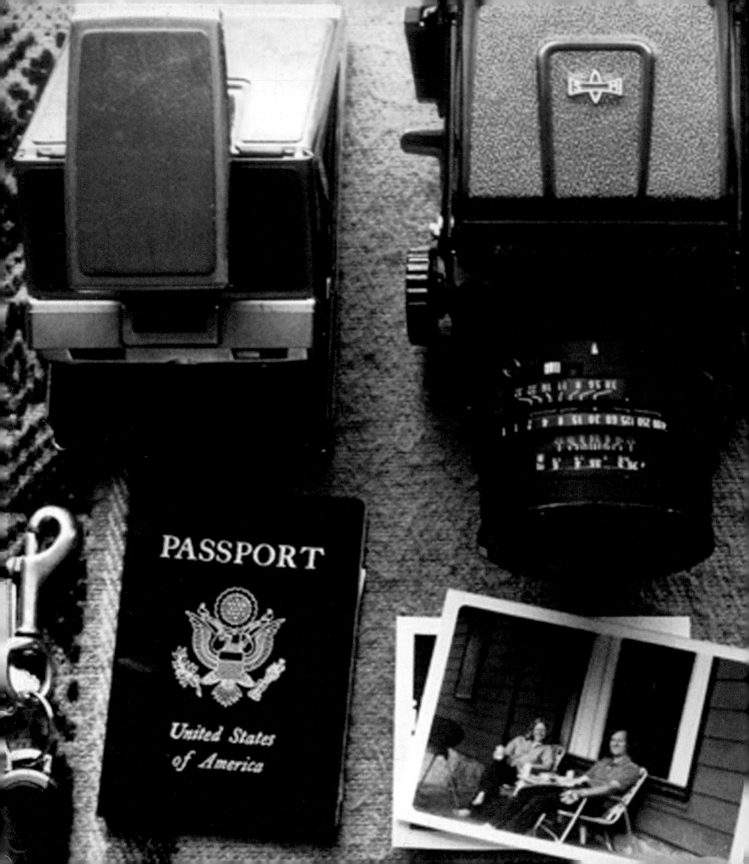

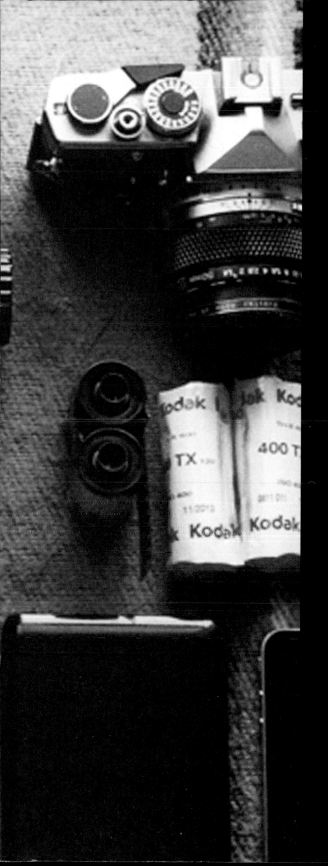

# ACKNOWLEDGMENTS

I would like to personally thank my family, Bryan Bowie for the logo, Dan Opalacz, Nick Wijnberg, Bethany Marcial, Art Leo, Peter Schulman, David Coggins, Spencer Bass, Tyson Fowler, Frank Warren, Nancy Ihlenfeldt, Aaron Lavine, Denise Oswald, and The Anthropologist for their support.

# ABOUT THE AUTHOR

Foster Huntington grew up in Portland, Oregon, and went to a small liberal arts college in Maine. After a stint working in design in New York, he left his job to focus on photography and spend time outdoors. He now travels around in a VW camper van taking photos for a handful of visual projects.